"Learning how to point a camera lens taught me not only how to turn and point my soul but also the art of looking for the light, subtracting from the frame, and focusing on beauty that can be found in the midst of anything. It has enabled me to do more than capture photos of our family; it has freed my heart to live into the expansive joy of the everyday. Joy Prouty's lens and love have been gentle guides, and the way she sees is absolutely breathtaking and life-giving."

ANN VOSKAMP, author of the *New York Times* bestseller *One Thousand Gifts* and *WayMaker*

"Everything! Everything! Everything is about how we see! Through honest words and vulnerable imagery, Joy Prouty invites us into perspective practices that help us see we are already standing on the sacred ground we have been searching for."

SCOTT ERICKSON, author of *Say Yes* and *Honest Advent*

"Few books have taken my breath away more times than *Practicing Presence*. This book has taught me how to be a better memory keeper and meaning maker, and after reading the beauty on these pages, I will forever be training my eyes how to look for the beauty and light in each moment. I don't want any mothers to miss the treasures in this book, as it will help them to not miss the treasures in their own hearts and lives."

ELLIE HOLCOMB, Dove Award–winning singer/songwriter and author

"Your life matters. Your humanity deserves to be honored and seen. There is goodness glinting through your days of both gladness and grief. *Practicing Presence* makes these truths feel real enough to receive as ours. Through stunning photography, poeticism, and compassion, Joy Prouty shows us the worth and the holy weight of paying attention to the lives that we have. *Practicing Presence* is a work of art that amplifies the art unfolding before our eyes."

K.J. RAMSEY, therapist and author of *The Book of Common Courage* and *The Lord Is My Courage*

"This book unlocked something within me I didn't realize was hidden away. With searching candor and armfuls of practical tips, Joy Prouty offers a gentle reminder that we don't need to settle for distraction and

disconnection. We already have what it takes to find our way back to curiosity, compassion, and, ultimately, each other."

SHANNAN MARTIN, author of *Start with Hello* and *The Ministry of Ordinary Places*

"Motherhood, like photos, develops in the dark—those unseen, exhausting hours that shape us and break us and make us. Somehow Joy has captured all that refracted light in this book. If you were to take a mother and press her like a flower between the pages of a book, you would have these stories—delicate, tender, surprising, and sacred."

LISA-JO BAKER, bestselling author of *Never Unfriended* and *Surprised by Motherhood* and podcast cohost of *Out of the Ordinary*

"For those desperate to see light in their darkness, let Joy's words guide you along the way. Through her vulnerability, I became open to my own. What our world needs now more than ever are whole people living out their God-given art. Read this book and breathe deeply the beauty of life."

ANJULI PASCHALL, author of *Stay* and *Awake* and (in)courage contributor

"*Practicing Presence* speaks to us through powerful writing and shows us, through Joy's incredible images and poetry, what it truly means to be alive. Joy's inspiring stories and moving method of communication speak right to the heart. This book had me not only believing in myself again but grabbing for my camera. This much-anticipated and welcome work is something I'll be buying for every budding, blooming, and hidden creative I know. I highly recommend!"

LEAH BODEN, author of *Modern Miss Mason*

"This book is a feast: beautiful, nourishing, healing, and celebratory. Joy Prouty is a lifelong artist who invites mothers to live artistically simply by showing up to witness the wonder of the present moment. Full of stories and advice, images and vulnerability, Joy's book is the embodiment of her own name: a light in darkness. If you, too, are seeking more light, *Practicing Presence* will help unleash your creativity and your ability to truly *see*, using tools that are already in your hands."

CHRISTIE PURIFOY, author of *Garden Maker* and *A Home in Bloom*

PRACTICING PRESENCE

PRACTICING PRESENCE

A MOTHER'S GUIDE TO SAVORING LIFE
THROUGH THE PHOTOS YOU'RE ALREADY TAKING

JOY PROUTY

BakerBooks
a division of Baker Publishing Group
Grand Rapids, Michigan

© 2023 by Joy Prouty

Published by Baker Books
a division of Baker Publishing Group
Grand Rapids, Michigan
www.bakerbooks.com

Printed in China

Library of Congress Cataloging-in-Publication Data
Names: Prouty, Joy, 1981– author.
Title: Practicing presence : a mother's guide to savoring life through the photos you're already taking / Joy Prouty.
Description: Grand Rapids, Michigan : Baker Books, a division of Baker Publishing Group, 2023. | Includes bibliographical references and index.
Identifiers: LCCN 2022040148 | ISBN 9781540902832 (cloth) | ISBN 9781493441167 (ebook)
Subjects: LCSH: Photography—Psychological aspects. | Prouty, Joy, 1981—Psychology. | Photographers—United States—Psychology. | Photography of families. | Mother and child. | Presence (Philosophy)
Classification: LCC TR183 .P77 2023 | DDC 770.1/9—dc23/eng/20220829
LC record available at https://lccn.loc.gov/2022040148

Scripture quotations are from the Holy Bible, New Living Translation, copyright © 1996, 2004, 2015 by Tyndale House Foundation. Used by permission of Tyndale House Publishers, Inc., Carol Stream, Illinois 60188. All rights reserved.

All photographs are copyright © Joy Prouty.

Published in association with Joy Eggerichs Reed of Punchline Agency, www.punchline agency.com.

Baker Publishing Group publications use paper produced from sustainable forestry practices and post-consumer waste whenever possible.

Interior design by William Overbeeke.

23 24 25 26 27 28 29 7 6 5 4 3 2 1

This book is dedicated to my children.

You have each taken me by the hand and shown me the beauty of the present moment. You have taught me how to play without worry of embarrassment, how to ask questions without feeling ashamed, how to create and imagine without hesitation, and how to compassionately love others and yourselves without judgment.

Any wisdom that I've gained and recorded into this book is only because of you having been my gracious teachers.

And to you, the reader,

I hope that you find yourself in these pages—that you feel validated, that you are inspired to create a practice of preserving presence in your own life, and that you develop more connectedness to the child still present deep inside of *you*.

CONTENTS

FOREWORD

L
ife is funny sometimes, isn't it? You grow up imagining that giant, dramatic movie moments will be the ones to alter the course of your life, and sometimes that happens. But in my experience it's mostly been the small things that have made the biggest impact. I've had so many seemingly ordinary, insignificant experiences and conversations that in hindsight turned out to be life-changing.

One such encounter happened in 2018 when an old friend told me she was coming to town for a photography retreat just for women. At the end of that weekend she came by my house and could not stop raving about the instructor—her wisdom and knowledge and her ability to teach women not only how to look through their cameras and discover beauty but also how to discover and celebrate the beauty within themselves. I was immediately curious, so I looked her up on Instagram. That was the first time I saw Joy Prouty's photographs, and I was instantly spellbound.

I clicked on post after post, finding Joy's words and photos equally stunning. This was at a time in my career when I began to intentionally focus my music on motherhood, and I wanted to create video content to go along with it. I began to wonder if Joy would ever be interested in photographing me or helping me film a music video.

I had already reached out to several filmmakers whose work I admired, but they all turned me down. They didn't understand my vision or the nurturing quality of my music. It wasn't dark or edgy enough for them, and they didn't want their name or brand attached to it. Because they questioned the value of my work, I started to question it too.

And then that small, life-changing moment happened so unexpectedly when my out-of-town friend came to Nashville and told me about Joy. Here was a woman who understood the sacred connection between mothers and children and how to capture it on film. I admit I was nervous to reach out because I was afraid of yet another heartbreaking rejection. Joy's response was something my wounded spirit didn't expect: wholehearted enthusiasm. Not only did she see the beauty in my work, but it was as if she held up a mirror and reflected that beauty back to me so I could see it too.

She was all-in for whatever I had in mind, and it has been an absolute delight working with her ever since. Joy has now taken hundreds of stunning photos of me, and the music videos she helped me make have been viewed over five million times. There's no denying she knows how to take gorgeous images, but she also knows how to put people at ease.

I probably don't need to tell you this, but it can feel quite vulnerable to pose in front of a camera, especially as a woman in her early forties attempting to take promotional photos. I can get caught up in how deep my wrinkles are getting or how the shape of my body is changing, but somehow Joy is able to pull me out of that negative mindset. She reminds me—sometimes with words but mostly with her presence—that simply being who I am is beautiful. The light is already there and she will find a way to capture it. I don't have to pretend to be anything other than myself.

Reading the pages of this exquisite book gave me the same feeling as sitting in front of Joy's camera lens. She's teaching all of us to see the way she sees—with compassion, kindness, curiosity, and wonder. We get to soak in her passionate, insightful words

and let them do their work in our hearts, reflecting who we are and who we are becoming.

Through the simple practices she lays out for us—photography, breathing, and just living our daily lives—Joy shows us how to be present to the magic that is happening all around us. She teaches us how to keep looking for the light and to be awake to the small, ordinary moments that might just change our lives.

—JJ Heller

WHY BECOMING PRESENT FEELS SO HARD

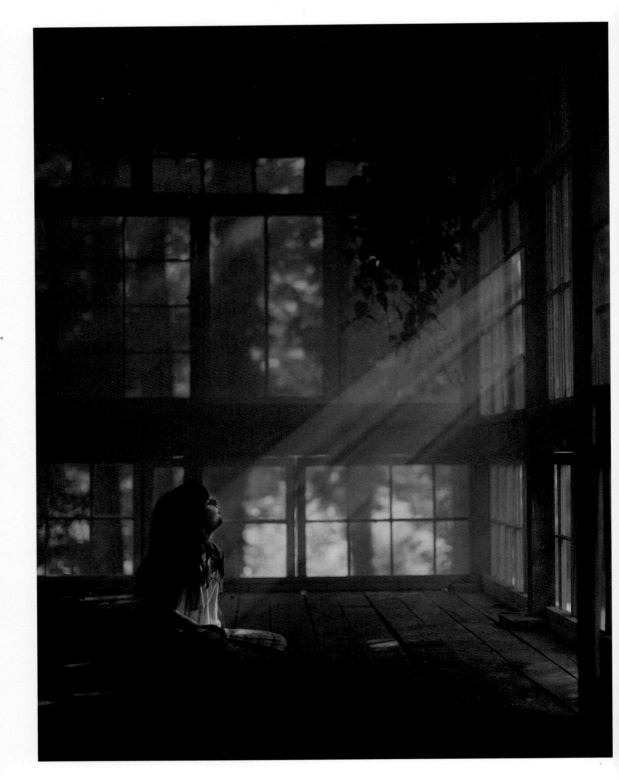

1

HOW I BEGAN
PRACTICING
PRESENCE

A few months after my thirty-ninth birthday, I was lying in a hospital bed, hooked up to all kinds of tubes, trying to give myself my very first insulin shot. I had just been diagnosed with type 1 diabetes. I also happened to be pregnant with our sixth child, and the doctors were not optimistic about the baby's outcome.

It wasn't great timing.

The week prior, my husband, Donny, had flown from Nashville to California to attend the funeral of one of his best friends, who had taken his own life. This friend was a radiant man with a beautiful wife and two young children. His death was an unbelievable shock, and my husband was devastated.

On the day I was discharged from the hospital, I felt so grateful to be alive, but I also felt the undercurrent of deep sadness. Donny and I were each, in our own ways, trying to figure out how

to grieve. We also had five young children looking to us to know how to carry on.

When it comes to parenting, there's just never a convenient time to fall apart.

Once home, I then had to learn to live as a type 1 diabetic, which meant keeping close track of my blood sugar numbers, tracking everything I ate and drank, giving myself regular injections, and prioritizing rest. This new way of having to care for myself became an incredibly enlightening experience, and for the very first time in my life I could measure the effect that stress had on my body. I found that when I would start to worry and get caught in a spiral of anxiety, my blood glucose numbers would spike, putting my body into fight-or-flight mode, and then when I would dose insulin, my levels would plummet to levels dangerous for both me and the baby. It was clear that I had to find a way to stay calm to keep both of us stable and healthy.

My fluctuating sugar levels were also contributing to vision loss, which felt absolutely terrifying to me as a working photographer. I became fueled with an urgency to document as much of my life as possible while I could still see. I cleaned off a shelf in our kitchen and put my camera there to be easily within reach.

My camera has always been my go-to antianxiety tool.

As a little girl, I remember playing in my room and hearing my dad screaming at my mom down the hall. I'd feel so confused and terrified. I remember doing a lot of praying for him to calm down, but when that wouldn't work, I'd pull out my small plastic camera that I'd gotten one Christmas, peer through the viewfinder, and pretend I was directing a movie. Somehow, just looking through that tiny square allowed me to focus on the small things in my room that made me feel safe instead of feeling out of control and afraid.

My camera became my constant companion in life.

When I was nineteen, I took some film photography classes at the local community college and spent hours in the darkroom falling in love with the process of watching images develop. Every

week, I'd gather up my strips of negatives and explore the magic of light. I painted backdrops and set up studio lighting in my mom's garage, documenting portraits for anyone who would let me.

I had a lot of fun but also felt frustrated because what I had grown up loving most about photography was documenting the beauty found in *real* life. And I began to find that most people did not want to look at pictures that showed the way they really looked. Clients would often ask if they could pay extra for me to photoshop and manipulate their faces and bodies in the images. It never sat right with me, but I wanted people to be happy, so I made a strong effort to make the images pleasing. I came to terms with the fact that most people prefer to be shown as perfect rather than real.

I spent the years that followed growing a successful photography business. I created images for families—always in the best light, in their prettiest clothes, on the seemingly best day of their lives. During a photo session, if a child would cry, the parent would often whisk them away before I could say a word, bribing them with candy and begging them to just keep a smile on until we were finished. The desire for a flawless Christmas card picture seemed to be monumental in the portrayal that their family had it all together. I was making a living as an artist, but I always felt that something was missing.

I became a mother at the age of twenty-six. We named our firstborn Grace, partly because I loved the name but also because I felt so completely undeserving of her. She was a calm, sweet baby, and she eased me gently into the new skin of motherhood. In those first weeks home with her, I spent almost every minute with my camera pressed up against my face, documenting each and every inch of her. I'd watch her chest rise and fall, and I'd breathe right along with her. My child taught me that good could come from holding still.

Her brother was born twenty months later, followed by two little sisters. Throughout that time, my business exploded. Donny quit his job to become the stay-at-home parent, and I often traveled

cross-country for work. We were both exhausted, living completely in survival mode.

My body paid the price. My time at home was split between spending endless hours on the computer editing pictures for clients and being locked away in our bedroom with horrific migraine headaches, the curtains shut tight to keep the light out. The irony was not lost on me that I was someone whose job it was to capture light, and yet when I was at home, I couldn't even bear to look at it.

I'd lie in bed, day after day in agony, hearing the children laugh and play just outside my closed door and knowing I was missing it. What started as migraines developed into a deep, foggy depression. At times I was sure my family would be better off without me. I didn't want to be absent from their lives, but I felt like such a burden.

I remember the small, quiet prayer I whispered into the dark one desperate night.

"God, why? Why am I in so much pain?"

It was a prayer I had been too scared to ask before that. I think it's because I was afraid that the answer would be—*I was suffering because I deserved it.*

In my despair, all I could hear were the hurtful things I remembered my father speaking over me as a child. Worthless. Undeserving of love. Piece of crap.

I guess I thought God felt the same.

And yet once I was willing to pose the question, almost immediately I felt the answer deep within me: *self-compassion.*

The words were so startling, I was instantly brought to tears.

I could feel the tension in my shoulders, neck, jaw, and brow as tight as piano strings. I knew I had been judging myself and my pain so harshly.

Learning to be kind to myself was the only way forward.

Looking back, I feel so much tenderness for this younger version of myself. The me that had not yet done the hard work of identifying the fear and lies ingrained within me. I have no doubt

that the physical pain I was suffering was caused by the weight of all the armor I had built around my heart and mind to survive my childhood.

Self-compassion began for me as an intentional pursuit to slow down. I paid close attention to when I'd feel anxiety in my chest, tension in my brow, and the stress of feeling rushed. I began a practice of gently reminding myself to take my time and to breathe instead of tensing up. I began cooking nourishing meals for myself, taking time to enjoy the process and the savory experience rather than just trying to get it over with to hurry up and eat. I started therapy to untangle the confusion within me, which freed up more room for joy. I moved my body and sought out opportunities to play just for the fun of it. And I began learning how to fully, deeply breathe, committing myself to the work of healing.

As I began to find light again, I also became highly aware of how many special moments I had missed with my family. I felt the importance of documenting all the memories I could. I didn't want to let them pass by me again.

It was in this season that I rediscovered my love for capturing the *real* parts of life. The lovely things and the difficult things. The laughter and the tears. Taking photographs purely as proof of presence, without judging how they would end up looking.

By learning to look at myself and my life with expectant curiosity, I began to find traces of beauty not only around me but also within me.

When the noise level in the house would rise, instead of yelling, I would reach for my camera and remind myself, "Just breathe and take in the miracle of living." I began to use my camera as a magnifying glass for light and meaning. I took pictures of flowers and shadows, scraped knees and dirty boots, and sometimes even my own reflection.

By taking a picture we declare an anthem of hope: *something here is worth remembering.* By learning to intentionally and honestly be present for ourselves through photographs, we learn to intentionally show up as our *true* selves in our lives. I took pictures

of everything, and in time a more clear picture of myself came into view.

That year I amassed tens of thousands of images of our family—none of them perfect or shiny by any means, but all exactly what I needed to help heal my body, mind, and heart. Practicing presence through mindful photography was gently rewiring my brain for self-compassion, joy, and peace.

This even spilled over into my professional life. I began sharing with my clients about how my perspective toward photography was changing, and I found that other people felt the way I did about being exhausted by posed pictures.

By taking a picture we declare an anthem of hope: *something here is worth remembering.*

I began offering full-day sessions in the homes of families where the only goal was to be present—no perfection allowed.

I had found that the missing piece in my previous work was vulnerability—we have to be willing to let ourselves be seen. This was my first big pivot as an artist into finding my most true voice. In the years that followed, I had the opportunity to photograph so many incredible families who welcomed me into the caverns of their deeply challenging and inspiring stories. I documented so many heart-shattering moments of birth, death, and everything in between.

My camera really has been my most effective tool in helping clearly see what matters most.

Several months after my diagnosis, I was still adjusting to life as a type 1 diabetic and was pregnant with a baby I wasn't sure would make it. I had a husband who was fairly detached and grieving, and I was also trying to support our family financially and raise five children. It was a lot, and yet I felt an undercurrent of peace. I had learned the art of self-compassion all those years earlier, and it was sustaining me now.

Throughout my pregnancy, because I was high-risk, I had regular appointments with my maternal fetal medicine doctor to monitor how I was doing with my diabetes management. It was crucial

that my numbers stayed as close to "perfect" as possible so as not to cause additional harm to my baby. She was a genius doctor, but even more was her thoughtfulness in the way she made me feel. Aside from her medical intrigue at my rare later-in-life diagnosis, she had taken a genuine interest in me as a person and was always encouraging me.

During one particularly memorable appointment, while checking my long list of recorded blood sugar numbers from the previous weeks, she looked up at me with a smile. "Joy, your progress is exceptional. This is not common for someone who is navigating something this medically demanding for the very first time in life, let alone how it's been made more complicated by the pregnancy."

She thought for a minute, and I did my best to fully take in her next words. "You know, I think I've figured out why you are doing so well. It's because you are viewing your diabetes management as an *art* rather than a science."

I sat in the chair across from her in that small, white exam room with the fluorescent lights buzzing above us, tears flooding my eyes. There was no way just by looking at my numbers that she could have known the countless times I'd picked up my camera over those last weeks to help me take my focus off my natural tendency toward seeking perfection. Or the number of times I had made a conscious choice to play with my children instead of giving in to the all-too-familiar constriction of stress. I know that she was only applauding my diabetes management, but it felt more like she was delivering a holy message. I felt completely seen and known in that moment.

I've thought a lot about my doctor's words in the years since then and how they resonated so deeply with my experience. I think that making life into an art form may be as simple as imperfectly showing up to the present moment with kindness and compassion for whatever happens to be there.

I went on to deliver a healthy baby boy that December. We named him Webb in honor of my husband's dear friend who had passed away, and every now and then we see a familiar glimmer in

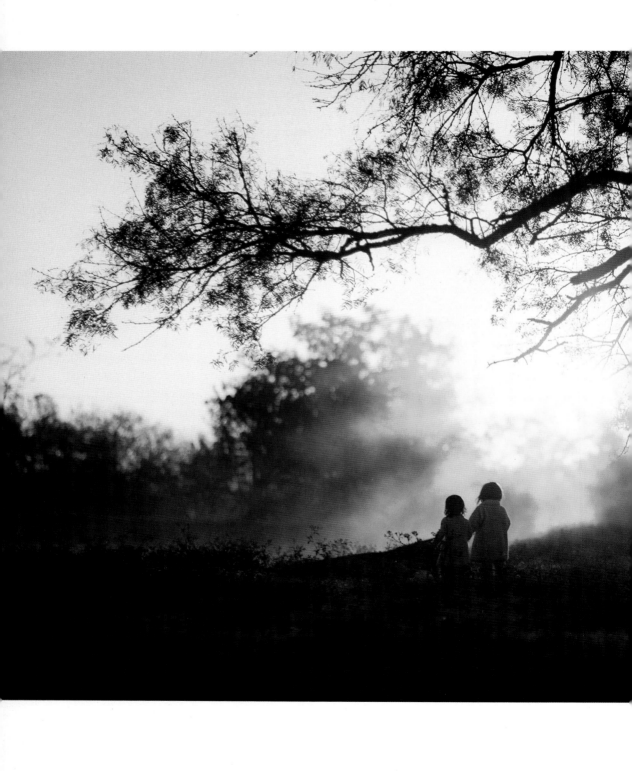

his eye that makes us laugh remembering our old friend's playful spirit.

I'm still in progress, like we all are. Grief still comes in waves. But so do the opportunities to enter into joy—my children extend this offer to me regularly. I have gotten pretty good at giving myself insulin injections—each one a reminder to hold still, breathe, and take in the miracle of living. And I still keep my camera on a shelf in the kitchen, because once you've found your survival tools for living, you make sure to keep them close by.

Our photographs hold and display the people and things that matter most to us and that we hope we will never forget.

To you, the mama reading this book, I know you are trying so hard to do everything "right" for your kids. I know those tears you hide on exhausting days while asking yourself if life will ever stop feeling so hard. But I also know the *joy* that shines out of you when you slow down and breathe, focus on what matters most, and choose to play instead of worry. And I know that smile on your face when you lift your phone to take a picture and feel for just one beautiful moment—*the warmth of true presence.*

Barbara Brown Taylor writes, "The reason so many of us cannot see the red X that marks the spot is because we are standing on it. The treasure we seek

requires no lengthy expedition. . . . All we lack is the willingness to imagine that we already have everything we need. The only thing missing is our consent to be where we are."[1]

I hope that your greatest takeaway in reading this book is the same thing that has been my greatest reward in writing it: the heightened awareness that maybe we don't need a whole new set of circumstances to finally feel peace, but instead we might just need a way to see our circumstances from a more present perspective.

Turns out, looking through the viewfinder of a *camera* can help us do just that. ¶

THE UNFOLDING

I saw wildflowers growing up through the snow in a ditch.
I wondered, did they know it was still winter?
Were they overachievers or, maybe, determined to show us how
 to still rise—
even in ditches,
even in grief,
even in the morning when the children wake way too early
 and tears flow like the faucet is broken and they just keep
 coming.
I thanked the blooms for their courage,
thinking maybe I could do it too?
Lift my weary head and bloom despite the darkness I find
 myself planted in,
to show the children how we carry on—
even in confusion,
even in worry,
even in winter when it feels warmth may never return.
Maybe we don't bloom because we are ready; instead, we just get
 so heavy that we either die or relax and unfold.
Somehow, turns out—
 the unfolding is beautiful.

2

RECLAIMING CHILDLIKE IMAGINATION

I can still see him in my memory, laughing and rolling around in that dust. He was in his own world of imagination and wonder, and I couldn't take my eyes off him. He turned to look at me for a moment, smiled, and then went right back to digging. He reached his hands deep down into that mountain of dust on his family's driveway, tossed it up over his head and down his back, and laughed with delight.

The humidity was thick that evening in central Florida, and I could feel the mosquitos nibbling my toes, but I was so captivated by this child's wild playfulness that I pulled my camera out to capture a few images just before we lost the light from the sky. He rolled around in the dust pile until the moon rose up behind us and his mama called him in for dinner.

The next day while loading the photographs onto my computer, I sat back in complete amazement at this one picture. The dust had fallen in such a way over his back that it looked like he was wearing a magical cape or a veil.

I sent the image to the boy's mother, who wrote back almost immediately to tell me she had called her son over to show him the photo, and at first glance he exclaimed, "Look, Mama, there they are—my wings! I've been telling you for so long that I had wings, but now in the photo you can see them!"

She told me that for two straight years, every night, he had prayed for *his wings*. He prayed for God to make it so that other people could see his wings too. And right there in that photograph, they were made visible for the very first time.

She later sent me a drawing that he did showing his version of this photo—him smiling with his wings.

Now, years later, I'm still in awe of what happened. Children can see what we cannot and are humble and curious about their expansive inner landscapes. Imagination is the oxygen that can turn dust into wings.

> Imagination is the oxygen that can turn dust into wings.

Imagination is what takes the seemingly meaningless pieces of our lives and transforms them into something whole and completely new. And it is children who invite us into that world of unpredictable wonder—to playfully explore ourselves and the world with curiosity, letting our weighty burdens fall away.

CHILDREN TEACH US THE POWER OF STORY AND IMAGINATION

From the time my oldest child, Grace, was very young, my husband would tell nightly stories to help her fall asleep. As the years went by and we added more children to our family, it became more difficult for him to tell her stories every night, as he would often have to rock a baby or brush the teeth of a toddler. But Gracie had grown so used to falling asleep while being told stories that she started telling stories to herself when he couldn't do it.

I would go in to say good night and hear her sweet voice telling herself a story under her blanket. Even now at fifteen, she has continued the tradition with her younger siblings. Every single

night before her brothers and sisters go to sleep, Grace curls up on the floor of their room and tells them imaginary tales, even using different voices for the different characters.

Storytelling is humanity's most ancient tradition for recording a person's perspective and passing it down through generations. Hieroglyphics on the walls of caves have preserved the memories and events of human lives—we look at them now, thousands of years later, and try to interpret their meaning. Just maybe we are intrigued by those first etchings in mud because we see parts of ourselves there too—creating pictures to contain the memories we never want to forget.

Today, our memories live within our photographs—they are images that make tangible what is often invisible. We hold them in our hands, collect them in boxes, and frame them on our walls so we can look at them and be reminded not to give up.

On a deep level, each photograph we take is a metaphor for something much more expansive than what we are able to comprehend in the moment it was captured.

In his interview with Krista Tippett for her podcast *On Being*, the late Eugene Peterson, a theologian and the author of *The Message*, spoke about his take on metaphor. He said, "A metaphor is a really remarkable kind of formation, because it both means what it says and what it doesn't say, and so those two things come together, and it creates an imagination which is active. You're not trying to figure things out, you're trying to enter into what's there."[1]

Creating helps us to become more deeply aware of things that are right in front of us but that we often cannot see because of our limited perspectives.

RECLAIMING IMAGINATION THROUGH PHOTOGRAPHS

So often I have thought back upon my experience with that little boy in the dust. I remember his willingness to enter into messy play—he did not hesitate for even a moment to consider what

anyone else would think of him. I was awestruck, and the photograph I took that ended up showing his wings was not one I had planned for in advance—it was *unexpected*.

I didn't fuss with the settings on my camera or look for ways to make the image more pleasing. I just stood in amazement, let my curiosity draw me closer, and did my best to create proof of his joy.

Not long after I took that picture, I stumbled upon a quote by American painter Robert Henri, who said, "Paint the flying *spirit* of the bird rather than its feathers."[2] That resonated so deeply with me that I began setting it as my intention every time I lifted the camera to my eye to create.

Paint the spirit.

When we make our goal in taking pictures to capture the deepest, most true parts of someone—the *spiritual* parts—rather than seeking to just document the obvious *physical* parts . . . well, it is then that an image comes alive.

You could devote your whole life to learning the technical aspects of photography and go on to achieve skills and status others might assess as "good." But when it comes to taking pictures of the things and people most personal to you, all that knowledge would, in the end, feel quite meaningless if there were never any desire to go deeper than what can be seen on the surface.

It is only when we release what we think photographs are *supposed* to look like that we make room for artistic imagination and childlike creativity.

When I take a picture of my child, I envision them holding it in their hands in thirty years. As the one preserving their story, I want them to look back at images of their youth and see the flying spirit that I saw within them. I want them to remember what made them laugh. I want them to feel how tenderly they were loved. I want their pictures to hold so much more than just distant memories—I want them to remember that there was, in fact, a time they once believed, much like that little boy in the dust, that they could fly.

When I look at the pictures my mother took of me in my early years, I am most drawn to the ones that show parts of me that sometimes feel foreign to my adult self. There is one of me around age three . . . I am sitting on the kitchen floor gripping handfuls of markers—every inch of my skin from head to toe covered in ink—and I have a huge, proud smile on my face. Sure, as a professional artist I love the fact that I can see how my interest in art seemed to come naturally to me from the start. But even more valuable to me in that picture is the glimmer in my eyes as I gazed at my mother. That glimmer shows I understood that not only was my mother *okay* with the mess I had made but she wanted to memorialize it so that neither of us would ever forget. She did not shame me for letting my curiosity lead my creativity; through her affirmation she modeled for me that playful expression was *good*.

Having someone stand witness to my creative exploration and affirm that my mess was not something to be ashamed of really allowed me to grow outside the box of acceptability. In the world today, unfortunately, there seem to be so many voices implying that our messes should be hidden and that anyone moving at an intentionally slow pace should either speed up or get out of the way.

SLOWING DOWN AMID A HUSTLING WORLD

Poet and painter William Blake was a visionary artist in England during the Industrial Revolution. The world was shifting from a rhythm of slowness into a more productivity-driven mindset of hustle. It was the Romantic artists of that time, such as Blake, who felt the weight of that change and tasked themselves with preserving and reminding people of the beauty still available within nature and love.

Our culture has gone through a similar shift over the last several decades when it comes to the use of technology and the introduction of social media, which has now become the main way we all stay connected. Our addictive use of technology has created a false sense of urgency in the way that we engage with the world and

one another. The level of pressure that accompanies that intense need to be available for others at all times can be overwhelming for the human spirit.

Social media apps have been designed to validate those who post the most pleasing representations of themselves online, rewarding people with a rush of oxytocin for achieving what the algorithm decides is a perfect-looking highlight reel.

We once captured family memories for the sheer pleasure of wanting to remember moments, not giving an ounce of energy to worrying if a photo might one day make it online. But the problem now is that our brains have a hard time telling the difference

between the pictures we share with others and the pictures we take just for ourselves.

We grow used to that feeling of affirmation and acceptance from others for making messy things look flawless, and over time that mindset begins to invade the way we document our lives when no one else is around.

I regularly confront this problem when I am photographing my clients. Even when they know that the photos I am taking are just for them, they instantly panic if I happen to capture a few photos that they weren't prepared for, and they tell me not to post any of those pictures online for anyone else to see. There is a great deal of energy spent on making sure only images deemed acceptable to others are worthy of existence. Social media has done a stealthy job of making us all feel that only our best parts are worthy of being seen, and sadly, more often than not, that perception is something we internalize and can begin repeating to ourselves.

In trying to make sense of his quickly changing and productivity-driven society of the 1700s, William Blake wrote, "In the universe, there are things that are known, and things that are unknown, and in between them, there are doors."[3] It feels like Blake is giving us a map of sorts for navigating everything that clamors for our attention in a swiftly evolving society.

There is the known—the truths and atrocities in the world that we are constantly being made aware of. And there is also the unknown—the place we typically fill with anxiety and worry. But, as Blake reminds us, the in-between is always accessible to us as well, and it is full of unexpected possibility.

I can't help thinking that I happened to walk through one of those magical doors when dust became wings for that little boy in my photograph. What was known and what was unknown faded into oblivion that evening when we got a taste of the miraculous in-between.

Each of us has access to these doors. We must just look *deeper* to see that the child within *us* holds the key. ¶

TAKE IN THE MIRACLE

———

When my newborn son smiled at me for the very first time,
I immediately reached for my camera—
I needed to capture the beauty and keep it safe forever.

Artists and poets are borne by the light of the moon,
hours spent with necks cricked and backs weary—
admiring tiny toes and fluttering eyelashes.

Over a lifetime we document the swiftness of time passing,
praying the magic of a *photograph*
will one day take us back to remember.

The camera has been here for it all, bearing witness
to all the years of our becoming—
never ceasing to remind us to hold still, breathe, and take in
 the miracle.

3

DISCOVERING *the* TRUE MEANING *of* JOY

On any given morning, mothers the world over are alerted to horrific tragedies while simultaneously changing diapers, singing little songs, and cutting the crusts off sandwiches. Life does not stop when the unthinkable happens.

A mother continually holds both grief and joy at the very same time.

We have the responsibility of protecting our vulnerable children from the harm of the world while also modeling how to find joy even when grief hits like a missile strike out of nowhere. I surely haven't perfected how to do this, but I keep a close watch on those brave warriors who, in the midst of great tragedy and overwhelm, make a practice of living in the *present*.

Maia Mikhaluk, a Ukrainian mother I follow on Facebook, has chronicled her family's journey since the first day war began raging upon their country in February 2022. In one post from inside a bomb shelter, Maia described how, just after her daughter had

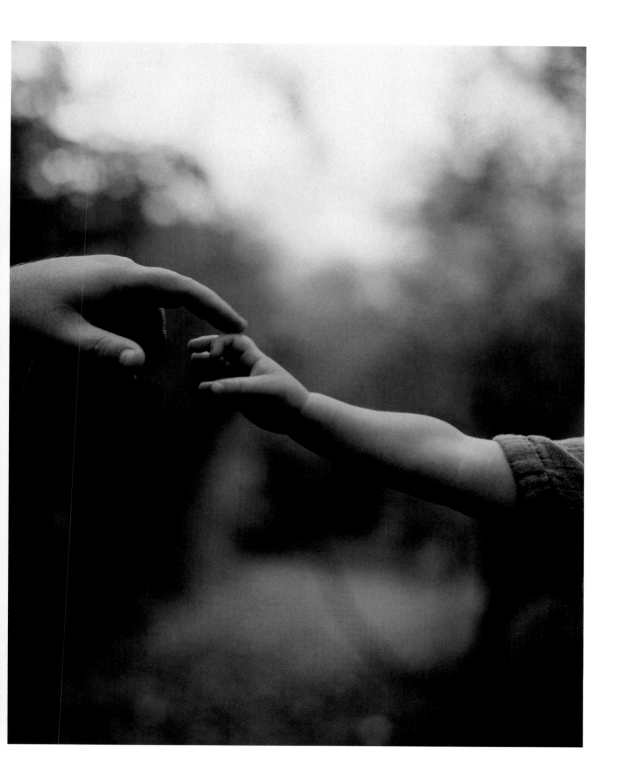

given birth and they were returning home with this new grandchild, they made the decision to take a detour across the city and visit the flower garden they had planted the year before. She detailed the wreckage they passed along the way to the garden—whole neighborhoods flattened by explosions and bodies scattered along the road.

And yet, upon arriving, they saw that their bulbs had opened up and bloomed despite never having been watered and with war raging all around. They gathered daffodils, with this new grandchild pressed against her mama's back, and took bouquets back home to their friends. The photos Maia posted showed the bright yellow flowers in stark contrast with the half-inhabited apartment buildings sitting in rubble.[1]

Frederick Buechner wrote in his book *The Hungering Dark*, "Joy is a mystery because it can happen anywhere, anytime, even under the most unpromising circumstances, even in the midst of suffering, with tears in its eyes."[2] Our most vulnerable offerings sustain us, even in the most uninhabitable landscapes.

I'm so inspired by Maia. I watch her courage in real time as she refuses to give up and drown in the sorrow. She embraces the reality of war—not denying it but having a clear understanding that life could end at any moment—and because of that she chooses to fight against despair by celebrating every morsel of beauty and light. She models the importance of prioritizing joy as a crucial thing to be done in the midst of despair.

It is presence that provides the energy we need to fight back against the dark.

WHY WE HESITATE FROM ENTERING INTO JOY

We've all been faced with realities of death these last few years. Aside from all the inner stuff we were trying to heal prior to 2020—well, then we all went through years of the pandemic together. The collective trauma spanned the globe. Some people told family members goodbye over a Zoom call. Many still don't

even know how to grieve. Even if you didn't lose a loved one, there were the deaths of relationships and jobs and the crushing of so many beautiful, tender dreams. Hope and vulnerability were lost. None of us came out unscathed. All our shoulders are heavy, and we wonder if we have forgotten how to feel joy.

Sure, maybe there are those who have amazingly color-coded, alphabetically organized closet systems and their children all slept through the night since birth. But I think most of us feel exhausted and conflicted and worry if we are raising the children right.

It makes sense that joy feels nearly impossible after bearing witness to so much heartbreak, because the one requirement to feel

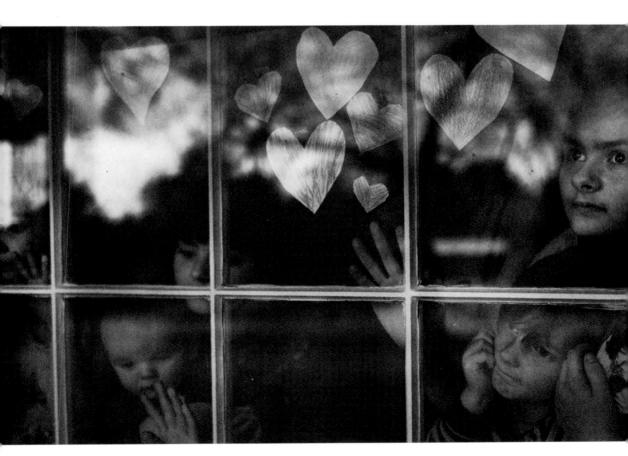

joy is a fully open heart. Israeli poet Yehuda Amichai has written, "There is a great battle raging: for my mouth not to harden and my jaws not to become like heavy doors of an iron safe, so my life may not be called pre-death."[3]

We are in a battle to not build walls between our soul and our companions. We tend to either fight hard for or run away from the things that matter most to us, and when we've been hurt deeply, fear can start to suffocate all possibility for connection.

In her book *Atlas of the Heart*, Brené Brown writes:

> When we lose our tolerance for vulnerability, joy becomes foreboding. No emotion is more frightening than joy, because we believe that if we allow ourselves to feel joy, we are inviting disaster. We start dress-rehearsing tragedy in the best moments of our lives in order to stop vulnerability from beating us to the punch. We are terrified of being blindsided by pain, so we practice tragedy and trauma. But there's a huge cost. When we push away joy, we squander the goodness that we need to build resilience, strength and courage.[4]

Living with an open heart is scary. We have all been hurt. No one wants to invite that pain in again.

I have been no stranger to the fear of vulnerability—it deeply affected the first decade of my marriage. Anytime my husband would attempt to initiate a sweet moment with me and look into my eyes—I would look away. I was terrified that if I allowed myself to be fully seen, he might not like what he saw there. My fear would yank me right out of the present moment, sending me into a spiral of anxiety and sadness. My first instinct when starting to feel joy would be to tighten up and beat vulnerability to the attack.

My emotional protection armor was up, and it felt impossible to set it down. I was not functioning from a place of resilience; instead, I was trying desperately to control things I had no power over. And because I resisted each and every invitation into play, I had zero reserves of joy to pull from to fight back against despair.

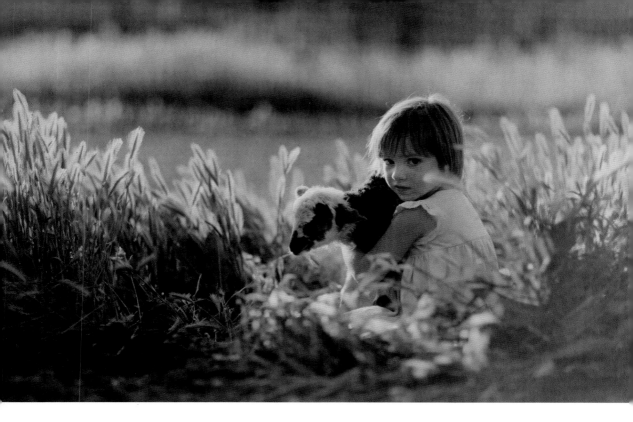

THE REAL MEANING OF JOY

For most of my life I really resented being named Joy. I just never felt like a very happy person. I wore melancholy as a sort of identity, and so my name had always felt unauthentic. But a few years back my mom finally shared with me why she had given me the name. She explained that for most of their marriage, my dad had suffered from extreme sorrow. He expressed that sadness in a lot of unhealthy ways. But throughout her pregnancy and when I was born, for the very first time he had displayed happiness and hope. In what were the darkest of days, it was like a light had been turned on. She told me, "Joy isn't happiness at all. Your name means light in darkness."

I realized that my dissatisfaction with my name had less to do with who I was and more to do with how I had been defining the word *joy*. I've come to understand that joy is not the absence of heaviness—it is the presence of peace that helps carry the weight.

Author and spiritual guide Liz Milani writes, "Happiness is stagnant, joy has a wild and holy flow to it. In ancient Hebrew, the word for 'joy' is *Simcha*. In the Torah, Simcha was not an individual experience; it had a collective quality. It's not something to be won, but something to be *shared*."[5]

Joy is meant to be wild, not perfectly planned.

Joy is experienced in fullness with others, not in isolation.

Raising children invites us into a very real journey of removing the armor from around our hearts by learning to play again. And it is through play that we lay the foundation for making memories of *shared* joy.

JUMPING INTO PRESENCE

One of my very favorite photographs was taken moments after I gave birth to my son Smith. He was born at home in a birthing pool in the wee hours of the morning, and in the picture you can see him, just moments old, on my chest. Beside me in the water is my daughter Clementine, who was four at the time, her face beaming like the sun. She had come downstairs in her footie pajamas right as I was pushing out the baby, and upon seeing us she jumped right into the tub without hesitation.

I can look at my daughter's face and be reminded of the kind of person I want to be. She jumped right into that bloody water, giggling and kicking her feet with the most unbelievable, unrestricted bliss. We were both completely present in that moment, and the picture memorialized it so I will never forget.

I see the joy I want to embody—the kind that doesn't hesitate to jump into the unknown and swim.

JOY KEEPS US AFLOAT

Most of my days as a mother have felt like I'm walking on a tightrope above the Grand Canyon with a child asking for a snack gripping onto each leg, a baby on my back pulling my hair out,

the burdens of the world heavy on my shoulders, and my arms full of cautious hopes and dreams. If you feel this way, know you are in good company.

There's a reason motherhood feels so weighty—because mamas carry within them every wondrous, heartbreaking, and joyful memory from every moment of their children's lives.

When the world feels too heavy, remembering the joy-filled memories we've carried all along can, in time, begin to carry *us*. ¶

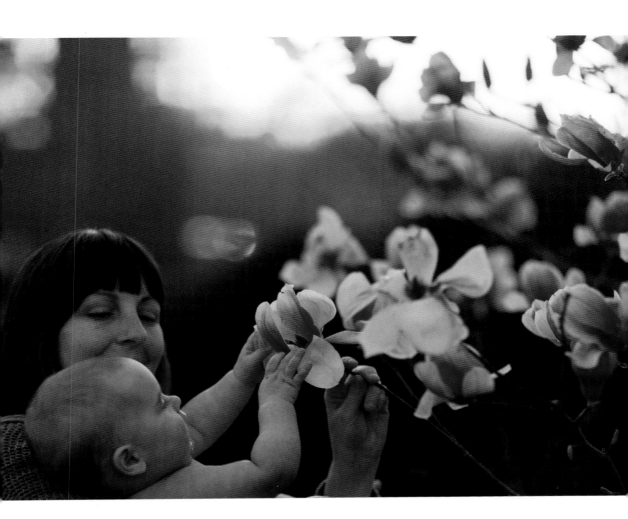

MOTHERS ARE
THE MEMORY KEEPERS

———

Mothers are the memory keepers,
holding every rock, coin, sticker, and heartache.

Collecting remnants of stories because togetherness is sacred,
even when it hurts to look.

The fossils of our past selves collected—
into jars and albums, pockets and drawers.
Like rings of trees, photographs show how we've grown;
our weary fingers can still trace the years that pressed us down.

We will want to remember even if we fear we won't—
every layer is worthy of being preserved.
For when this life of collecting comes to an end,
let's hope our pockets overflow with keepsakes.

And someday,
when our child may forget the way it felt to be small
and cradled in our arms,
they can pick up a photograph
and *remember.*

PRACTICING
the ART
of PRESENCE

4

The PRESENCE PRINCIPLE

I have a collection of ten very important little rocks that I keep right beside my writing desk. They were entrusted into my care last spring by Smith, my six-year-old son, just after his cousin had come for a visit.

The boys had played joyfully for an entire weekend, laughing, joking, and staying up late telling each other stories with flashlights beneath a blanket fort in Smith's room. My in-laws and nephew set off on a Sunday afternoon to drive back home, and we all waved goodbye as they drove away. Everyone went inside the house, but long after they had gone, Smith still lingered on the driveway. I watched my still-small-to-me boy from the window as he paced across the yard. His hands were shoved deep into his pockets and his head hung low, facing the ground. After about twenty minutes, he quietly came inside and didn't say much until close to bedtime. Which, if you knew Smith, you'd realize was fairly significant because there has never been a time he hasn't had something to say.

That night as I tucked him into bed, I could see that he was still holding a lot of feelings inside. His eyes were red from crying

and he was doing his best not to look at me. I nudged him over a bit and curled up right beside him.

"You okay, buddy?"

Silence.

"Are you feeling sad because your cousin left?"

More silence.

I lay there for a few minutes and then felt one of his tears fall onto my shoulder. He began to wrestle his arms around a bit, looking for something in his pockets, and without looking me in the eye, he pulled out one fist and thrust it toward me.

"That's why I have these," he exclaimed, just trying to get the words out quickly. He slowly uncurled his fingers to reveal ten tiny rocks. He looked up at me with his big, thoughtful eyes and said, "I just never want to *forget*."

I looked closely at the tiny fossils held within his trembling hand. I wrapped my arms around him and held him until he wiggled out of my grasp and told me it was okay for me to go.

"Just keep them safe for me, okay, Mommy? Put them by your desk."

I held back my tears for the moment and assured him his treasures would be safe. As I walked down the stairs with his rocks in my dress pocket, I could quite literally feel the weight of being entrusted with his vulnerable heart.

In the time that has passed since then, I've found the rocks arranged in countless different ways upon arriving to work in my office. Recently I asked Smith how he feels when he sees the rocks these days.

He said, "I'm not sad anymore. Now when I hold them I just remember how we played and it makes me happy."

Those rocks were Smith's way of creating tangible proof of the feeling of being present with his cousin. By just holding them in his hand, he was able to recall the memories.

As I gaze upon these remnants of the unfolding story of his life, I see a reminder to not hesitate to memorialize moments—because even if at first it hurts to look, one day I will want to remember.

Where is your proof of presence preserved?

For most people, it's on their phone's camera roll. We use our phone as a magnifying glass for presence without even knowing it. Or maybe we do realize the precious cargo we have been collecting, and it feels urgent not to let it slip away.

Everything we hope we never forget is preserved in photographs.

The camera has gotten a bad rap over the years for being something that takes us *out* of the moment. Because of that worry, we sometimes feel guilty for taking pictures, thinking it distracts us from being present in the experience. But the research actually proves the *opposite*—looking through a camera lens and focusing on beauty catapults all of our attention onto the people that matter most, bringing us out of our heads and into the present moment.

> Looking through a camera lens and focusing on beauty catapults all of our attention onto the people that matter most, bringing us out of our heads and into the present moment.

Our ability to retain the memories of our lives all comes down to attention. What are we giving our attention to? What parts of our lives are being converted into actual memories that will stay with us?

Just in living a normal day of our lives we take in so much information through our senses. At this exact moment I can hear the sound of my fingers clacking on the keyboard. I can hear the buzz of the air conditioner. I feel the ache of my neck and shoulders from writing in a chair all day. I feel the cool sensation of ice water on my tongue. A gardener is using a leaf blower down the street, cars are driving by, my feet are tingling, it hurts a bit to look at the screen. And if my kids were all home, the sensory input would be explosive. I mean, I could just keep going and going. We are taking in endless tiny messages through our senses at all times, and there isn't room for all those things to be converted into actual long-term memories.

The truth is, if we are not paying close attention to our moments, then the memories of them literally do pass us by.

LEARNING TO PAY ATTENTION WELL

We are actually faced with a challenge when it comes to how our brains store memories: the human brain has a built-in "negativity bias," meaning it fixates on the bad but quickly forgets the good. This originated in primitive times, when remembering threats of danger was crucial for staying alive. But times are a bit different now with all different kinds of threats. Our ways of living have evolved, but our brains still retain that negativity bias.

According to neuroscientist Rick Hanson, "The brain is like Velcro for negative experiences, but Teflon for positive ones."[1] Hanson explains that research shows a negative experience takes only *one second* to imprint the memory upon the brain, while a positive experience takes *twenty to thirty seconds* to imprint! This means that if we are not actively present for at least twenty seconds in our moments of joy, then we will not retain them.

I'm quite sure this is why so many of us feel as if the early years of raising children pass by in a blur, because there are so many things to be done, so many times, for so long—on such little sleep. Being exhausted makes it impossible to pay close attention for extended periods of time.

As parents, we try our best to focus on the small miracles of childhood, but we also have to constantly pay attention to basic things. Really, so many parenting tasks are mindless and yet are crucial for our children to live. And then there are the things that actually require thoughtfulness and sincerity. Like when it comes to answering all their hard questions. And helping them resolve conflicts in loving ways. And then, in addition to all those responsibilities, we are also highly aware that they are mostly learning to resolve problems by watching how *we* do it for ourselves. *That is a serious amount of pressure.*

There's just so much coming at us from the outside and the inside at all times. Attempting to complete several tasks at the same time as quickly as possible is just a normal occurrence for a parent. However, this felt need to always be multitasking makes savoring life and becoming fully present feel nearly impossible.

Amisha Jha, a neuroscientist and the director of contemplative neuroscience for the UMindfulness Initiative, has spent her career researching the human brain's ability to focus. Jha explains that people often feel pride in their perceived ability to multitask, but research shows that our focus is actually *finite*—meaning we only have a *limited* supply. Jha refers to attention as "a flashlight you can direct to whatever you choose."[2]

Yes, we can control what we point our attention to, but we have to be very intentional about its direction because we have a limited amount of focus. If we choose to spread it out over various tasks all at once, then our focus will become weakened and dispersed. This is why the *camera* is such a powerful tool for learning to pay attention well.

The camera is our attention flashlight. Focusing our attention through the camera on what matters most to us is a powerful method of preserving hope when everything else is shouting at us to give up. The challenge for us is to not just take a picture and move on with our lives, but to fully experience the moment we are viewing through the lens and imprint the memory upon the brain using all our senses.

Henry David Thoreau once wrote, "It's not what you look at that matters, it's what you see."[3] Thoreau says quite beautifully what we now see neuroscience research also proving: we have to *savor* the moments we are given through rich sensory stimulation *and* stay and look more deeply at what is before us. We cannot rush through our moments. We must spend time taking it all in. Research shows that the very act of slowing down, savoring a moment, and then later revisiting the moment helps to cement the memory into the brain. The act of being present pushes our experiences past our short-term memory buffers and into long-term storage.

By taking a picture we declare—*something here is worth my attention.*

WHAT IT MEANS TO "PRACTICE"

Learning to practice presence is not about trying to take "better" pictures—it's about embarking on the journey of living your whole *life* as an art. The adventure begins with simply taking your time to savor the moments before you that you are already taking pictures of. There is a reason you are drawn to a certain moment—soak it in as though it were a salve to soothe all the hurting things.

Practicing presence is about becoming thoughtfully aware and looking at yourself, your family, and your life from a kinder perspective. The practice is about softening to what is being experienced and honoring those feelings through photographs rather than gripping tightly, putting up defenses, and refusing to be in the present moment.

I find it helpful to approach learning to be present the same way you would view the challenge of learning a foreign language. *No one* learning a foreign language starts out speaking fluently. Everybody fumbles all over and accidentally says things that make very little sense. It makes us uncomfortable, and we become easily embarrassed. We may even be tempted to give up on learning the new language because grasping even the most basic terms can be filled with feelings of discouragement and frustration. Hear me when I say that this is completely normal!

For many of us who have functioned in survival mode, we know that it can easily expand

from being a temporary emergency shelter into more of a long-term dwelling place. Our bodies, minds, and spirits grow used to speaking the language of hustle.

So be gentle with your humanity—getting used to the new language of presence can feel slow. Not having the instant gratification of numbing out can be so frustrating after growing used to not feeling highs or lows for so long. In survival mode we get so good at pushing emotions, intentionality, and creativity aside that to begin prioritizing being awake again takes some getting used to.

Remember that you don't have to be *good* at taking pictures for the practice of presence to work. And you certainly don't need to be a pro. You just have to be willing to feel the feelings that await in that uncertain, in-between place (this is the place of discovery). Discomfort isn't bad, and it actually can signal that you are starting to rewire some of those worrisome connections in your brain.

THE PRESENCE PRINCIPLE

Taking photographs of my life has served as a profound tool in helping me to enter the present moment while also documenting my family in an artistic way.

The Presence Principle is a simple four-step method I first created for myself. It is based on neuroscience research about how memories are imprinted in the brain, combined with intentional, mindful photography. It only takes a few minutes and can be done anytime, anywhere as a way to bring your mind back into your body when you feel anxiety setting in and need a way to ground yourself in the present moment.

STEP 1: Slow down and breathe.

Slowing down will help you pay attention to the thoughts you are thinking, the stress you are holding in your body, and will give you a minute to get outside your head and into your senses.

Taking a few intentional deep breaths in and out will help to regulate your central nervous system. The entire point of step 1 is to get you calm and prepare your mind to take in the intention you will be setting in step 2.

STEP 2: Set an intention and write it everywhere.

Think about what it is that is most important to you. In times of stress, a simple intention I set at home is "Be all here." I say it out loud, put it into my phone, and try to write it down somewhere I'll see that day. By making this positive declaration, my conscious mind will alert my subconscious mind to focus on being all here.

STEP 3: Engage in a sensory-rich memory.

Savor your life. Wherever you find yourself, get outside your comfort zone and look for opportunities to play. Practice the art of paying attention to your surroundings. Look for the way light dances and shadows cast interesting patterns around you.

When our bodies get involved, we develop sensory-motor memory in addition to emotional memory! For me, this is the part that gets me to actually jump into the moment unfolding before me. Instead of just watching my child play, I enrich the experience by joining in. My body starts moving, my heart is pumping wildly, and I have become an active participant in the present moment.

Become a sponge for the experience and make a conscious effort to allow the good to sink in deep. Make intentional eye contact and cement the memory in your mind.

Make sure to extend the duration for at least twenty seconds.

STEP 4: Focus and take a picture.

Memorialize the moment . . . grab your camera and take a picture! I don't mean just snap one real quick. Really take

your time. Look through the viewfinder and ponder what it is you hope you never forget about that moment.

Take a photo that does justice to the feeling you just experienced. Don't worry about it being perfect. Just capture the essence, the way the moment made you feel. Sometimes the images I love most are blurry because there was movement occurring during the moment. The blur of the image makes me remember not only what it looked like but how it *felt* to move within the experience.

That's it!

If you like to journal and want to take preserving the memory one step further, write down the date and sum up the moment you actively savored in one sentence. This can work well if you like to take Polaroids because you can write a caption in marker directly on the bottom of the picture to accompany the memory. You can also add captions as notes on your phone's camera roll.

You just need some sort of proof that you chased the beauty. In the words of photographer Dorothea Lange, "The camera is an instrument that teaches people how to see *without* a camera."[4]

> The photograph exists to remind us of the memory. It is not an image of perfection we are after but merely to create proof of presence.

The photograph exists to remind us of the memory. It is not an image of perfection we are after but merely to create proof of presence. It is a method of preserving hope when everything else shouts at us to give up.

LEARNING TO FOCUS ON SETTING INTENTIONS

When I find myself living inside my head and trying to make sense of things that are impossible to make sense of, the only thing that helps me is to enter my actual senses. I have to find a way to get out of my head and into my body.

We can use our senses to hone in on the present moment. Everything that we see, hear, feel, smell, and taste enriches the experiences of our lives. Our senses welcome us back into our bodies and back into the deepest parts of ourselves. The challenge is in learning to sustain a lifestyle of presence so that even when unexpected grief hits, it is still possible to feel joy in the midst of it.

To better understand how the art of paying attention can enrich our lives, we have to learn the science of how our brains actually do the focusing. We will use the research to help us make our lives into an art.

All the sensory input we take in is sent directly to a part of the brain called the *reticular activating system* (RAS). This is the same part of the brain responsible for our fight-or-flight response, and it is located at the base of the brain stem.[5] Researchers and mindfulness professionals refer to the RAS as the nightclub bouncer of the brain that makes sure the mind doesn't get overwhelmed. It directs our subconscious energy toward whatever we tell it to look for.

Our brain needs something to focus on, and the RAS thrives on the setting of intentions. For example, one morning I was watching a National Geographic documentary with the kids that was all about lions. As I paid attention to the show, my brain was absorbing all this stuff about lions. And then right after it was over, I went to get my toddler up from his nap and noticed that he had a lion on his pajamas. I thought, *Oh my gosh, a lion!* The interesting thing is that he had worn those pajamas many times before and this was the first time I had noticed the lion. Because my conscious brain was being filled with information about lions, my RAS told my subconscious to look for evidence of lions all around me and I was able to see something that had *previously gone unnoticed*.

Our conscious mind is continuously scanning for evidence to confirm what our subconscious mind is telling it to look for.

Learning about the way the brain directs focus has helped me to overcome some negative repeating thought patterns. I had a major wake-up call a few years back when I realized that I'd been carrying

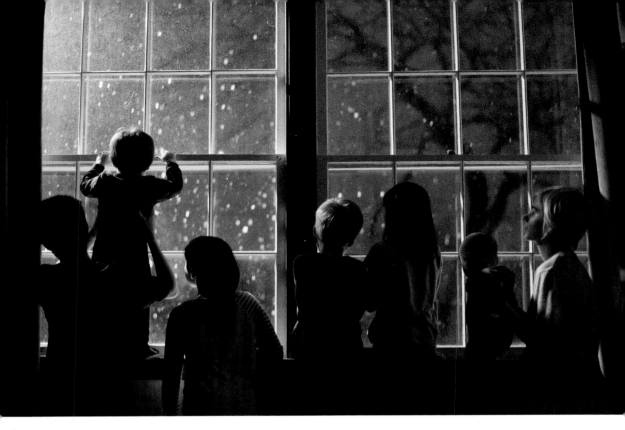

around a toxic repeating thought in my mind since childhood. The thought was something I remembered my father saying to me in a variety of ways when I was young: *You are unworthy of love.*

Those words had run circles in my subconscious for so many years that they had worn a track deep within me. Everywhere I looked for most of my life, I'd be scanning my surroundings and my relationships for further evidence that the negative thought was indeed true. It was a very lonely way to live. Jumping the track and healing from that negative repeating thought became possible once I finally voiced the lie out loud and realized it wasn't true. I have used the knowledge I've gained about the RAS to begin recognizing and removing the negative repeating thoughts in my mind, replacing them with healing, nourishing words of love.

We can't control the things around us, but we can choose what we give our attention to and what we focus on.

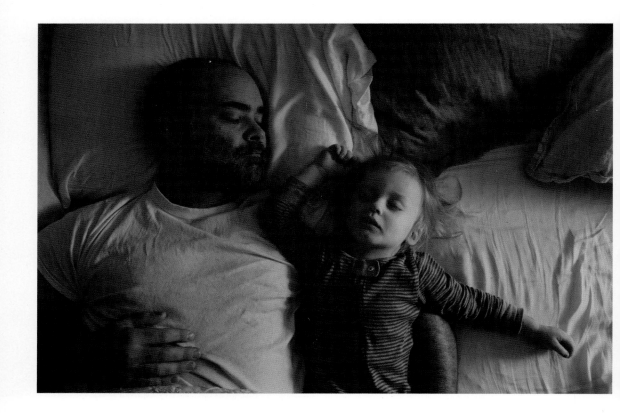

Creating positive, gentle intentions for myself has been a tremendous help in accessing calm. Setting an intention is a way of using the conscious mind to tell the subconscious mind what to focus on. We can fire up our brains with specific positive messages that we want to walk toward, and our subconscious will shine the flashlight for those messages all around us.

Our attention span is limited—*it can only go so far.* This means that anytime we are splitting our focus, whatever we are trying to focus on will only get a portion of our available focus. On days that I do *not* set intentions for myself, I notice a dramatic difference in my ability to find peace. Without an anchor of good, my brain actively scans my surroundings looking to affirm the worries swirling inside my head. Positive internal intentions help to guide me. They set me on the path toward finding goodness and beauty that I might not otherwise see.

For me, picking up the camera and looking through the view-finder provides the most effective way to exit confusion and enter true sight. Instead of viewing the wide expanse of all the never-ending things beckoning to be done, the camera helps direct my focus onto just one meaningful thing at a time. When I look through the viewfinder, my brain knows to hold still, breathe in and out, and take in the miracle.

When we look closely at our lives, we immerse ourselves in the present moment. We will one day want to remember this time, even if it doesn't feel like it right now. We have to believe there is something waiting in the present moment that we need—we just have to hold our arms open and receive that gift.

I currently have 85,022 photos on my phone. Each capture is proof that I paid attention. Proof that for a snippet of time I focused on the beauty around me instead of dwelling on the untrue stories circling in my mind.

Photographs make the invisible visible and preserve all the things we hope we never forget. We enter the present moment because something unexpected waits there to draw us nearer to our truest self. And when we commit to becoming authentic, we invite all those around us to do the same.

LEARNING TO DOCUMENT LIFE IN DIFFICULT TIMES

It is fairly easy to document beauty when everything feels positive. But it can be a real challenge to feel hopeful enough to document joy in the midst of sadness.

I have learned so much from my friend Tiffany about the importance of documenting life in the midst of sorrow. Her son Truman died at the age of three in a deeply tragic accident—a curious little boy found his daddy's gun on the front porch and thought it was a toy. I've watched Tiffany walk through a lot of grief in recent years, and it is clear that the photos of Truman that mean the most to her are the unposed, *real* ones—photos of his sparkling blue eyes grinning at *her* behind the camera. And

snapshots of his little red cowboy boots by the front door with his Buzz Lightyear toy next to a pile of his tiny laundry.

I first met Tiffany over email when she contacted me and my husband about making an informational film for their nonprofit organization. We exchanged a few emails about the kind of video she wanted to make, and she shared that including their family's grief and healing journey would be an important part of explaining the why behind their organization. I share parts of our correspondence with her permission:

Joy,

When my child left this earth, so did a part of me. I found myself with two choices, to either allow this pain to consume me or to use it as much as I possibly could to help others. . . . I want Truman to know that his life and even his death made me a better person, not a bitter person. It is a daily battle to choose to not let the guilt consume me. My husband and I take full responsibility for our son's death and are adamant in sharing our story to bring awareness about the importance of responsible gun safety and ownership.

My last memory with Truman is of him running through the sheets as I hung them on the clothesline, asking me through his sweet giggles, "Why you do that?" That's not my last memory of that day, but it's the last one of him alive that I can remember. I know there was more, but when trauma takes your mind captive it has a way of robbing you of the good memories just as much as the bad. For the last five years I've been so angry knowing there was more that my mind just won't let me remember. I don't remember the last time I kissed him or told him I loved him or the last thing I said to him.

I didn't realize the true power of taking photos and videos until after my three-year-old son died. The trauma of his death robbed me of so many of my precious memories—photos not only became my greatest gift of remembering the moments with my child but also brought me hope in my darkest

moments. Photographs have become my stones—symbols mark-
ing the story we've been given, like in Joshua in the Bible. As
my heart began to heal after Truman's death, I felt a spiritual
prompting to stack my own "stones" for our family and future
generations—much like the Israelites thousands of years ago,
telling our story to pass throughout generations. This is why I
want to work with you to create a film and photographs.

Tiffany and I spoke on the phone several times through tears and made plans for us to create a film with the purpose of sharing their story, providing support for other grieving families, and advocating for preventing preventable losses. The film they wanted to make was a cinematic documentary showing how easy it can be for an accident to happen—*that little hands are stronger than you think.*

Donny and I traveled to their home in North Texas and spent two days filming their family. They were determined to share their heartbreak in the effort of saving other children in the future. The honor of being let inside someone's secret world of grieving is indescribable. Both Donny and I were completely changed by the experience.

Several weeks after we had wrapped with the work, I came upon a few photographs I'd taken of Tiffany from when we had been filming, and I was struck by the strength I saw in her. She had taken a moment in between scenes to comfort her crying son (who had been born several years after Truman). The images seemed to capture the understandably painful tension of the joy of embracing her living son and at the same time recognizing Truman's absence.

In the photographs, Tiffany's eyes are closed, and she's swaying side to side to comfort her boy. I thought it was so beautiful how in the midst of reliving the most painful day of her life, she allowed herself to be fully present. She made space for compassion in the middle of grief. I could see it there in her face—complete and total *presence.*

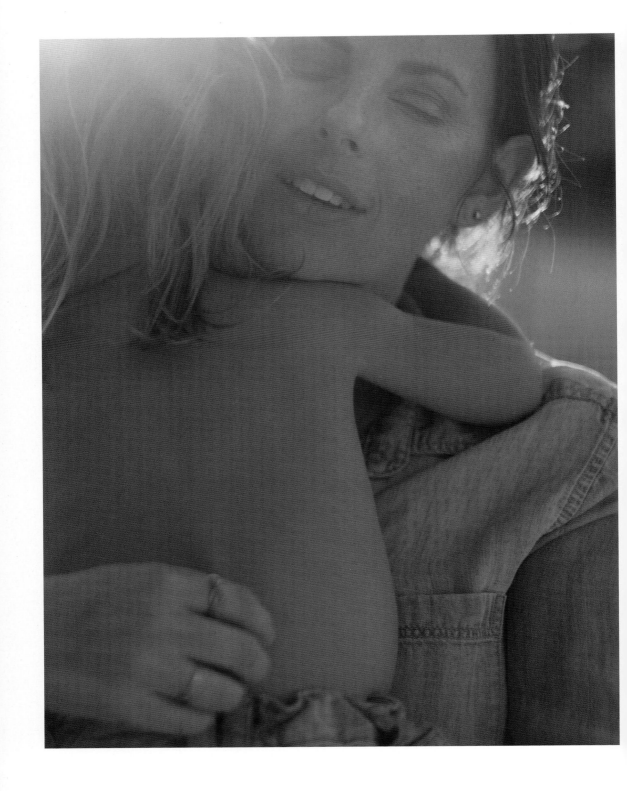

I sent her the photographs that night, thinking that it might warm her heart to see them. This is what Tiffany wrote back to me after she saw them:

Joy,

I am not sure if you knew, but today is Truman's sixth birthday and I awoke to the gift of these photographs from you. I sat staring at them, crying for Truman when I heard God say, "Tiffany, THIS is the memory I want you to have and hold on to. The new memory is a gift. It is a pause in time and exactly how I want you to remember that day—your last day with him on earth."

I feel so seen by God. I no longer feel the burden of needing to know the other missing moments.

Love,
Tiffany

No words can do justice to the deep level of awe I have for the courage of their entire family to share their deepest heartbreak so publicly. Tiffany made a choice to enter back into the most painful day of her life. She allowed herself to relive a heartbreaking memory, and by vulnerably facing her pain, she was given a new perspective. She held both the memory of the grief and the joy of the present moment simultaneously—it was looking back at the *photograph* that helped her to see the moment from a new perspective.

Photographs are powerful! They often reveal things that we can't see in the moment but that unfold after some space, time, and growth.

We all want to have special ways to remember. Some of us, like my son Smith, have actual stones to recall their memories. Others, like Tiffany, have photographs that feel like symbolic stones displaying the legacy of her family's story.

No matter how we choose to preserve presence, we all need something we can stack up and look back on when we can't remember how to have hope. ¶

DAFFODILS

———

She dreamed of daffodils.

Within a fence built high round rocky soil,
lost in toil, you'll find her there.
A wall built to keep them out—
all of the burdens keep them out.

> *All of the blessings*
> *she's gone without.*

This end, this utter defeat,
flowers crushed beneath rushing feet.
Trembling child, you are not alone—
Love has come to bring you home!
To turn your swords into shovels,
melt icicles to puddles.
Be still now, child—
your *heart* is the greatest muscle.
Breathe in, breathe out,
breath is miracle in motion.
Ride these waves of deep feeling—
knowing *you* are a mighty ocean.

Love came down as a helping friend,
she gently took you by the hand.
Planted truth into weary bones—
allowed the *blooms* beneath your feet to grow.

So gather them up and give them away,
the more you give, the more you gain.

Knock down your fence,
love your neighbor,
help a stranger,
hug *yourself.*

Scatter love, child,
like daffodils.

5

PRESERVING PRESENCE *with* YOUR CAMERA

When people ask me what kind of camera they should get, I always pause for a moment and ask them what it is about their current way of taking pictures that they wish could improve. Typically their answer is something along the lines of, "Well, if I just had a great camera then I could take great pictures, right?"

As someone who has made a career out of capturing what some might define as "great" pictures, let me share with you the secret any lifelong artist inevitably learns: the best tool to create with is the one that is *already* in your hand.

Yes, yes, I know there are *so* many technical things that professionals left and right will say you *must* know to take "good" pictures. But the real purpose of *this* book is to learn the value in imperfection by setting aside what other people may define as a pleasing picture.

While I *will* be sharing photography tips and advice in this chapter, I also want to remind you that practicing presence is *not* about taking technically better pictures. It is about learning to more deeply savor your *life* through the pictures you are already taking using whatever camera you have right now.

So instead of wasting your valuable energy worrying about how to make your pictures technically better, ponder instead how you could make them *deeper*. Instead of looking at the pictures you are taking and pointing out how they don't turn out the way you want them to, look longer upon what *is* visible within your pictures and affirm your own creativity. Look for the good in what *you* make the same way you would for your own child if they were to show you something *they* made.

We become an artist by using our imagination to get more creative with the tools we *already* have.

> We become an artist by using our imagination to get more creative with the tools we *already* have.

CAMERA SUGGESTIONS

Like I said, the best camera for preserving presence will always be the one you have with you. So just think about it . . . in your own life every day, what tool do you have most easily accessible all the time to be able to preserve presence through photographs?

I would encourage you to *not* try learning how to use a brand-new camera while also attempting to put the prompts within this book into practice. (At least not for your first read-through!) But if you are already comfortable using a DSLR camera, by all means go for it!

You get to decide how you will make this practice authentic to you in *your* life and cause the least amount of added stress.

I use my phone to capture everyday memories, but I also give myself strict boundaries anytime I pick my phone up while I am with my kids. If I think I will be regularly using my phone to take pictures over a span of time, I switch into airplane mode and

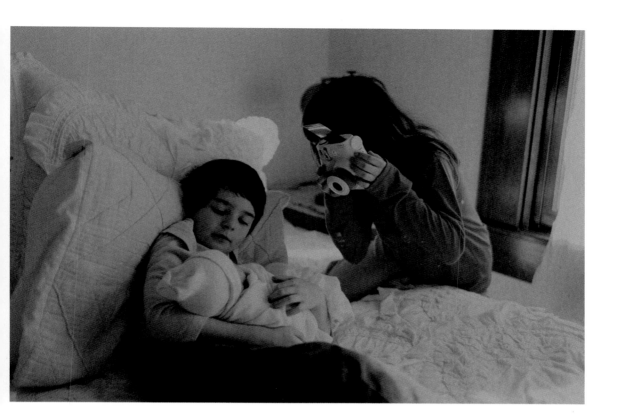

turn my Wi-Fi off. While the phone is a great tool and is typically nearby, it also can quickly shift into being a major distraction. So just be compassionately curious about your tendencies for when you use your phone. Figure out what steps you can take to maximize its use rather than having it pull you out of the present moment.

I have several other kinds of cameras that I alternate using besides my phone. One is a Polaroid camera, which is wonderful for creating images that feel like art the second they pop out. A few of my kids also have Polaroid mini cameras, which gives them a way to capture their own perspectives of the world—free of filters and digital manipulation. They will push that button and wait excitedly for the picture to emerge. We all gather round and hold our breath as the image slowly reveals itself, and we celebrate whatever comes into view.

The professional camera that I use for work as well as for taking pictures of my own life and loved ones is the Canon 5D Mark IV. It is called a DSLR (digital single-lens reflex), which simply means it is a digital camera that allows for interchangeable lenses to be used with it. I do have a collection of professional lenses, but the one lens that stays on my camera 75 percent of the time is my 35mm lens. This lens has a depth similar to what I can see with my natural eyesight. It does not distort or stretch to encompass a super-wide view, nor does it zoom in unnaturally close. I choose this depth because I want to remember my family the same way I see them with my own eyes when I take the picture. When I don't have that lens on, I typically am using my 50mm lens—it's a little closer in than the 35mm. I like the way I am able to create portraits of individuals where the background just fades away and all the focus falls completely on my subject.

If the idea of upgrading to a new camera interests you, I would recommend going into a camera shop so you can hold different brands and models in your hands and really get a feel for them yourself. You can also rent camera bodies and lenses from local shops and online companies that allow you to test out the equipment for a week or so. That way you can make a wise decision about whether such an investment would enhance the vision you have for your art. Just try to keep it all as simple as possible and remember that nicer gear doesn't immediately equate to better pictures.

EDITING YOUR DIGITAL PHOTOGRAPHS

My best advice here is to not spend too much of your time and energy on editing your pictures. For me, the goal is to just take the picture the way I want to remember it. I wish I hadn't overedited so many pictures when I was starting out as a photographer. I look back now and see how I made skies look weirdly yellow and how skin tones were sometimes green or too pink. I wasted a lot of time trying to make poorly exposed pictures look better by adding

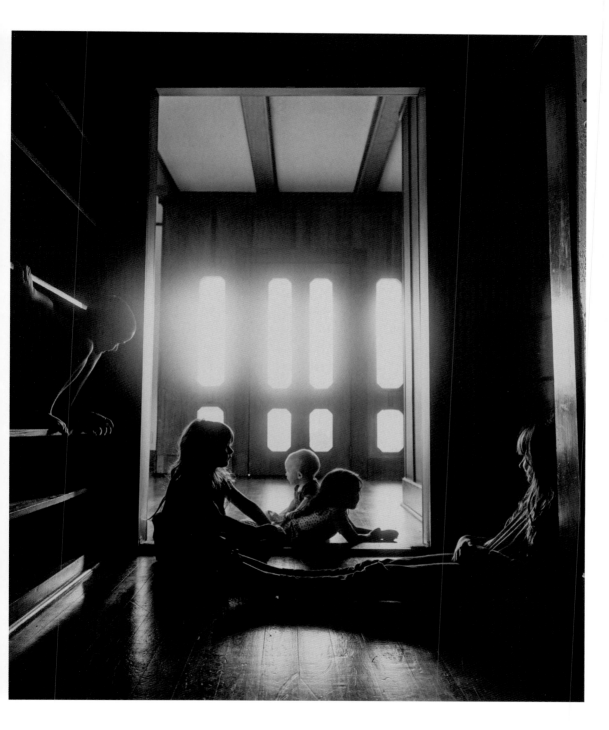

filters instead of just *practicing* and learning to take better pictures. If anything, at this point in my work, I will use Lightroom on my computer or the photo editor on my phone's camera to bump up the brightness and contrast on my favorite images just a tad bit. I love the imperfection of film photography and would say my style leans toward that aesthetic.

The way you edit can sometimes box you in to defining yourself by a certain style, so I would encourage you to just experiment and have fun. Over time your unique perspective and creative voice will surely grow wings and emerge.

STORING YOUR DIGITAL PHOTOGRAPHS

When it comes to backing up the images on your phone, I recommend setting up some kind of cloud storage where your photographs automatically upload to an online server. I have auto-backup turned on in my settings as well as a cloud account where I regularly upload my favorite images for safekeeping. I also create a folder in my phone for my favorites and regularly send those images to my computer before *also* backing them up to an external hard drive.

I keep all the external hard drives I have filled over the years in fireproof, waterproof cases just in case any kind of disaster were to happen. I guess you could say I have backups of my backups and more backups. To me, keeping our memories safe is a major priority, and I would bet it is for you too.

ORGANIZING YOUR DIGITAL PHOTOGRAPHS

I find that organizing my photos into digital albums can be incredibly helpful in conquering that feeling of file overwhelm. I do this both for my professional camera photographs saved to my external hard drives as well as the photographs on my phone.

Phone albums are easy to create. You just open the camera roll, select the photos you want to put in an album, click the Share

button, and then click Add to Album. You can create as many as you want. I have lots of different albums, and it helps me to feel like there is purpose in the images, like I am creating tiny galleries right there in my Albums folder. It also makes the photos easy to find, print, and share.

PRINTING YOUR DIGITAL PHOTOGRAPHS

Research shows that having photographs on the walls at home helps children to feel more secure in themselves and grows their confidence. Displaying pictures of togetherness as well as images of each person individually can be a powerful way we help our loved ones feel seen.

I also make it a goal to print loose photographs every season, even if it is just a few. I often find them tucked into my children's books and in places of great value to them. We also have a wall of framed pictures in our living room, and more pictures get added often.

I have one big coffee-table book printed at the end of every year to authentically tell the story of our family throughout those last 365 days. All of us love picking up those old books from previous years to revel again in the memories of times past.

HOW MANY PICTURES TO TAKE

When it comes to the number of photographs you take in one sitting, my advice would be to just go with the flow. Let your intuition guide you. Set personal intentions for yourself centered around being open to seeing more opportunities to practice presence within your normal days. You are learning the art of paying attention through the pictures you are taking, so just have your camera nearby for when something sparks your interest.

Don't be afraid to take a lot of photos if you are used to being conservative about your typical number of captures. And on the flip side, if you commonly find yourself overshooting (rapid-fire picture taking) but not actually savoring the fullness of the moment in

front of you, then I recommend you slow down and really look longer and engage with your subject. Challenge yourself to be more intentional about what it is you are really preserving within those images.

BATTLING THE TENSION OF TAKING FAMILY PHOTOS

My approach to taking pictures of my kids has evolved over time. I once thought that my camera was mostly to be used to document our happy times. Because of that, looking back, it's rare to find pictures that are not posed or that show anything besides smiling faces. The pictures I chose to take only showed the "highlight reel" version of our lives. Yes, they were full of visual beauty, but they lacked the wisdom of authenticity.

When special days would come around, like the first day of school, holidays, or birthdays, I always made sure to take a picture, but often I also felt like I was rushing through it, just trying to get it over with so as not to make it torturous for everyone. Taking a picture was something I felt I had to bribe my kids to do, and the whole thing just created negative feelings, knowing it was something that everyone dreaded. I was trying to make the pictures look flawless, but now when I look back at those seemingly perfect pictures, what I remember is the tension I felt while taking them, the kind of candy I used to bribe the kids, and how everything fell apart the second after I clicked the shutter.

Over time I have come to realize the importance of preserving authenticity within our family photographs. I want all of us to look back at pictures from the past and see the fullness of who we were as unique individuals. So when I photograph my children, I seek

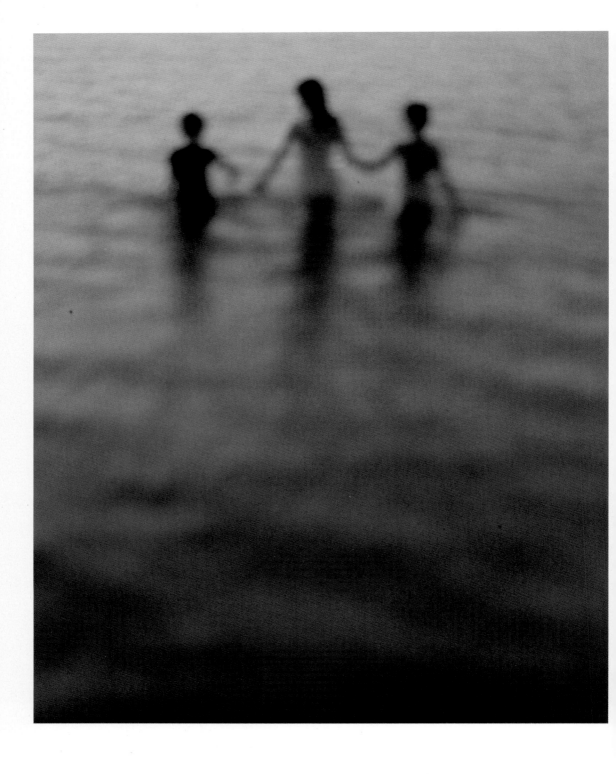

to preserve their facial expressions, not just their pleasing smiles. I try to capture them in motion doing things that make them come alive, not just being frozen for a picture in a position that doesn't feel comfortable for them. Even when trying to take self-portraits, I rarely just sit there and smile for the camera because that typically doesn't feel exactly true to me.

Each individual contains a full spectrum of personality, and each layer deserves to be honored and preserved in photographs. For me, self-compassion often looks like honoring whatever I am experiencing internally within the moment the pictures are taken. Sometimes joy, sometimes grief, sometimes hope or even exhaustion—there is room for it all.

> Each individual contains a full spectrum of personality, and each layer deserves to be honored and preserved in photographs.

The goal is to get into a regular practice of taking pictures of all different emotions so that the discomfort and stress of "having to get ready to take a picture" can lessen. Creating proof of presence is less something you have to prep for and more of a comfortable, regular rhythm of honoring your life.

If you find that tension rises up in you and your family members whenever the subject of taking pictures comes up, give some thought to what has, until now, been your family culture around taking photographs. Has it been something to dread or something to look forward to? Know that even if tension has occurred in the past, you can establish a new way!

It is important to have thoughtful talks with the ones we love about their feelings around taking pictures and what it brings up inside of *them*. This is a wonderful way to connect, build trust, and understand more about those we would like to honor in our images.

You have the opportunity to develop a new family culture around photography by modeling a fresh, nonthreatening relationship with the camera and with being *seen*.

* * *

In this next section, I will share some of the ways I stay inspired to keep making pictures, as well as tips for using both your camera phone and other cameras to create interesting and authentic images.

FINDING LIGHT AND SHADOWS

I encourage you to take notice of the little pockets of light around your home. Start to write down what time of day the pretty light hits which walls so that you can think about and be ready to create photographs in those spots. I often hang lace in my windows where the golden afternoon light comes in to create interesting shadows on the wall. I am a fan of using only natural light whenever

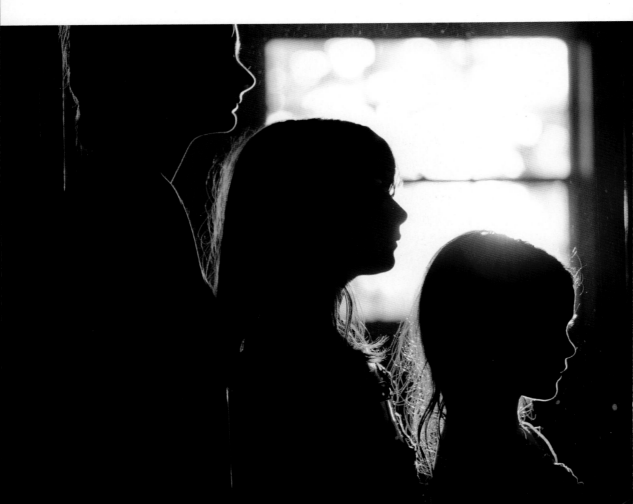

possible—I turn off all interior lamps and look for windows with blinds casting interesting patterns, but I encourage you to experiment with all the lights available to you and just have fun as you play. Even opening up the fridge in a completely dark kitchen can be a super cool light source for creating unique, sometimes even moody images.

Thinking about the light and then intentionally putting yourself in the way of it is *powerful*. Knowing when and where the light hits will help you develop a relationship with the light, and I personally think this is the most important thing for creating interesting images that speak.

FRAMING YOUR SUBJECT ARTISTICALLY

I am always looking for ways to creatively frame the pictures I am taking. I sometimes duck behind sheer curtains and shoot through them to create a vintage-looking haze around the subjects in my images. I also shoot through tree limbs, flowers, grass, doorways, and LEGO castles to create intrigue. The goal is to make your own "frame" that will appear blurred or undistinguishable in the photo but looks interesting and draws all the attention to your subject. Just place yourself a few inches back from that object you are shooting through and focus only on your subject.

SHIFTING YOUR PERSPECTIVE

It is pretty common to take pictures while we are standing up, but in doing so we miss out on the world from other angles. My favorite photos I have taken of my kids are ones where I am down on their level, seeing them and their surroundings at their exact eyeline. Remember to keep your practice of presence playful! Get curious about how things might look from up really high or down really low. Maybe even ask your child to photograph you from their own perspective and stay open and compassionate toward

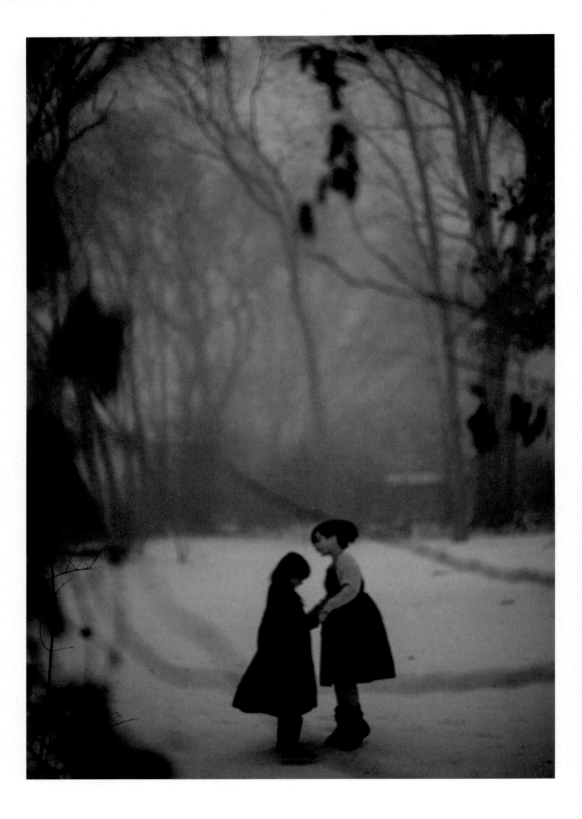

the experience, knowing that learning more about yourself can lead to transformational growth.

GET CLOSER

Get physically closer to your subject instead of zooming or cropping in with your camera. Seek to show your connection with the subject you are photographing and let that engaged relationship be visible in the images. For me, I never want to just be a "fly on the wall" when I am taking pictures of my kids; I want to see myself in my children's eyes and in their body language when I look back on those photographs years from now. I fill the frame the exact way that I would want to print it later. That way there is no need to crop, as cropping in can decrease the quality of your digital images.

LOOK FOR INSPIRATION FROM ALL KINDS OF ARTISTS

While I have certain favorite photographers I admire and follow, I do my best to look for inspiration from musicians, painters, dancers, and artists from other genres not related to photography. I love going to art galleries and seeing the way artists transform their feelings through unique creativity. I watch the way dancers hold their bodies, and it helps me gain inspiration for how to hold my own body in symbolic positions for when I take self-portraits. In paintings, I look at the way light is directed, and it helps me think of how I want to use light in the pictures I take.

If you find yourself needing a boost of inspiration, I encourage you to try exposing yourself to something different. Maybe put on a beautiful piece of instrumental music you've never heard before, or open up a book of unfamiliar art and let your imagination run wild with ideas as you turn the pages.

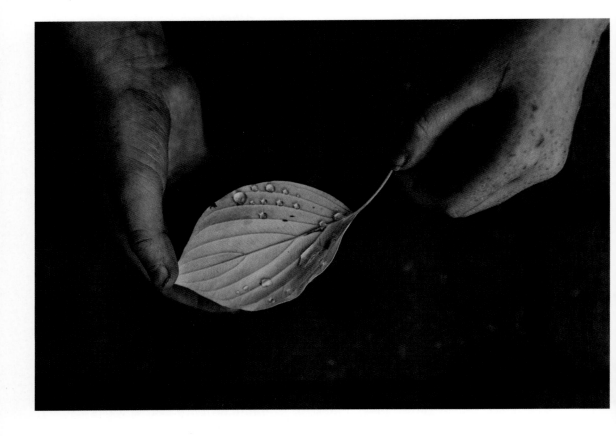

PORTRAIT MODE

You can use Portrait mode on most smartphone cameras to enhance the wonder and magic in your photos. To access this mode, open up your camera and click on Portrait and experiment with capturing images in different kinds of light. Portrait mode replicates the look of shooting with a shallow aperture, meaning that you are able to have only one area of your photo in focus and everything else fades into a beautiful blur. Just tap the screen where you want the phone to focus. This can look super beautiful when shooting into the sun when it is low in the sky. This mode is great when you want to really draw attention to one thing or one person.

If you don't have Portrait mode, you can create a similar look using your phone's camera by getting closer to your subject and tapping on that spot on your screen . . . the background should blur out more and more the closer you get.

TRY NIGHT MODE

I discovered this built-in setting on my iPhone accidentally. I found my son adorably asleep in his bed with his books piled all over him and pulled out my phone to take a picture. The main lights were off, and the only source of light came from a tiny nightlight by his bed. My phone sensed that there wasn't enough light to properly expose the picture, and because I had my flash turned off (using a flash can take the emotion out of images), my phone used Night mode to expose the picture. The words "Hold Still" appeared on my screen while my phone executed a long exposure—leaving the shutter of the camera open for a second or two to allow more light to enter and properly brighten up my son in that dark room. It was necessary to *hold still* because if I were to move while the shutter was open, the image would appear blurry. Some people use long exposure to show streaks of light, like when using sparklers to draw letters in the dark on the Fourth of July. Long exposure "records" all the light that moves within the darkness.

MAKING REFLECTION IMAGES

Don't overthink this. Just keep an eye out for reflections all around you. Instead of looking out from inside, walk outside your home and start to look *in*. Gaze upon the layers of reflections in the windows—look at the way light and color and nature might reflect off the glass. Look for new perspectives—in puddles, ponds, really any bodies of water. Don't be afraid to get the hose and make yourself a puddle. Car windows make for excellent reflections. Find a friend, a child, a mirror—and just snap away. *You cannot*

do this wrong. The goal is just to step outside your norm and go looking at your world with fresh eyes.

DOUBLE EXPOSURE IMAGES

Double exposures are multilayered images. To me, they contain deep symbolism—more than just a single frame can hold. I encourage you to consider your own story and the uniqueness of your loved ones as you ponder making these images. My kids love it when I make double exposures of them. In springtime when flowers are blooming, my younger girls often ask me to "layer them with flowers" in pictures. They love the finished images and feel one with the flowers—the photographs somehow make visible the not-always-seen beauty living deep *within* them.

The editing part is truly the quickest part—it is more the *thought* behind the layers you choose that defines the photo's meaning. Think about what kinds of images you might *need* to help encourage your spirit. What might you need to see an image of *you* layered with? What season are you in or what are you holding on to hope for? Think about nature and what makes you feel calm or full of joy and imagine how you could embody that in an image.

You can easily create double exposure images on your phone, and I find it to be super fun! Download a camera editing app that says it has a double exposure feature—for me, it really helps shift my mind into an artistic mode of meaning. If you are using a DSLR camera, I think the fastest, least-perfectionistic way to create double exposures is in-camera. Most newer DSLRs do have a setting for double exposures built into the camera. You just have to be very intentional about placement, as the images are taken one after the other in sequence and will automatically layer upon each other, which is a fun challenge. If you have a DSLR and aren't sure if your camera has this setting or how to work it, I recommend looking it up in the user manual.

INTENTIONALLY OUT-OF-FOCUS IMAGES

Out-of-focus pictures are my very favorite. By allowing my images to be intentionally blurry, the harshness of what I see before me feels more like painting with watercolors—all the chaos of life symbolically blending together into beauty.

To do this using your phone's camera, download a photography app that allows for manual focus. If you are using a DSLR camera, just switch your lens from AF mode (auto focus) to MF mode (manual focus). Play with the focus to create images that translate how you feel.

I remember one time when I saw my daughters holding hands and spinning in the backyard, giggling without a care in the world,

and I just ran out to capture the moment before they stopped. I was snapping away with my camera and didn't realize that I had accidentally bumped it into manual mode. So when I got back inside and pressed Play to review the images I had just taken, I was at first disappointed to see they were out of focus. But then the longer I looked, I became completely taken by the beauty. They were more like a painting than a photograph. This one photo stopped me completely when I saw the heart. It was an unexpected gift in the process of practicing presence. And truly, *this* is my very favorite thing about taking pictures—those little surprise miracles that show up unexpectedly to affirm I am walking in the right direction.

When I look at this picture, I see that love is always waiting to find me—it just finally becomes visible when I release my need to have everything perfectly clear and focused. Had I been taking in-focus, crisp pictures that day, the heart would not have become visible. Sometimes simply softening our perspective can powerfully reveal all the magic.

A FEW WORDS OF WISDOM FOR YOUR CREATIVE JOURNEY

As you begin the practice of preserving presence with a camera, you might find yourself feeling frustrated that the images you are creating don't quite match what you see in your head. So, first, just as a reminder—*please be kind to yourself.*

Growth often takes the form of self-criticism, anxiety, feelings of failure, confusion, blame, and the desire to give up. When these feelings arise in you while trying to make art, please do not see it as proof that you are not doing it right. Instead, take it as a sign that you are indeed growing—discomfort *always* accompanies transformation.

Please do not look for errors in your pictures. There is no right or wrong way to preserve proof of the present moment. If there is a mark or quality about the images you create that you find yourself dissatisfied with, ask yourself what might be at the root of that feeling. It's okay to take breaks and set down the camera to process the emotions that arise from within you.

Our goal in creating symbolic images is to help process the emotions that we can find difficult to put into words. This is huge, and one person's experience cannot possibly be compared to the next. Just please do not mistake discomfort for failure. If you find yourself trying to make sense of things, I invite you to instead enter your body and senses and simply be present in the moment as much as you feel you are able. Watching and waiting for the concepts within this book to play out in the context of your *own*

life is half the beauty. Leave room for the unexpected as you begin to create your art.

Remember that becoming present is not something we achieve, but a way of fully living that can become both a rhythm and a practice. ¶

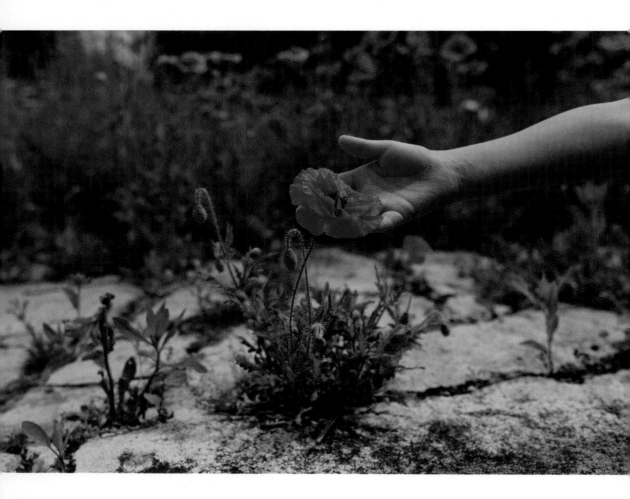

BAPTIZED BY PRESENCE

———

I stood at the sink for a while
and noticed my hands looked like my mother's.
I held them out and admired them fully—
delicate, wrinkly, safe.
I picked up a brush and painted the trim in the hallway—
maybe emerald green will do us all some good.
The moon is still out
and the only light shining is from streetlights.
I'll go out soon and water the garden,
feel the grass on my feet before the sweltering heat settles in.
I'll find the ripest tomato
and face the rising sun
while savoring the sweetness.
Just maybe, if there's time,
I'll take pictures of the children sleeping—
breathe in their beauty like medicine
and be baptized by presence once again.

6

LETTING GO *of* PERFECT PICTURES

For my first few Christmases as a mother, I thought that it was important to create an elaborate holiday card where my children looked darling and magical. I mean, I was the town photographer after all, and this was another opportunity to show how imaginative I could be with my images. Of course, looking back I realize that I was spending my energy in all kinds of unproductive ways. But at the time I felt this unconscious need to prove I could deliver with my own family what I was trying to get other people to hire me to do for theirs. I think I was afraid that if I didn't have anything to show of my own family, people might question whether I was capable of delivering awesome artwork for them.

My unhealthy perfectionism was rooted in what other people might think. I was letting the unpredictable opinions of others decide how I felt about myself, my family, my work, and my life. Several years in a row my children posed in vintage clothes I'd

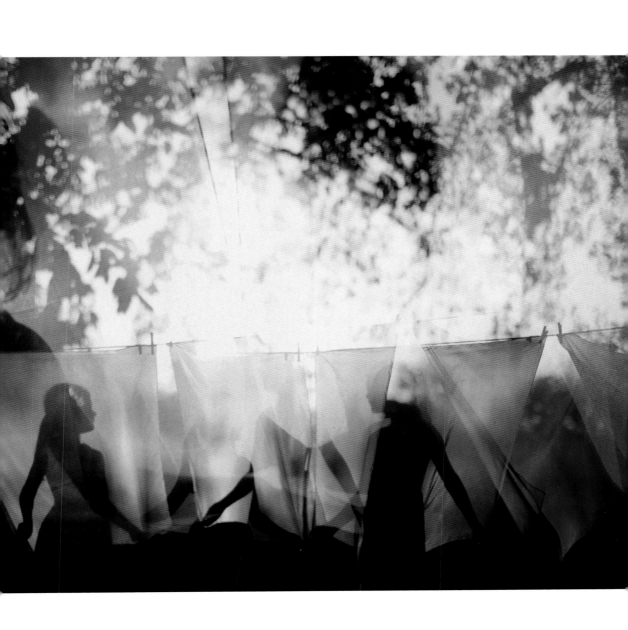

found at antique stores, the whole time complaining that they were painful and scratchy—and keeping them on only long enough to take the pictures. I remember thinking it was lucky that the images on the cards were fairly small because it made it harder to see the sticky, colorful stains on their faces from the Skittles I'd used to bribe them to smile for the camera.

At the time I didn't know that when I looked back at those perfectly posed pictures, I would always remember how frustrated and tense I felt in those moments. I didn't know that the things I would never want to forget would be the things that were imperfect, unposed, and *real*. I never slowed down to think about what I most wanted in my heart to *remember*; instead, I was only thinking about how I wanted everything to *look*.

Brené Brown says, "When perfectionism is driving, shame is always riding shotgun and fear is the annoying backseat driver. We struggle with perfectionism in areas we feel most vulnerable to *shame*."[1] When I find myself anxious and looking for a way to numb the discomfort, it is typically because I am dealing with something internally that I feel *ashamed* about. And in addition to that, I am also typically making myself sick *worrying* about what has yet to happen in the future.

So when I am sitting in my living room with my kids, trying to be in the present moment, I often find myself looking around the room while growing more and more critical. Because presence feels so vulnerable, my mind tries to distract me from it and sends me looking for familiar things to do instead. These distractions are typically tasks that my brain knows would give me an automatic oxytocin boost—like scrolling on social media or repotting my houseplants—things that cause me to feel instant gratification.

It's not that spending time with my kids isn't important to me; it's just that I typically feel overwhelmed and exhausted. When I am full of unexpressed emotions and close to boiling over, my body and my brain become dysregulated. This imbalance almost always leads to feeling like I am letting people down, which then opens wide the door to *shame*.

Becoming present is a practice that requires entering the uncomfortable unknown over and over and over and over again, believing that in time the discomfort will subside and joy will be accessed more easily.

SETTING DOWN PERFECTIONISM

The photographs your children will care most about someday will not be the ones that show how you looked but the ones that show how it *felt* for them to be *loved* by you. The mindset that has most helped me recover from the tendency to want things looking perfect before I take pictures is to remember my goal of simply preserving proof of presence—*not to create a facade of perfection.*

The best thing I can advise for getting started is to be content to take an endless amount of completely imperfect pictures. Instead of becoming frustrated, remember this is a practice in embracing *imperfection as a lifestyle* and it requires *reframing* the way you think about taking pictures.

Photography *is* the art of creating images, but you can let it be about so much more than just capturing *appearances.* In every picture you take, you get to make the choice as to what you honor and preserve.

Our perspectives evolve as we mature, and what you might have thought was disappointing in the past, you may grow to see as more beautiful as time goes on. Your personal lens has been formed by the experiences of your life, your relationships, the pain you have endured, and how you have dealt with that pain.

The first time you look at your pictures, you most likely will see everything that you dislike. You may even hear an old voice in your head telling you to feel ashamed or embarrassed by what

you see. This is normal. Be as gentle with yourself as possible. Take some time, consider how you feel, and allow yourself an abundance of grace. Look again at the photos in a few days or weeks or months. Maybe even share the photos with someone you trust and ask them what they see that you might not have seen. Then look at them again and try to view them from a different perspective.

Let what you see in these images mean something new to you every time you look at them. Photographs are quite magical that way—the more time that goes by since they were captured, the more beauty and meaning we are able to see. Just as we are able to record proof of the rapid physical growth of our children in the photographs we take of them, we are also able to see spiritual growth within ourselves.

Please do not waste your precious energy on worrying about making your photographs technically "correct." All cameras are basically *machines*. Learning to use any kind of machine is a challenge, and it is ingrained in most of us to try to do things "right" or, at the very least, to follow the instructions that came with the machine. But I am asking you to do your best to suspend whatever "rules" you have been taught about how a camera is supposed to be used. I want you to begin to see your camera as a magnifying glass that helps you to focus on what matters most to you and less as a complex electronic machine that is separate from you.

If you become frustrated with yourself for not taking the kinds of photos you wish you could be taking, ask yourself why that is— let yourself be led into sincere self-reflection as you consider this. Remember that the goal here is merely to create proof of presence, not perfection. If you find yourself wanting to learn more about photography, wonderful! But for the purpose of this book, try to remind yourself that this journey is about learning to pay closer attention to your life with the intent of internal growth, and that growing internally means also accepting the discomfort that will arise as we expand.

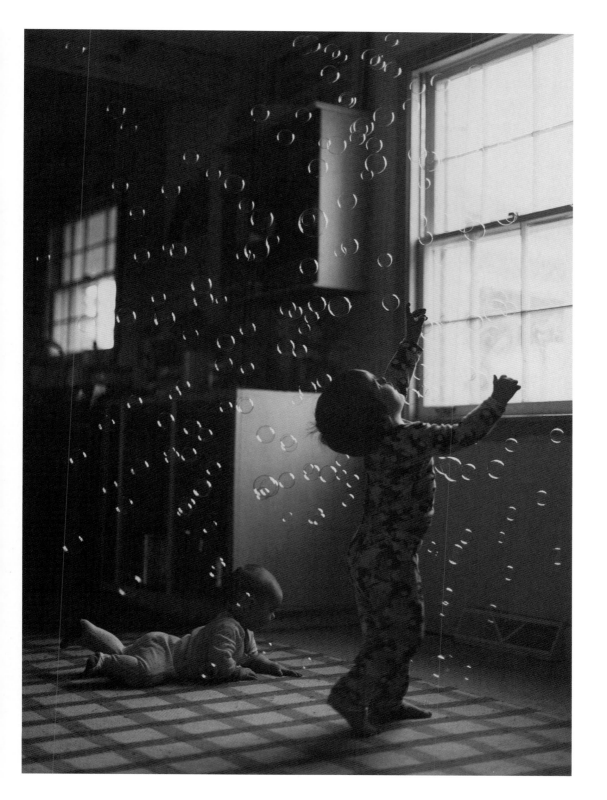

THERE ARE NO MISTAKES, ONLY HAPPY ACCIDENTS

Painter Bob Ross was well known for his amazing hair and positive attitude. In *The Joy of Painting*, his TV program that debuted in 1983, he taught landscape oil painting technique, but at a deeper level he was imparting wisdom for facing the difficult things of everyday *life*. He had overcome a lot personally, which led him to become a painter, and he wanted to share his peaceful take on dealing with adversity through his programming.

In the book *Be a Peaceful Cloud and Other Life Lessons from Bob Ross*, readers learn that the mountains Bob painted were "neither ominous nor insurmountable. Often shown in direct sunlight, these are not obstacles that are to be hidden from view or never discussed. Instead they are evidence of struggles or barriers that, with some time and effort, can be overcome or traversed."[2] Bob's mountains were metaphors for the hard things that rise up before us and leave us feeling stuck, frozen, and afraid. He models how we can use art to be thoughtfully mindful of the things before us. He shows us the power of using creativity to become aware of what we experience so that we can find peace alongside our challenges. He said, "You can go over, around—or yes, even *through*—that mountain range and find yourself in a quiet refreshing place, where a warm cabin waits to shelter you."[3]

Photography can be a translation tool in the same way painting was a translation tool for Bob. Creating images can allow us to fully see what is before us as meaningful and worthy of remembrance. To preserve the present moment in the tangible form of a photograph is to paint light into the uncertainty of everyday life.

On those days when I find myself trying to find peace, I remind myself of the Presence Principle:

1. Slow down and breathe.
2. Set an intention and write it everywhere.

3. Engage in a sensory-rich memory.
4. Focus and take a picture.

The four steps are beneficial not only for taking pictures but also for knowing what to do when we feel stuck. The steps help to regulate our emotions when we feel overwhelmed. Once we are calm, it is easier for us to access our creativity, think of imaginative solutions, and recall that it is not perfection we are after—it is *presence* that we need.

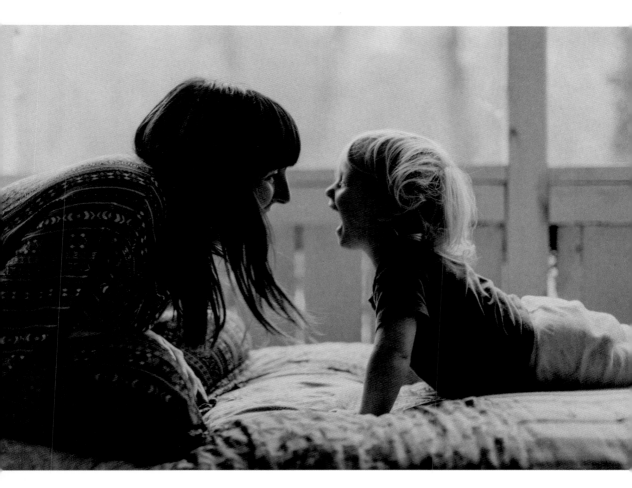

When you are not sure how to enter the present moment, just take the hand of your child and let them lead the way.

DOCUMENTING REAL LIFE

In the early days of my photography career, I commonly photographed couples and families in extravagant locations while surrounded by customized props to make it appear as though they had stepped directly into a fairy tale. Over the years, however, I grew in my understanding of the value in telling authentic, unembellished stories. I knew the truest story I could capture for my clients was the one taking place in their very own home on just an ordinary day.

When I first began presenting the idea to my clients, they would often be worried and they would immediately begin thinking of all the ways their homes showed imperfection.

Home is a place filled with all kinds of vulnerabilities, and I've found that the things people later wish they could remember are often the things they are currently trying to forget. Like the worn place on the couch where they always sit to fold laundry or the corner they curl up in at night to tell bedtime stories.

Your pictures should serve the purpose of showing your actual life that is passing by in a blinding blur instead of comparing your right now to someone else's curated version of acceptability.

One of my favorite photographs of my grandma was taken in the mid-1950s when she was about the age I am now. She is in her backyard in upstate New York, standing on a ladder up under her apple tree. She's wearing her sun hat and holding a fruit basket and is looking straight into the camera, completely confident and content. It makes me yearn to have known that side of her. That photograph captures a slice of her spirit that had dimmed by the time I knew her. I searched for a photo from her later years that would show even a bit of that same spirit, but I found only posed, more perfectly curated images.

HOW KODAK'S MARKETING CHANGED PHOTOGRAPHY

Photography in the world really changed when Kodak introduced the first consumer-friendly camera. Their advertisements featured celebratory events—everyone happy and joyous. Their slogans were written in an effort to use happiness to sell photography: "Kodak knows no dark days!"[4] "Save your happy memories with a Kodak!"[5] In time, "Kodak Moments" became the new American standard for how pleasing photos of families should look.[6] The idea of everyone looking happy became more mainstream than honesty.

About a decade ago, I did a photo session for a mother who had just been diagnosed with stage 4 breast cancer. Her desire was to document her last time breastfeeding her daughter before beginning treatments. The baby girl nursed, wrapping her mama's long hair around her chubby fingers, happily nuzzling into the extra cushy skin around her mama's belly.

The next time I saw that mama was about a year later. I barely recognized her. The chemo treatments had changed her appearance so drastically, she no longer resembled the woman with the squishy belly. Upon recognizing me, she hugged me so tightly and later that day sent me the following text message:

> Thank you, Joy, for those pictures. I couldn't bring myself to look at them at the time because I felt so fat after having my daughter, but I knew it was important we took them because of having to start chemo. Well, I finally looked at them for the first time a few weeks ago. And you know what I saw? I realized how cruel I was to my body and how critical I was back then—even though I was healthy. I see from a new perspective now. I can finally see all the beauty I couldn't see before because I was so worried about looking so perfect.

Photographs that spread true hope are never contrived—they are the most honest of them all, the ones that take your breath away and make you want to truly live.

In looking back at pictures from when my biggest kids were little, I find so much sacred meaning in observing not only how much my children have grown and changed but also how different the *backgrounds* of our lives are now compared to those in the pictures. All at once the memories flood back as I recall all the special blankets, jammies, books, toys, and foods each of my children once loved. Within every portrait documented at home, the landscape of life being lived there is also preserved for safekeeping.

When I share those images with my kids, they point out things in the background that I would never notice on my own. "Mommy, remember when we used to laugh so hard playing that game?" I look where they are pointing and see board game pieces scattered on the ground in the back corner of the picture. And then another child motions to photos from the first kitchen we ever cooked in as a family and says, "We should make donuts again, Mama! Remember how yummy those donuts were that we used to make?" I look where they are pointing and see that small, yellow mini-donut maker on the kitchen counter almost hidden in the background of a photograph more than a decade old.

I gaze at that picture and remember we used to make donuts every single Saturday when our big kids were young. We would make a dozen kinds of frosting, experiment with different flavors of batter, sprinkle sugars on the top—and we enjoyed every minute spent baking together. I realized that when we moved from that house, we lost track of that donut maker. Hearing them recall those times with such joy made me want to begin our special Saturdays once again to bring back what was clearly a life-giving family tradition.

Looking back and hearing the memories that stand out to my children in our pictures inspires me to keep looking for ways to reignite that spark of nostalgia. I am reminded of how detrimental it is to think I should wait until everything feels photo-ready to be able to take creative pictures. I've realized that the things I think

I need to remove from our current pictures are in fact the things I will grow to treasure the very most.

I know that a time will inevitably come when that huge pile of laundry I spend most days wishing would disappear from the background of our pictures will remind me of the tiny clothes I no longer have the honor of washing. I know I am going to want to remember.

It is so important that we keep reminding one another not to put off taking pictures in the regular and wonderful mess of *right now*. The unedited, unpolished, unfiltered version of life is the one most important to preserve.

The more compassion we can extend to ourselves in the way we *think* about practicing our creativity, the more compassion we will be able to extend to all the other parts and people in our lives.

And the more compassion we can extend to ourselves in the way we *think* about practicing our creativity, the more compassion we will be able to extend to all the other parts and people in our lives.

REFRAMING IMPERFECTION

I urge you to take notice.

Notice when life is passing you by and fight to stay present. Fight against fear when it tells you that there isn't anything worth remembering. Because those wasted days turn into numbed-out years.

Don't miss it. Document real life in your wonderfully imperfect home. Don't worry if there's laundry on the floor from last week—soon your baby will outgrow those tiny clothes, your hands won't be so full, and when you look back at the pictures you'll want something as close as possible to a time capsule that will bring you right back into the feeling.

Looking back, you won't want *perfect*. You'll want to recall your child's wild, tangled morning hair . . . the steam rising from the cof-feepot . . . the frost on the windows with traces of tiny fingerprints

from months of hands pressed against the glass.

You'll want to remember the scribbles on the wall, the height chart at the end of the hall, the muddy shoes kicked off by the front door, the ice cream truck driving down the street that made the children squeal with delight, and the humming of the fridge only audible when everything finally quiets down at night.

You'll want to look at that picture from 2:00 a.m. as you peeked in on the baby—when that strip of light fell so beautifully across their face . . . that time you couldn't help but gasp and want to capture it forever in a picture.

One day you'll want to *feel* it all. But by removing any trace of these normal messy miracles from your photographs, you're inadvertently erasing any chance of recalling the memories.

So if there is sadness, don't keep it hidden. If there is bliss, document the dancing. More than anything, allow everyone room to be documented authentically.

Photographing things that have fallen apart helps to reframe our disappointment in the brokenness. When Leonard Cohen sings "there is a crack, a crack in everything, that's how the light gets in," it's a reminder to choose presence over perfection.[7]

Taking pictures instead of instantly rushing into a mode of frustration creates space to distance ourselves from the intensity of the moment. We are able to see the mess not as a bunch of parts to dissect but as one entire piece of art. When we are forced to zoom out and take a wider perspective, we don't nitpick the tiny things we wish were different. We move from being a force of control to being an objective observer.

Taking a picture and looking at it through eyes of compassion helps to settle us and teaches us to be kind to ourselves. In these small opportunities to reframe our thinking, we train our brains to become resilient. ¶

WHICHEVER WAY
YOU SLICE IT

———

I used the dull end of a baby spoon to slice bread
because I couldn't find a knife.
Standing at the counter I pressed my weight into the loaf,
attempting to saw it into pieces.

Crumbs flew everywhere, and it ripped into a gruesome mess.
Staring into the bin, I realized this has been our rhythm these
 days—
doing simple things with insufficient tools
because the once-normal ones have been lost.

"This is how we learn to be creative" is what I'd tell a student
if they presented to me this problem.
But when you're tired and worn,
 creativity is a foreign language.

It's just plain hard finally looking your demons in the face,
and no matter how we slice it,
beauty and anguish live together
in the house of growth.

Sometimes using the dull side of a baby spoon
isn't just a last resort,
but perhaps the entry point
 to life becoming an art in itself.

COMING HOME
to *YOURSELF*
in the PRESENT

7

BECOMING PRESENT *to* YOUR TRUE WORTH

Have you ever had to really psych yourself up to share something vulnerable online, only to have that post met with just a few hearts and maybe one comment that obviously showed the commenter didn't even read what you shared? I think it has happened to the majority of us. And while I wish I could say that it doesn't bother me when that happens, it does. It takes the wind out of me for a bit. It hurts because it feels like the world is confirming that little secret the darkness whispers to me when I am feeling down—*that my voice doesn't really matter anyway.*

For those of us who have had our feelings invalidated in the past, that barely seen social media post can feel less like a fluke and more like proof that vulnerability should be avoided at all costs. This, of course, is not true, but it can sure feel true in the moment.

Staying curious about what triggers our feelings of worthlessness can be a crucial step in learning to practice presence.

I spent the first part of my life looking for validation from others to prove my worth because many times my parents were not able to hold space for me to express my pain. I remember feeling so frustrated during my childhood by the injustice I observed in my own home. Often when I would try to advocate for myself or for my mother, the adults I told would quickly change the subject or act as though what had happened wasn't that bad. Whenever I would get the courage to express my feelings of sadness, fear, or rage about our safety or well-being, I was told to calm down and focus on more positive things instead.

I understand now that this was an unhealthy way to cope. But because my child mind couldn't decipher between a coping mechanism and a normal way of living, I inadvertently learned that strong emotions were to be avoided at all costs. I learned unhealthy ways to manage my feelings by watching how unhealthy adults managed theirs—*keep busy and pretend the bad isn't that bad.*

As I grew, whenever someone harmed me, I would tell myself that it wasn't that bad. I told myself that if I allowed myself to feel the depth of the feelings, it meant I was weak. And so I stuffed my feelings down.

After many years of working through the complicated emotions from my past, I can now say I have sincere tenderness toward the adults that were unable to support me, knowing we all just do the best we can with what we know at the time.

I can know that what happened was wrong while also acknowledging that the current research proving trauma's effects on the human brain was not available to past generations. The widely accepted problem-solving model for parenting in America has long consisted of sending children into isolation for having feelings that make their parents uncomfortable, as well as the use of fear and separation from relationship as motivators for obedience. Invalidation has looked different for all of us, and it feels like more of a spectrum rather than black-and-white. Especially now, with the

constant pressure to share our lives on social media, the chance of being hit with feelings of invalidation is greater than ever before.

An article written by Jenny TeGrotenhuis, a certified clinical trauma professional, really opened my eyes to understanding how our early experiences of invalidation can alter our brains and our capacity for trust. She writes:

> Those who've studied trauma have learned that when witnesses to injustice do nothing, it's a greater source of distress for sufferers than the act of brutality itself. This is because "neutrality" is a form of deep invalidation. When we humans experience invalidation from others, it sends a message to the survival parts of our brains that we aren't valued or protected. This lack of safety creates pressure under which the human mind eventually will either "implode" or "explode"—usually a little of both. Invalidation is a form of relational trauma which, over time, harms the brain and nervous system. Clearly, it also results in the disintegration of any healthy bonds of connection, and dissolution of trust in others.[1]

When I read this I couldn't help thinking about how closely this research on invalidation relates to Brené Brown's research that she shared in episode 1 of her HBO Max special *Atlas of the Heart*: "Our connection with other people is only as solid and deep as our connection to ourselves. In order for me to be connected to you, I have to know who I am. I have to be connected to myself."[2]

When our emotions have been invalidated in childhood, it is common that we learn to distrust how we feel. When our emotional needs are brushed off, ignored, or shamed by our caregivers, it is common not to learn how to be compassionate toward our own pain or the pain of others. And when our childlike vulnerability is invalidated, we learn to be tough and to compartmentalize feelings to avoid being hurt so deeply again.

For so many years of my motherhood, I felt an immense amount of guilt for being annoyed when my children would have big emotions and need me to hold them while they cried. In my

mind, I knew how important connection with my child was during their times of overwhelm, but I also recognized that it did not come naturally to me. It actually felt quite uncomfortable. I took on so much shame, like something must have been broken inside me because of my inability to hold space for their emotions. Over time I just assumed that I wasn't someone capable of natural tender compassion, and that belief was a source of deep sorrow.

It wasn't until reading the end of the article by Jenny TeGrotenhuis, where she gives advice for how to begin healing the deep wounds of invalidation, that I realized compassion could be viewed more as a *practice* rather than as a quality we are (or aren't) born with. She writes, "[This will] require the slow, ongoing work of diligent growth in character, self-awareness, and love. We've learned that it takes 20 experiences of attunement—or turning toward—to heal the limbic brain from one episode of invalidation. But because of neuroplasticity, practicing 'small things often' creates lasting change."[3]

When I first read that 20-to-1 ratio it made me feel exceptionally hopeless. *Twenty times of attuning for each episode of invalidation?!* What about when invalidation has lasted *years*? But I was determined to find a way out of my negative thought patterns of unworthiness, and committed myself to the understanding that small things do add up to noticeable change over time. I began pondering how researchers might define one experience of attunement and self-validation.

Merriam-Webster defines the verb *validate* as "to recognize, establish, or illustrate the worthiness of."[4] So, by turning toward ourselves with compassion instead of judgment, we affirm that our inner child is in fact *worthy*. Worthy of taking up space in the world. Worthy of being heard. Worthy of peace, joy, beauty, and love.

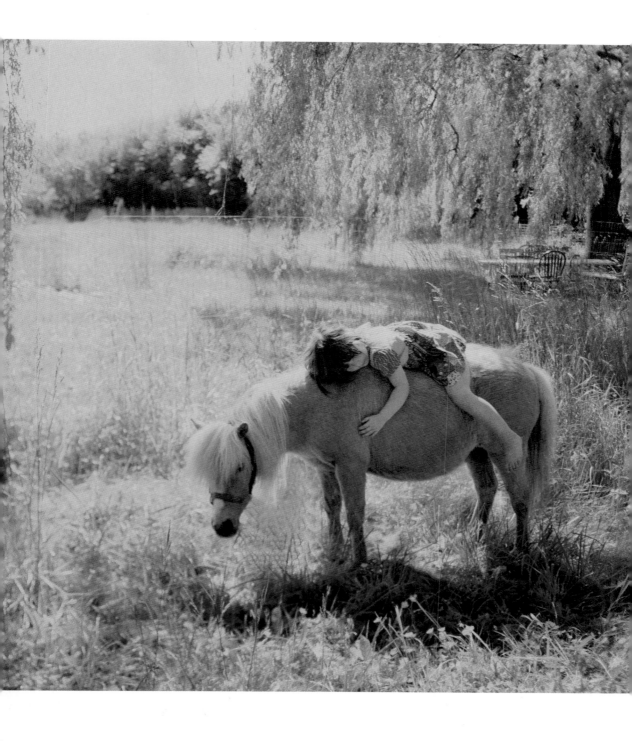

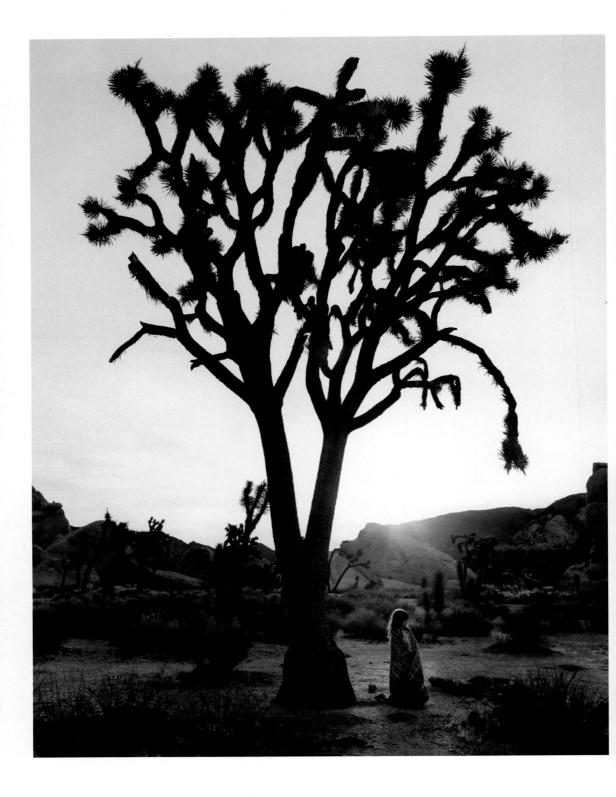

The most natural way that I have found to validate my life experience and give voice to my internal dialogue is through my photographs.

SELF-VALIDATING THROUGH PHOTOGRAPHS

When we take a photograph of something we find interesting, we are proclaiming that our perspective *matters*. When we take self-portraits and bravely choose not to critique them, instead extending tenderness to the ever-developing version of ourselves, we affirm the innate worthiness of our existence. And when our children bear witness to the grace and kindness we choose to offer ourselves, especially when it does not come easy to us, we model that compassion is something we can *learn* to embody.

> When we take a photograph of something we find interesting, we are proclaiming that our perspective *matters*.

Compassion and presence are not qualities to be acquired—they are *practices* that require patience, commitment, and courage. I have seen this in the work I have done over the last decade mentoring professional artists. The one common denominator that I see continually holds women back from sharing their art publicly is the thought that their creativity is a selfish endeavor. After learning about the way invalidation alters the brain, it became clear to me why we often have a hard time believing our art is worthy of being seen.

I've observed that a lot of artists consider giving up on creativity completely because of the uncomfortable vulnerability required in the creative process. I have done my best to remind them of their strength in those moments. The origin of our word *valid* comes from the Latin word *valere* meaning "be strong." This was absolutely fascinating to me! So when we practice self-validation, we are significantly gaining emotional strength.

Validating yourself through personal creativity equips you with mental, emotional, and spiritual strength!

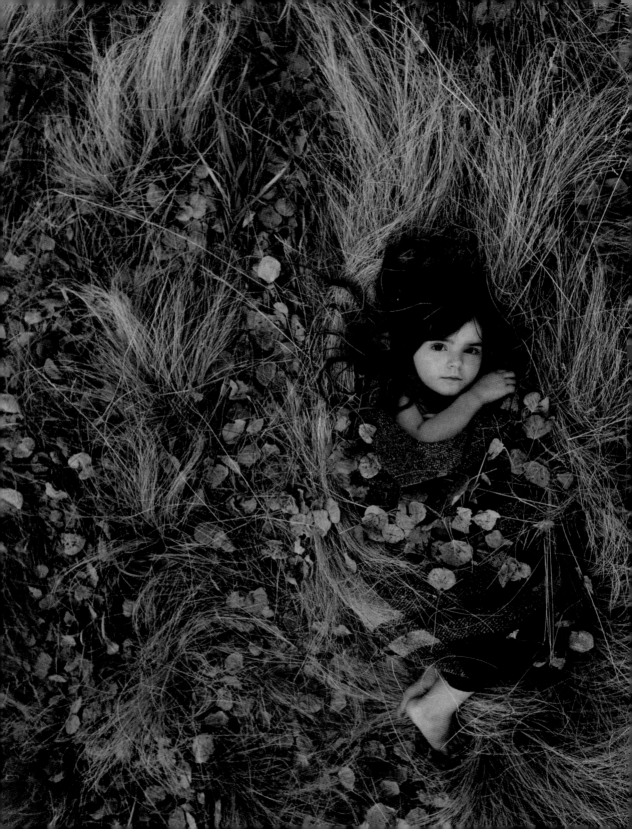

Find every opportunity to attune to your deepest self and let your feelings find the freedom of expression. You get to define what that means for you, but just remember that these small acts of compassion are growing in you a treasure trove of strength you'll be able to pull from to feel worthy rather than leaning on others to build you up.

SINGING YOUR UNIQUE SONG

It was the end of autumn in an aspen grove in Flagstaff, Arizona, and all the leaves had fallen from the trees, cushioning the forest floor with lush beauty. My daughter and I ran barefoot through the trees, and after a while Clementine curled up in a soft spot. I joined her, and as we looked up at the sky and the expansive branches above us, she squeezed my hand, saying that we were like baby birds in a nest. I wrapped my scarf around her just before we left and asked if I could take her picture.

When I see the photograph now, I remember the sacred quiet of that afternoon and her glittering eyes as she sang while we walked back to the car. Listening to her that day, I couldn't help thinking that maybe birds learn to sing freely when they just have a safe nest in which to practice their song.

That's what practicing presence as a mother simply is—confidently singing our own song, which creates a nest of safety for our children to gain confidence to sing unique songs of *their own*.

I want my children to know how to release, unfold, and not blame themselves or others when things get hard. So by extending grace to myself often and in small, visible ways, I hope to show them how they too can embody softness.

WHY SELF-VALIDATION THROUGH CREATIVITY MATTERS

When we create, we make space inside of us. Space to process thoughts and for new ideas to form. We expand. Our shoulders

relax and anxiety lessens. We remember who we are at our deepest core and gain emotional momentum not to give up. We exit survival mode and enter the present moment—a place of childlike imagination and healing wonder.

A mother nourishes her children from what overflows out of her own cup—the more often she artistically honors her true worth, the more creativity and joy flood out.

The ultimate reward in creating is never going to be the finished product—it's the wiser version of *you* that waits on the other side of the making.

YOUR WELL OF CREATIVE COURAGE

I like to imagine that there is a well of creative courage within each of us, and every time we practice self-validation we contribute to our personal well. If we are regularly practicing self-validation by allowing our feelings to flow *through* us rather than staying stuck inside, then our well is full of nourishment, able to sustain us, with no need to seek validation from anyone else.

I do my best to remember these truths on those days when I post on social media and what I thought would be the most wise, life-altering post ever ends up garnering minimal response. When I notice my mind starting to make up stories about my presumably questionable worth, I remind myself that I have a well of courage deep within me accessible

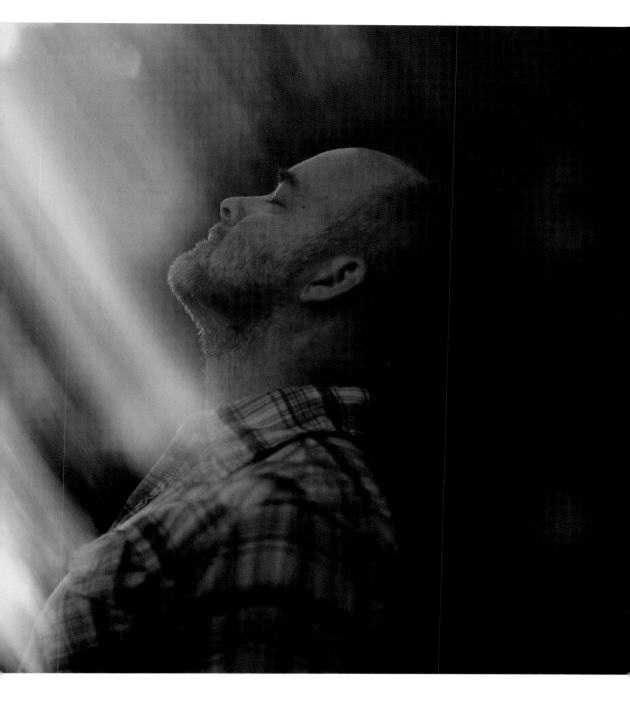

at all times and that no amount of affirmation from others will ever quench the deepest thirst of my soul.

We cease seeking validation outside ourselves for the things we create when we learn that the purpose of creative expression is not to please people but to help us find our own courage and strength. ¶

APPLYING THE PRESENCE PRINCIPLE TO BECOME PRESENT TO *YOUR* TRUE WORTH

1. **Slow down and breathe.**

2. **Set an intention and write it everywhere.** When you find yourself believing those old lies whispering that you are worthless, set an intention that boldly declares the opposite. An example: "I am worthy of being seen."

3. **Engage in a sensory-rich memory.** Look for opportunities to validate your own worth throughout your normal days. Think of what made you come alive when you were a child, and revisit one of those activities—being fully present for it through sight, sound, touch, taste, and smell. Cement that memory into your muscles, your mind, and your heart.

4. **Focus and take a picture.** Create an image that honors the spirit of your most true self.

LET IT POUR OUT

You let it swell up—
a fire in your belly.
A wave about to crash over
that was never meant to be held back.
Pour out—
to soak all the properly placed too-perfect things.
Spill the paint until it says
what couldn't be said.
Let it come—
as a whisper or a crash,
whatever shape it must take,
let it out.

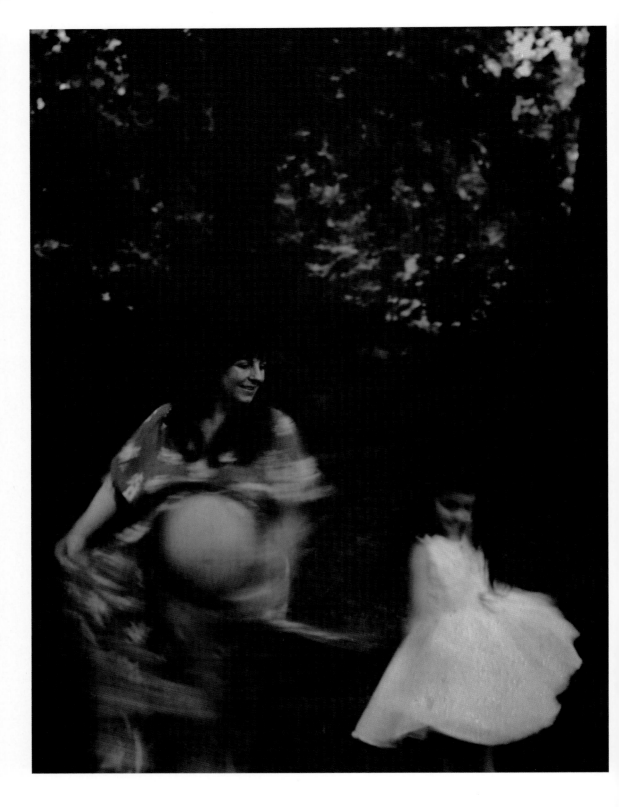

8

BECOMING
PRESENT
to COMPASSION

I remember the first mother who ever cried in front of my lens. Within the first few minutes of our session, she told me how nervous she was to be photographed alongside her family—she said it was because she was still carrying some extra weight from her pregnancy. I told her not to worry, naming specific attributes about her I found beautiful as she stood before me. She just shook off the compliments, saying, "Focus on the rest of the family instead. When it's time for the group shots, I'll just jump in there and hide behind the children."

She avoided my gaze, so I continued taking photographs of the kids as she'd requested. I bent down on my knees for a better angle of the children playing in the glow of the setting sun and happened to catch a glimpse of their mother adoring them, beaming with golden light spread across her cheeks. I was so taken by the beauty I turned my camera to photograph her, unable to resist.

Upon realizing that her joy had been captured, she visibly shrank into the shadows.

"Oh no, I wasn't ready! These pictures aren't supposed to be about me!"

I watched her eyes spill over with tears and then looked toward her husband, who wisely scooped up their children for a snack break. I put my camera down and stood with her for a few moments, holding space until she was ready to go on.

She told me that she had never felt pretty enough, good enough, talented enough, or happy enough to be photographed. She was afraid that the images would show the pain in her eyes. She didn't want to remember herself that way, let alone have the sorrow documented for her children to one day see.

Oh, what power a photograph can hold! When we are just trying to keep everything from falling apart and want to keep our vulnerabilities from being exposed—*photographs tend to tell truths that we would rather have kept hidden.*

I mustered the courage to quietly ask her, "Do you trust me?"

She looked up, her cheeks wet with tears, and offered a timid, "Yes."

I asked her to close her eyes and take a deep breath in and out. She attempted to breathe, but her mouth was shut tight and her body was rigid—I could see that she needed an example. I removed the camera from my neck and placed it on the ground. I stood before her and began to model the breathing I did at home when my anxiety would spike: open mouth, shoulders back, lungs filled and then lungs emptied. We stood together breathing in and out until she finally opened her eyes and smiled at me through tears.

I grabbed my camera and asked her not to look away.

I told her again how beautiful she was, not because of her appearance but because of her willingness to hold space for the feelings. She stood there in the sun with her face lifted, burdens seemingly shed from her shoulders. She began to hum a tune as she saw her children running toward her in the distance.

I captured hundreds of photographs that evening, and as we said goodbye after sunset, she thanked me for seeing the real her.

Several months after the session, she sent me a letter explaining how important our time together had been for her. She told me that she had made it a goal to start taking pictures of herself with her children every day—and since she had started, she found it enabled her to become present. She said she was happier than she had been in a long time.

I still keep my favorite photograph from that family's session in my journal all these years later. I look at it when I need to remember the value in showing up for life even when my mind tells me that I am not worthy of goodness. Even in my sometimes-embarrassment, I know that documenting my life journey through photographs is an important part of owning the fullness of who I am and of who we are as a family.

When I look back on photographs from the past, I am glad I have them. I find that over time I develop more and more grace for my past self. I see that I was trying my best with the limited life experience and wisdom I had access to at the time. I also see the parts of myself that were hurting, and I see the girl who got me to where I am today. She was so very brave, and I'm so thankful to have photographic proof of how far I have come on my journey.

SEEING OURSELVES IN PHOTOGRAPHS

Taking photographs of ourselves is an exceptionally vulnerable act.

Selfies are one thing, mostly because we are able to control how we make ourselves look. You know the angle—a little bit from above, without any hint of a double chin, in the best light. But being photographed by someone else means releasing all control completely. And then taking it a step further . . . setting up a camera with a self-timer to photograph yourself in full honesty without flattering angles—whoa! Hold up. That can feel terrifying. It is scary because capturing proof of what we actually look like

without filters or ring lights or tricks means that we have to take a look at what's really there.

Seeing yourself as you are can be terrifying, but it can also be profoundly therapeutic. It helps to be curious rather than judgmental about what we see in our reflected image.

For me, it is important for my children to see me documenting myself in both difficult times *and* joyful times. I don't want my kids to struggle with the fear of vulnerability that has held *me* back. I want to show them how to face life even while being pummeled by unexpected challenges. Sometimes that looks like advocating, sometimes it looks like resting, sometimes it looks like making art—it can look all kinds of ways. I just don't want them to carry the same shame that I carried from worrying about how I was being perceived.

> Seeing yourself as you are can be terrifying, but it can also be profoundly therapeutic.

I want to model for them a posture of embracing the fullness of my life experience while creating proof of that presence so we can all look back and remember.

NURTURING YOUR INNER CHILD

I remember the first bath I took postpartum. I let the hot water pour down my back and felt like my soul was returning to my body. I hadn't even realized that she had left.

Feeling that warmth on my skin allowed me to move my tense muscles, to stretch my neck and breathe in the renewal that I hadn't known I needed. I cupped the steaming water in my palms and brought it to my cheeks. I closed my eyes and recalled a memory from my childhood—I had spent the night at my aunt's house and couldn't sleep. She had curled up next to me and gently massaged my face—I'd felt so adored and seen by her.

I decided not to rush through my bath and held my face in my hands with the same gentleness my aunt had shown me. I put my fingertips on my cheeks and massaged my brow. I closed my eyes

and traced my eyelids with my fingers. I held my hands against my face and inhaled the steam until I felt it deep in my lungs. I remembered that I too was loved. I felt my inner child telling me to savor this—that this remembering was an important ritual of compassion.

I see how much tenderness means to my children and how they let all their defenses fall when I scratch their backs at night and sing them to sleep . . . and oh how I wish that someone would do that for me! I am learning that I can do this for my inner child— I can reparent myself by wrapping compassion around the child within *me*.

You can find your own unique ways of doing this, starting with basic daily tasks. For example, when you wash your hands, just take a little extra time and examine the beauty of your own skin— marvel at the design. When you wash your face in the morning or at night, gently press your palms against your cheeks and then trace your brows and eyelids with your fingertips.

Slow down, focus on peace, create space for sacred moments to unfold, and let life flow through you without constricting. Tell yourself the same things you might tell your child—that your life is worthy of being seen, your voice is worthy of being heard, and your story is worthy of being honored.

MOTHERING OURSELVES

I have to prick my finger to draw blood as many as ten times a day. And then I have to give myself an injection of insulin at every meal—and sometimes also in the middle of the night, and then any time I eat or drink anything else. So I have a lot of injection holes on the tips of my fingers and on my legs and stomach. Most of my fingers have calluses, but still pretty regularly I'll prick myself and squeeze, and all of a sudden my finger will look like a yard sprinkler with little droplets of blood coming out of all the unhealed wounds I didn't realize I still had.

I think this is what happens to us as parents. We walk around thinking that our wounds have healed, but we've had to compartmentalize them so well that any evidence of battle has long disappeared from the surface. In a moment of complete exhaustion and overwhelm, when the baby won't sleep and the toddler is screaming and it feels like the walls are closing in—it's like we just get pricked. And instead of bleeding only a little, somehow the pressure rips the scabs right off all the unresolved griefs and traumas that had been perfectly tucked away within us.

Parenthood, for me, has been the unexpected journey of raising children while figuring out how to somehow raise myself alongside them.

Learning to be compassionate with our own mind, body, and soul is the art of mothering ourselves. Now, I'm not talking about indulging in selfishness or even self-care in the way the beauty industry tries to sell it. The kind of deep self-compassion I mean is a full transformation from feeling unworthy of being seen to instead fully embracing the current, evolving version of ourselves.

Self-compassion begins by embracing a practice of gentle attentiveness to the feelings living inside us. By being curious instead of judgmental about our thoughts and feelings, we begin to undo the damage caused by thinking everything needs to fit within perfectly separate boxes inside our once-compartmentalized souls. Stuffed emotions calcify and become walls against true connection with the child within us and the ones we love the very most. Instead of hiding how we feel, healthy emotional regulation requires that we practice sincere empathy toward our own pain, perhaps the way a gentle mother would for her young child.

Motherhood is the journey of learning to raise our children while also learning to compassionately mother ourselves.

Motherhood is the journey of learning to raise our children while also learning to compassionately mother ourselves.

One of the greatest benefits for me in learning to embody self-compassion is that I have found my relationships grow deeper and

more trusting. Because I have made it a practice to extend grace to *myself* and not hold myself to my own impossible standards, I have also released *others* from the impossible standards I subconsciously had set for them.

I have realized that my contentment in the present moment comes down to what I *expect* that moment to be like. I have to regularly remind myself that to be present is to remove any judgment for what is in the moment and to just open my arms

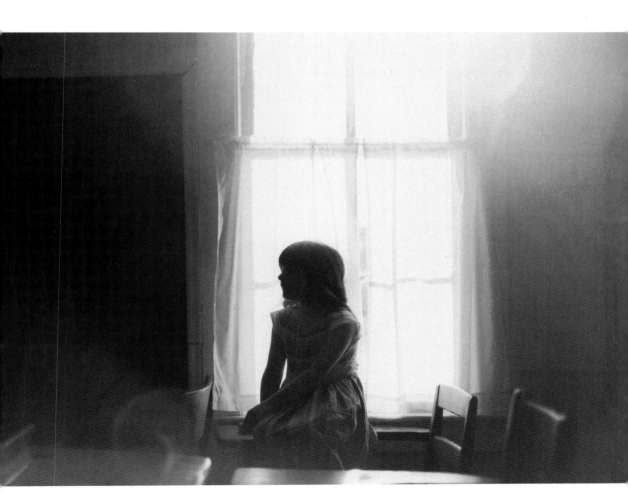

to receive the gifts that come. I do not need to assess my life so harshly.

CHILDREN HELP US LEARN SELF-COMPASSION

Worrying myself sick about things I cannot control is something I am continually working on as a mother and as a human.

One of the lessons I learned while working away from home for many years while being a nursing and pumping mother was that there was absolutely no way to get my milk to let down if I was anxious or worried. My mind simply would not allow my body to release the milk until I was calm.

That physical lockup illustrated my inability to access the deepest, most vulnerable parts of myself when feeling anxious. We can't function in a way that is free, and we definitely have no ability to feel joy. As mothers, we can't nourish our children when our own souls are thirsty and our minds are exhausted.

Do you want to know the thing that always helped to get my milk to let down? *Looking at pictures of my baby.* When I'd look at their pictures or watch videos of them cooing, I was able to get out of my mind and into my body. I tapped into my baby's essence by using my senses to imagine that they were right there with me at my breast. I could relax, gain relief, and give.

Children bring us to the brink of ourselves, but they also offer us a new way through the pain—*by learning to be compassionate with ourselves*.

Compassion comes alongside the wounded without trying to fix anything and just *stays*.

Compassion holds our hand, reminds us our pain is valid, and welcomes all of our feelings.

Compassion reminds us to let our feelings flow through us instead of looking away.

Compassion often arrives when our children do—because they jumpstart our hearts into wanting to live.

BECOMING PRESENT TO YOURSELF THROUGH SELF-PORTRAITS

You do not have to be a professional photographer to take self-portraits. You just need some way to record proof of your current place in your life journey. It can be as simple as starting to take more *intentional* pictures of yourself—and making space to absorb the beauty of this wiser, most current version of you.

Over time you will think less about dissecting how you look in the pictures and spend more time being enthralled by the art of documenting your life.

In his book *Atomic Habits*, James Clear writes, "When you fall in love with the process rather than the product you don't have to wait to give yourself permission to be happy, you can be satisfied anytime your system is running."[1] Developing a sincere practice of paying attention to your life through photography is a *system* that can keep your *spirit* running.

Showing up intentionally to document the journey helps to externalize what is being invisibly carried. You preserve the legacy of your life from your own perspective with your photographs. Self-portraits honor the person you are today and preserve the legacy of your expanding story.

I try to set my camera up to take a portrait of myself once a week. Sometimes my children are in the images and sometimes I am by myself. But what's most important is that I show up and face the camera and refuse to judge the image no matter what I might initially see that feels unsettling.

Sometimes the pictures I take look like lingering in the light or shutting down the noise just long enough to take a deep breath. Sometimes I document that tiny break of vibrant sun on the kitchen wall in the middle of the pre-dinner storm. And at times it's a picture of me with one of my children to capture the last of things I know might be coming to an end—like the feeling of my baby's hand touching my cheek when I feed him.

It only takes a moment to grab your camera and preserve the memory. Images make visible the things that cannot be seen—they

provide proof that all hope is not lost when we look back and remember.

TAKING PICTURES TO HONOR DIFFICULT PERSONAL EXPERIENCES

A friend of mine once reached out to me after she had experienced a missed miscarriage. She hadn't told those around her about the pregnancy or the loss, choosing up until that point to keep the experience to herself. We talked about the importance of honoring her experience and not stuffing the feelings down.

She wanted to creatively process through the feelings, so she asked if I could give her some tips on how to honor the life that had lived within her. If you have found yourself in a similar circumstance, I encourage you to consider creating a series of photographs to honor experiences that have made you who you are.

I shared with her the following insights and offer them now to you. Remember, the more we lean into creating portraits to validate ourselves, the more strength and courage we gain.

As you get started, gentleness with yourself is most important— allow yourself to feel whatever feelings come up and don't rush away from the discomfort. Write down what your inner child needs and give yourself as much time and tenderness as you require.

Personal loss can go by without ever being *acknowledged*, let alone *honored*. The world can seem to keep going, and the people around us keep going on because they don't know what to say and they don't want to risk saying the wrong thing. In the case of my friend who experienced a missed miscarriage, she felt that she never got the chance to acknowledge or honor her motherhood with that child.

Making these personal photographs can help us honor those we love while also paying tribute to the person *we* have become. We meet the deeper version of ourselves on the other side of the processing.

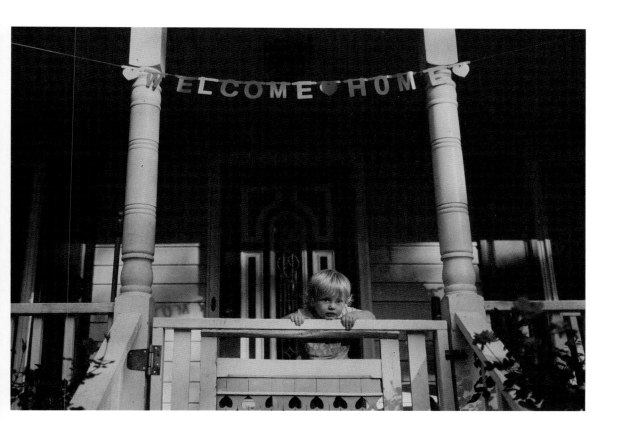

When I am trying to create, my first step is to put the *feeling* inside of me that I cannot quite name into a *picture* that I can hold so I can see my experience from a different perspective.

While going through a severe depression, the last thing I felt like doing was taking pictures of myself. My thoughts were so negative and hopeless—they told me that taking pictures was a waste of energy because I wouldn't want to remember that time anyway. But because I had experienced regret for not documenting my feelings in the midst of other difficult times in the past, I knew I needed to take photographs—*even in my darkness*. When I look back on those pictures now, I see how far I have come and how much resilience I gained from that time.

I often see that the light captured in my images seems to represent hope. Whether I'm facing the light, facing away from it, or trying to curl up in it and let it warm my aching bones, I find it valuable to just be open and look for pockets of light to serve as metaphorical symbols I can literally step into.

Think about how the light feels to you right now. Would a photograph feel the most true if you were covered in light, or would you perhaps be crouching in a shadowy corner with your hand outstretched toward it?

Look for symbols in nature, in shadows, in movement, in people, and in the sky. Look for symbols everywhere and remind yourself that you are worthy of taking the time to heal—no matter how long it takes and no matter what it looks like to others.

My friend sent me several photographs that she had taken in that season following her pregnancy loss. She was genuinely surprised at how many symbolic things she began seeing after setting the intention to do so.

A few months later, I asked her how she felt looking back on that experience and her willingness to create photographs during the grieving process. She said, "I think you gave me permission. I realized I had been comparing myself to friends and family who had experienced miscarriages farther along, and I was telling myself that I didn't even know I was pregnant until I had lost it. I was telling myself that I should just be over it. But you encouraged me to honor it with something beautiful. And that didn't mean I had to go cry, or that I had to go see a therapist—which, by the way, I'm fine with crying, and I go to therapy. It just felt important, like in Scripture when someone would build an altar to remember the things that had happened in their journey so that they wouldn't forget and could tell others. That photo-taking experience was a marker for me, and it was really helpful. I look at those photos and they are beautiful to me."

I am so grateful to stand witness to the strength of courageous women—both hers and *yours*.

MAKE THE PICTURES

Make the pictures for your current self that needs a way through the wilderness. Make the pictures for your future self that will want to see how far you've come. Make the pictures for your past self that longed for a tool like this to navigate through emotions. Make the pictures for your inner child who longs to be held. And make the pictures for your children to someday find in a drawer— let them see that you were human and that *their* humanity matters too.

Make the pictures and let yourself be seen. ¶

APPLYING THE PRESENCE PRINCIPLE TO BECOME PRESENT TO COMPASSION

1. **Slow down and breathe.**

2. **Set an intention and write it everywhere.** When you find yourself feeling afraid of letting yourself be truly seen, set an intention to see that vulnerability has the potential for good. An example: "It is a gift to see others and to let myself be seen."

3. **Engage in a sensory-rich memory.** Look for ways to care for yourself with a little more tenderness in your everyday habits and routines. What are some things that you do regularly that you could take a little longer to savor and experience with deeper meaning? Think about things you *listen* to that make you feel loved, things you *smell* and *taste* that remind you you're safe, things you can *touch* that comfort your heart, and things you can put yourself in the way of *seeing* to embody your inherent belovedness.

4. **Focus and take a picture.** Create an image that shows your embrace of self-compassion.

WE CARRY EACH OTHER

───

I awoke to find my son digging a grave in the garden.
His hamster had died.
He didn't cry, but his sisters did—
loud and barreling.
He tried his best not to hate them for showing grief
 more than he.
It was his hamster, after all—
an early birthday gift from the previous week.
And here, on the eve of celebration,
he shoveled earth as the rain trickled down.

I watched my husband observe from the window—
"He wants to do it alone, he won't let me help."
His first gentle words to me in days.
Our broken hearts had been battling,
round and round with resentment.
Guess we just stay dizzy and disillusioned until something jolts
 us back to life—
like death.

Like watching your son dig a grave.

Like watching your husband remember the day he scattered his
best friend's ashes to the sea.

I walked out barefoot in my nightgown,

acorns stinging my freezing feet as I made my way past a cross
made from string and sticks.

"Go back in, Mama. Just go."

He let me kiss his face.

I cried and he kept digging (a far deeper hole than any hamster
would need).

I guess funerals are for the living, not the dead.

And then I walked back inside to wide open arms.

Arms that have held caskets and babies and groceries and grief,

and me, for twenty years through a thousand different
heartaches.

Yesterday I could barely look at him,

but today I can't let him go.

I guess that's the thing about sorrow—

we carry it alone until we find . . .

we just were never meant to.

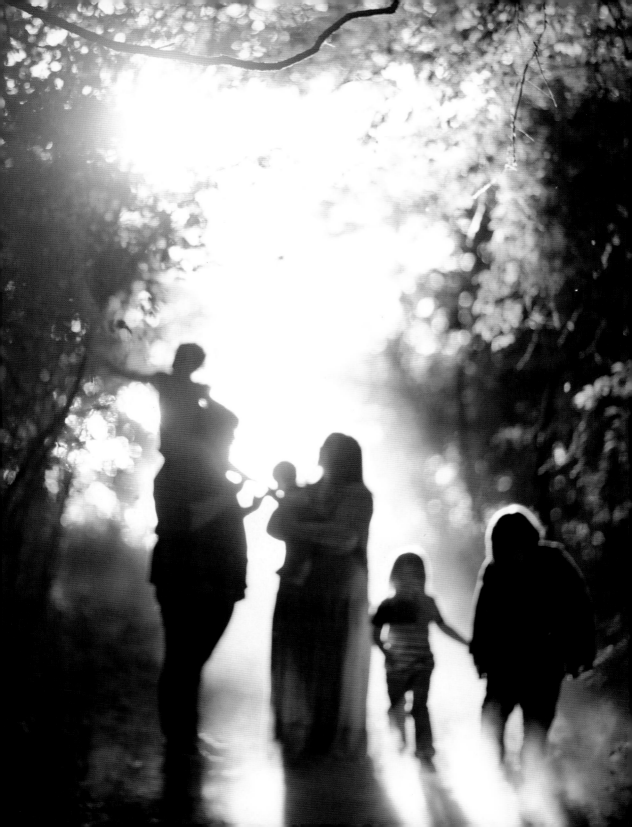

9

BECOMING PRESENT *to* BEAUTY

One Saturday afternoon when we had a rare few hours alone without the kids, Donny and I decided to go on a little date to our local art museum. We walked up three flights of stairs to the top floor of the historic marble post office building, taking in the grandeur of the architecture. As we walked the corridor through the building, we came to an exhibit titled *Everything Is Beautiful* by the captivating artist Alma Thomas.

According to her bio at the National Museum of Women in the Arts, Alma Woodsey Thomas was born in 1891 and "became an important role model for women, African Americans, and older artists. . . . She debuted her abstract work in an exhibition at Howard [University] in 1966, at the age of 75. . . . She was the first African American woman to have a solo exhibition at New York's Whitney Museum of American Art, and she exhibited her paintings at the White House three times."[1] Her paintings are mostly composed of brightly colored brushstroke patterns that seem to symbolize a larger image when you step back to take in the whole piece.

As we walked through the exhibit, I stopped at a sign that explained the work Alma Thomas continued doing in her later years, even when her body began to fail her due to arthritis, a broken hip, and a degenerative heart ailment. The sign read:

> Physical impairments neither dulled her mind nor dampened her resolve. Tenacious until the end, she reportedly took art supplies with her on her final trip to the hospital. . . . At the very end, she had herself wedged in to be able to stand up to paint, she was so weak. Thomas herself described this, but with her characteristic optimism, saying: "Do you see that painting? Look at it move. That's energy and I'm the one who put it there. . . . I transform energy with these old limbs of mine."[2]

Her perspective toward seeing her whole life as art inspired me greatly! Alma could not move her body the way she once had, but she translated that physical desire for expression into the movement of a painting. Her words made me feel seen in my own journey—with creativity, with aging, and with motherhood.

At times I feel really restricted by my body. It doesn't move the way it once did. And a lot of times I feel really restricted by my thoughts, which are often centered around regrets from the past or worries about the future. I am continually held back by all of my feelings inside me that restrict me from being able to feel fully free.

Freedom does come when I pick up my camera and look through that familiar little glass square. I am able to create something from a *deeper* place within me. Deeper than my doubts and anxieties, deeper than my concerns about being embarrassed for my body or my personality. I am able to access the energy in the deepest place within me and transform it into an image. In my own way I am saying to myself what Alma said about her paintings: *"I transform energy with these old limbs of mine."*

Art allows us to transform invisible feelings we cannot put into words into a tangible form that can be seen and understood. Even

when our limbs feel like they are old. Even when our minds feel like they are failing. *Still*—the child deep within longs to create! To splash color onto a blank canvas and enter into the land of self-expression and play.

The art we make is always an extension of what we need to look at and process through to grow. In this same way, I think the feelings that arise in our motherhood journey often point us to what we need to look at and process through to grow.

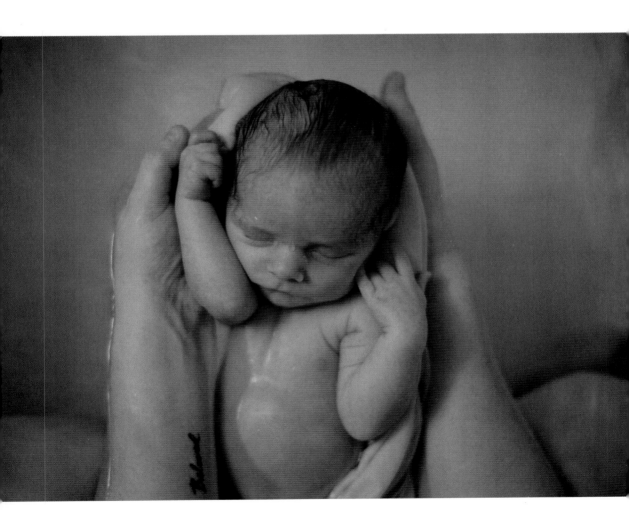

A dear friend came over recently with her baby, and something she said made me think of motherhood as a conduit for the transfer of energy. My friend was feeling pretty exhausted—it was a particularly hot day, she had been going through a flare-up of her autoimmune disease, and I was happy to snuggle her adorable infant for a bit so she could rest her body. She looked at me as she lay on my couch and said through tears, "Sometimes I worry that I'm not enough for him. That I'm not strong enough to be the mother that he needs. But . . ." She hesitated and then projected her voice with more strength than before: "In all of the ways I feel like my body is failing me, I look at my son and I see how healthy *he* is. I know that my body is good because I am sustaining his life by nourishing him, and he is absolutely *thriving*."

In a way, I heard my friend describe the same thing Alma Thomas had when she described the energy that was transferred and came alive through her paintings. Observing my weary yet optimistic friend sit back and admire the health and beauty of her son felt like she was saying, *Do you see that baby of mine? Look at him move. That's energy, and I'm the one who put it there. I transform energy with this old body of mine.*

As mothers, we pour ourselves completely into our children, and then we see them grow and become expansive expressions of themselves with parts of us in there too. We look at them and think, *This exhaustion has not been for nothing.* We watch our children delight in the world and we think, *Look at them move! That's love and I helped to put it there.* Parenting, if we are intentional about it, can be our most interesting and compassionate way of practicing creativity.

Motherhood feels extra hard when you are trying to do it "right" rather than just letting it expand to become more of an art. Looking back, I can see that the times I've thought I wasn't the right fit for my kids—that I was too weak or too broken or too ill-equipped for the task of motherhood—I really just needed to

become the healthiest version of *me* and let the overflow of that goodness nourish my children. By living fully into my uniqueness as a whole person, I've found I fit together like puzzle pieces with the uniqueness of each of my children.

Alma Thomas's paintings were so bright and vibrant. Even when trying to bring attention to difficult, sensitive topics, she did so with bold, playful, engaging color. The exhibit took its name from the song "Everything Is Beautiful" by Ray Stevens, and that song was playing as we walked through the gallery. I like to imagine that Alma may have been giving us an anthem to sing along with as we contemplate seeing our entire lives as a canvas for making art.

> Motherhood feels extra hard when you are trying to do it "right" rather than just letting it expand to become more of an art.

In an interview, Seth Feman, co-curator for the *Everything Is Beautiful* exhibit, said this: "Without a doubt, beauty is necessary for the work of making the world a better place. This was Thomas's faith, and it is made real every time people interact with her art."[3] Beauty is necessary for the work of making the world a better place, and invisible things are made into masterpieces when creativity is given permission to flow through us.

OUR CHILDREN GUIDE US INTO BEAUTY

How can we develop a practice of preserving presence as a regular rhythm so that it doesn't feel like a rusty switch we turn off and on?

Well, think first about the pictures you are already taking. Consider what it is that usually makes you reach for your camera to take a picture—what inspires you to want to press Record on your life?

Of course there are the typical moments we take pictures of, like holidays and celebrations. But what about the other moments that you capture, hoping to keep safe forever? For me, inspiration usually strikes when I find myself reaching for the camera or grabbing a pen to write down something profound I have observed

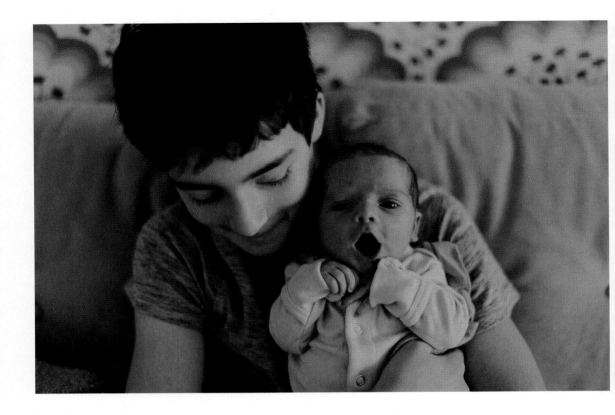

my child do or heard them say that, on a deeper level, informs *my own* personal journey.

Our children continually wave to us from the doorway into the beauty of the present moment. Many times I am too preoccupied to follow their lead. Other times I begin running toward that door, but on the way there I trip over a LEGO village and then somebody asks for a snack and then my toddler starts screaming that ear-shattering screeching sound, causing me to completely lose track of where I was even trying to run.

I often say under my breath, "Why can't everything just stop so that I can focus?!" But, as a mother, I realize that's never going to happen. The needs of my children are never going to stop. So if I want to embrace the current moment, I have to stop being frustrated that my expectations of a perfect scenario will never be met and instead start to *adjust the lens I am looking at my life through.*

TRY MONOCHROME MODE

When I'm feeling sensitive and easily triggered emotionally, I often set my camera to monochrome or black-and-white mode to merely look for the light in the little world before me. I may not have the energy to clean up the house, but I don't want that to deter me from shooting. The beauty of black-and-white is that all I see is the light, my children's faces, and movement. I don't see the bright, loud, messy toys. I just see the *light*. And there is always beauty in light.

LET YOUR ART BE MEANINGFUL AND EXPANSIVE

As you consider the kinds of moments in your life that you want to preserve in photographs, I'd like to offer some ideas on how to deepen your creative experience.

One of my clients, a mother, was telling me about her hopes for her images. Knowing she was a writer, I asked if she would consider writing something short about why having the portraits done was meaningful to her. She sent me a beautiful poem where she referred to her daughter several times as *light*. She then shared with me: "The love that I felt for her when she emerged from my womb took me by surprise—a feeling that made me 'fall.' And when I was down and looked up, I could see my daughter's light filtering brilliantly through the thick forest around me."

These words enabled me to posture my heart toward seeing her daughter as a light to her. All of the artistic decisions I made during the portrait session—exposure, light direction, aperture—were based on looking for a way to express this. When the sun dipped down at the horizon and flooded my camera with this golden radiance, I asked the mama to exhale and be fully present for the light shining on her through her baby girl in that moment.

Upon seeing the photograph later, she said, "You captured it perfectly—I see her bestowing her light on me!"

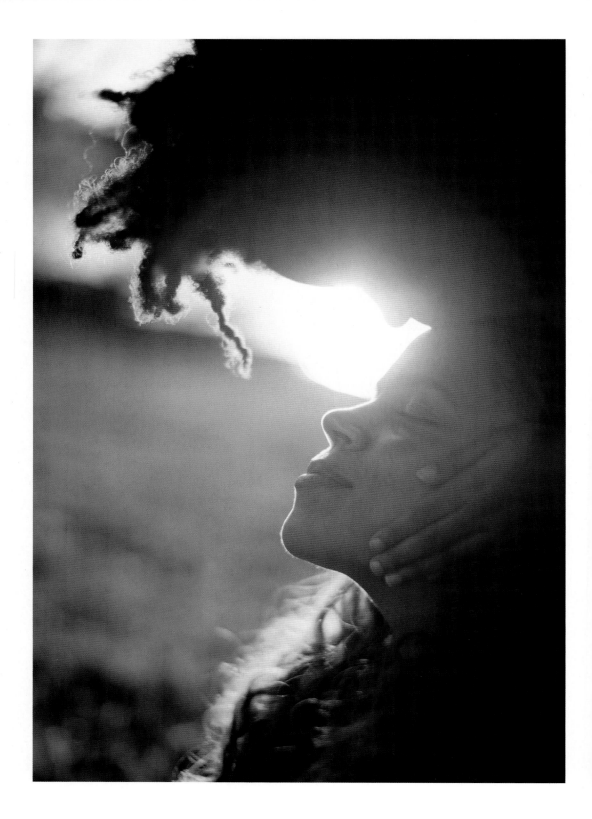

This image is a collaboration—her deep dive into poetry tuned my eyes to see her love in a symbolic, artistic way when I looked through my camera. Her willingness to enter alongside me into expansive vulnerability brought forth an image that goes beyond categorical beauty—*it is symbolic of a legacy.*

This is the kind of creativity I want you to welcome into your life: the *expansive* kind.

Instead of gripping tightly when things don't go the way you expected, just give yourself the gift of releasing and accepting the gift that awaits within the present moment—document *that.*

The real thing.

The beautiful right-now.

Imperfect and messy and true.

LAYERS OF BEAUTY

On a previous visit to that same downtown art museum, I stood before a vibrant impressionistic painting that hung in one of the galleries. At first I was drawn to the color, the only gold in a sea of earth tones. But then it was the *layers* that kept me looking. People alongside me took turns observing the canvas covered in yellow haystacks, but it was a man with more wrinkles than this painting had brushstrokes who most got my attention. He said something to me that I hope I never forget: "Well, they just keep stacking them on. Over and over. I bet it felt pretty meaningless at the time. But look at us, mesmerized by the work. So much so that we can't bear to look away."

I turned to him. "You're right," I said. "It's the layers, isn't it?"

At which point he turned to me and said with a wink as he wandered off, "None of it is meaningless, dear. Just keep stacking the layers."

My eyes instantly filled with tears—it was such a special moment.

We stack the layers of our lives every day, small bits of vibrancy hidden in our daily tasks. The meals we prepare, the photographs we take, and every smile given—all small ordinary things we do

over and over that become extraordinary in time. The most beautiful things we will one day long for are the ones that feel exhausting in the right now.

We just have to occasionally step back and hold still long enough to remember that life is short. As the wise Alma Thomas reminds us: *everything is beautiful.* ¶

APPLYING THE PRESENCE PRINCIPLE TO BECOME PRESENT TO BEAUTY

1. **Slow down and breathe.**

2. **Set an intention and write it everywhere.** When everything feels ugly in the world, set an intention to look for beauty everywhere. An example: "Beauty is ever before me."

3. **Engage in a sensory-rich memory.** Look for ways to notice and richly savor the beauty of life around you—in the sky, in water, in music, in your interactions with your children, in food, in gardening, in nurturing yourself, in the creative process, in everything.

4. **Focus and take a picture.** Create an image that preserves the beauty you might have missed if you hadn't been actively looking.

A MOTHER

—

I stumbled upon a sunflower praying
and stood beside her awhile—
both of our necks cricked,
thousands of seeds ripe between the two of us.

Cynics said it was the weight that pulled her down
and they shouted at her to shrivel up—
to abandon her ideas.
"Nothing good comes from pain," they stammered.

But she paid no attention,
sights set on her purpose—
to let go and be multiplied,
giving what was already given within.

A goldfinch coming for a snack
a yellow butterfly needing a place to rest—
she gave and she gave.
"I'm a mother too," she eventually whispered.

But I had already known—
the strong heart, the weary back,
and the humble giving of herself
in a thousand ways.

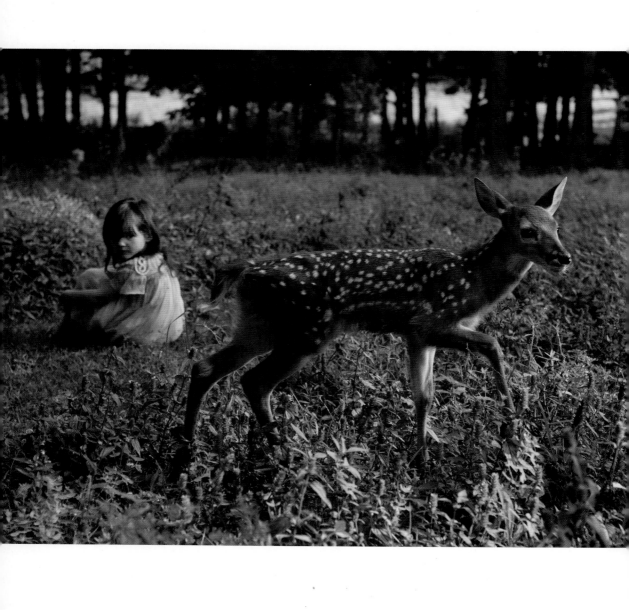

10

BECOMING PRESENT *to* LIGHT

Our neighbors were rehabilitating a fawn whose mama had been hit by a car. We'd see her across the street, bounding around in their yard and playing with their dogs. After being there for several weeks, the fawn became so attached to our neighbors that she would even curl up in bed with them to watch TV and sleep in their bathtub.

We'd visit now and then to bottle-feed the fawn, and one day while we were over I brought my camera. We all went into the yard, and for a long time my daughter Mabel sat with her arm outstretched with the glass bottle of milk, but the deer was just too excited to drink. I took a few photos of Mabel waiting patiently before the fawn ran off to play in the woods. I didn't think I had gotten a good image, but when I pulled the photos up on my computer, one in particular brought me to instant tears.

The image felt incredibly symbolic. I saw myself there in Mabel—hopeful but facing the dark with shoulders slumped forward. Seemingly desperate to turn toward joy but too afraid to move from the shadows.

I keep this photograph where I can always see it at my desk because it reminds me that it's okay and necessary to unfold my aching, defensive body. To lift my heart toward the sun and walk toward what is healing. To drink from waters of restoration that are sure to revive my weary soul.

The deer in the photo is on the *move*, showing where real sustenance is found—*in the pursuit of light.*

WELCOMING LIGHT AS A DAILY PRACTICE

For the past several years I have taken just two minutes most mornings to welcome the light of the day. As a photographer, of course I am a natural "light chaser" of sorts. But rather than seeking good light for the purpose of creating images, this specific light practice is something I do as an act of renewing my mind and soul.

I was inspired listening to the recording of a 2018 talk that Father Richard Rohr gave in Albuquerque, New Mexico, about what it meant for him to "walk in beauty." He shared how back in the summer of 1969, he was just starting out as a deacon in Acoma Pueblo and was tasked with driving around to take the census. He said, "Invariably at sunrise, I would see a mother outside the door of her home, with her children standing beside her . . . reaching out with both hands uplifted to 'scoop' up the new day and then 'pour' it over their heads and bodies as if in blessing. . . . The Navajo or Diné—the people—see the world through the lens of *hozho*: all the goodness to be found through harmony, balance, beauty, and blessing."[1]

This is the well-known Navajo prayer that the mothers would speak while pouring the light over themselves and their children:

> In beauty I walk
> With beauty before me I walk
> With beauty behind me I walk
> With beauty above me I walk
> With beauty around me I walk

It has become beauty again
It has become beauty again
It has become beauty again
It has become beauty again.[2]

We have this prayer written on the chalkboard in our living room, and you will also find it written down on index cards and put up all around our house as reminders. It's so easy to forget that beauty and light are all around; life feels so heavy that it makes sense sometimes just to slump down and accept the darkness.

Father Richard implores us to incorporate this practice of welcome into all parts of our lives: "Looking for beauty all around us is a contemplative practice, an exercise in opening our hearts, minds, and bodies to the divine image. . . . Move slowly, noticing the sensations in your body—discomfort, surprise, challenge, pleasure, ease. . . . Be present to what is."[3]

When I first read his retelling of his experience with the Navajo light practice, the reverence of it resonated deeply with me. I felt like I *needed* it. I needed to reconnect with light, with the earth, with inhabiting my own body without tension. I was committed to the practice.

UNDERSTANDING EMBARRASSMENT

Well, just because you believe in something strongly and believe that you desperately need it doesn't mean it won't feel very *uncomfortable* at first. On the first morning I tried this, I felt like all of my neighbors were watching me. I felt like my husband was watching me. I felt silly.

It is completely normal for this practice to feel somewhat embarrassing at first! But just like I told myself that morning and all the other mornings since, if I want to be free of those little whispers telling me to give up and go numb myself, then it means I have to sit in that discomfort and have faith in this attempt at *a new way*.

When I feel embarrassment rise up within me, it feels like a block, an internal hesitation that keeps me from full expression of joy.

Think about the places you feel blocked within you, the times when you feel embarrassment arise in you, and instead of feeling ashamed or silly, name those embarrassments for what they are: *soul blocks*. Naming my feelings when they come up rather than blaming myself for the feelings has been hugely helpful in my spiritual and creative journey toward peace. By becoming conscious of the things I feel embarrassed about and writing them down, I can trace the feelings back to their very roots—to the *why* of it all.

You get to decide what and how freedom comes for you and if you are being true to yourself. Being present for you won't look like what being present looks like for me.

Sometimes I still feel a little embarrassed when cars drive by and people see me standing in my doorway pouring invisible light over my head, but mostly I feel pretty proud of myself for sticking to a practice that has transformed the way I see light. My kids know that this is a practice we do, and as soon as my toddler son sees me in the morning, he reaches his hand upward to me and says, "Mommy, let's go, walk beauty!"

So I stand in that doorway, lift my face to the warmth of the sun, and speak the words of the blessing out loud: *In beauty I walk.*

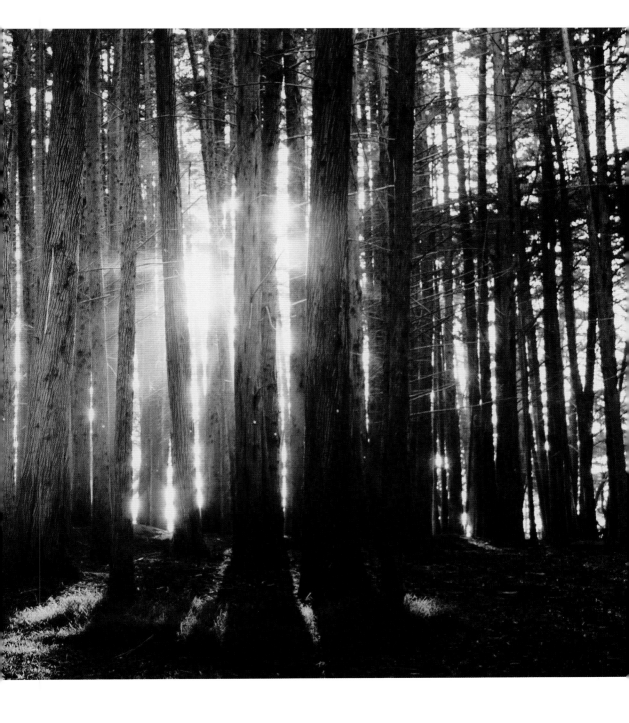

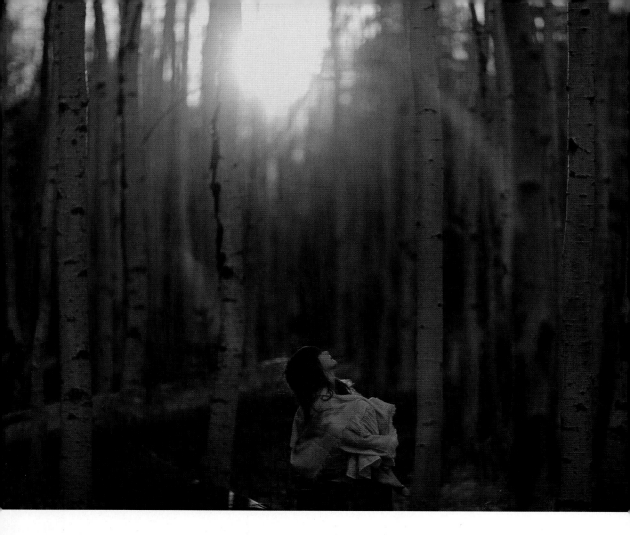

I watch my children running and laughing out on the driveway, and their voices carry across the wind like an invitation beckoning me to see that it *is* with beauty before me that I walk.

I step out into the new day with my bare feet in the cool grass, feel the morning dew between my toes, and say to my weary limbs: *With beauty behind me I walk.*

I lift my face toward the rhythm of squirrels jumping from branch to branch and I repeat the words: *With beauty above me I walk.*

I reach my hands outward until a pool of sunlight spills warmth into my palms, and I exhale while pouring it over my head in blessing: *With beauty around me I walk.*

I put my trembling hands on my heart and remind myself that it's okay to believe: *It has become beauty again.* These aging, wrinkling, thin-skinned hands of mine that have rocked babies for hours and cleaned up vomit at three in the morning, that have made meals and written essays and wiped tears of grief from my loved ones' cheeks.

I need those two minutes in the mornings where I put myself in the way of *light.* When I am tired and need to remember what all this effort is even for. When I need to hold out my hands, imagine the golden warmth covering me like a baptism, and offer these words of intention *and* expectation: *It has become beauty again. It has become beauty again. It has become beauty again.*

When my kids look back on their childhoods someday, surely they will be able to name a lot of things I did wrong as a mother. But if I can just keep showing them how to find the light on their own, despite all my shortcomings, hopefully they will be able to find the beauty before them, behind them, above them, around them, and most importantly—deep *within* them wherever they go.

For now, we do this practice together. And one day when they lose track of the beauty, I pray they find a slice of sun coming through a window, hold out their hands, and remember.

CAPTURING RAINBOWS

Occasionally when I am photographing a family on a sunny evening, a rainbow appears like a circle around the family as the sun is slipping down past the horizon. I run toward them, camera in hand, and reach out to show them the photo on my camera screen. Their eyes grow large in awe and disbelief, and they throw their heads back with joy.

When it comes to capturing evidence of *hope*, often the very thing we have all been searching for is already right here wrapped

A FEW CAMERA TIPS FOR DOCUMENTING YOUR OWN RAINBOWS

If you are using a professional camera, keep your aperture wide open and take off any lens protectors or filters so that the pure light is flooding into your lens.

If you are using a camera phone, you will want to point it directly into the sun. Sometimes it can show a natural circle burst of light when shooting into direct light, so it's not terribly difficult to get a rainbow using your phone! Obviously the quality will be different than if you were using a pro camera, but remember—you are going for symbolism and presence, not perfection.

around us—we just might need to view *ourselves* from a different perspective to see it.

Sometimes evidence of hope can piece us back together. Seeing tangible proof that we have endured. Proof that we are held.

For me as the artist, capturing a rainbow is less about technique or being good at taking pictures and more about just showing up every single day in the golden light, hoping it will meet me there. Seeing one gets me so excited because it always feels like a sacred gift.

Who in your life do you feel needs to be circled in redemptive and beautiful light? Is it you? Is it your child acting as your muse? Your parents? Your spouse?

Even if it's only for two minutes each day, inviting the light to cover us and lead our thoughts upward toward beauty is such a powerful act of resistance against fear and anxiety. It fills my heart with absolute joy to imagine mothers around the world reading this book, all of us energetically stepping into each new day together.

The first light of the day, when the sunlight is soft and golden, makes capturing rainbows more likely. Most importantly, however, keep in mind that the magic of capturing rainbows is that they *don't* come around every day. I've tried tens of thousands of times and have only a few hundred to show from my attempts.

But always the best part of creativity of any kind is in receiving the unexpected beauty that shows up along the way!

Be patient and kind with yourself. ¶

APPLYING THE PRESENCE PRINCIPLE TO BECOME PRESENT TO LIGHT

1. **Slow down and breathe.**

2. **Set an intention and write it everywhere.** When the darkness feels like it is ever-present, set an intention to step into the light. An example: "Light is within me and around me."

3. **Engage in a sensory-rich memory.** Allow yourself to feel the warmth of the sun on your skin. Think of light as a friend—sit with the light, play in the light, and dance within the light. Allow the radiance to wrap around you and feel it completely.

4. **Focus and take a picture.** Create an image that shows your pursuit of light.

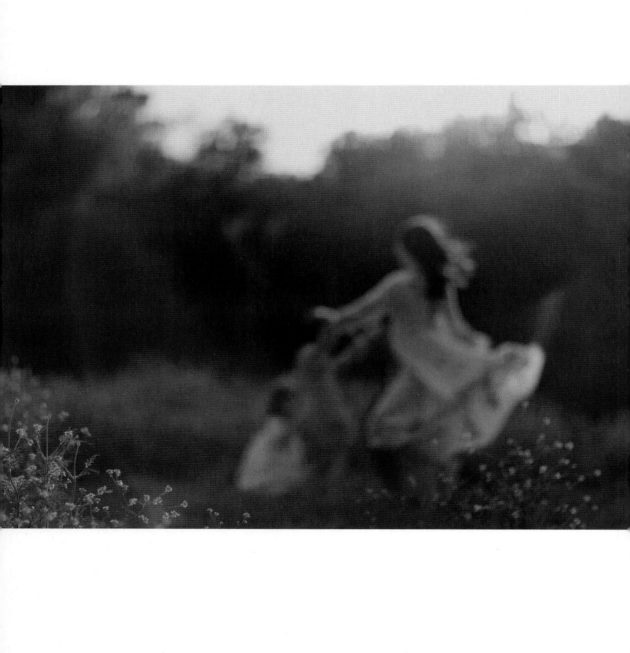

MAKING SPACE
TO EXPAND

———

All of us are artists,
and artists are *innovators*.

Once we realize we have grown
too deep and too wide
for the boxes we've existed within—
we have no choice
but to create
and expand.

Spreading up and out
into the unknown,
we fill the emptiness
with imagination
and with light.

Because making art makes space
to heal, to process, to grow—
allowing us to no longer shrink
into smallness,
but instead
expand into strength.

11

BECOMING PRESENT *to* YOUR FOUNDATION

We didn't notice it at first—*that our house was sinking.* One day I just couldn't get the nursery door to close for the baby's nap, and the next week the kids had to start slamming the bathroom door to make it shut. And we had to cut wooden dowels to keep the windows from coming open because the locks were no longer aligning. Upon closer inspection, we saw little cracks at the tops of all the walls and could feel the uneven ground beneath our feet.

What began as quirks in that old house quickly turned into emergent concerns.

There had been only a handful of times in all of our years of marriage that I'd heard Donny dread something as much as he seemed to dread going underneath the house, but the time had come. "I can barely move, it's so narrow and dark under there," he told me, already bracing himself. "I can't see the things I feel

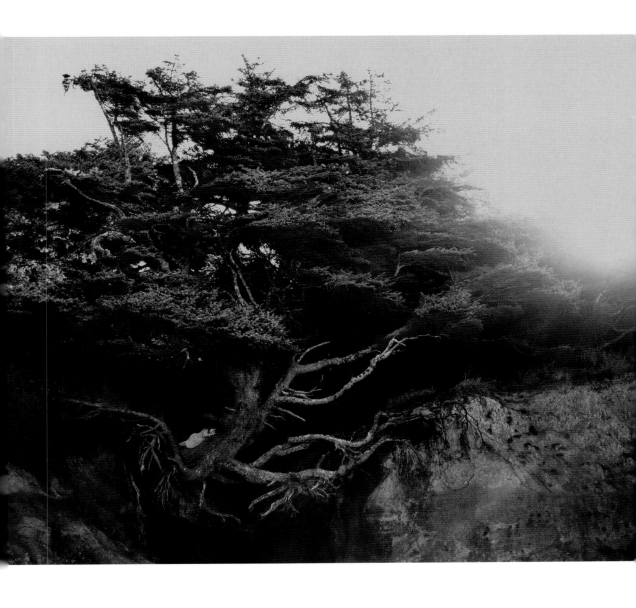

crawling on me, and I have to keep completely calm because if I think about it too much, I'll have a panic attack, and then I'd have to tunnel my way out."

Even so, he did a little deep breathing, put on coveralls, boots, goggles, and a headlamp, grabbed a big flashlight, and ventured into the abyss. About a half hour later he emerged, covered in dirt and sweat, with his headlamp still shining and looking like one of the Ghostbusters.

"Well, the bad news is that the house is sinking. The good news is that I know how to fix it."

That evening after the kids had gone to sleep, he pulled out his clipboard and explained his findings. "Okay, so from what I can tell, there are two things happening. The first is that the house may not have been built upon stable ground to begin with. The second is damage from flooding water—whoever built this house didn't think about protecting the foundation from storms. The water gets under the house and then has no way to get out, and so it just seeps down deeper and deeper, taking the structure with it."

By the time he finished speaking, I was in tears. I knew he was talking about our house, but I felt like he was talking about *me*. My foundation felt unstable, and I had spent much of my life worrying and absorbing the worries of those around me, never quite sure how to let them out. My worries sank me deeper and deeper into sorrow and isolation.

I just started firing off questions at him through tears: "Is there any hope for the house, or is it forever doomed? Please tell me that the fix isn't going to hurt or cost too much!"

He smiled at me and his eyes squinted sweetly—this was not the first time that a home repair had turned into a life metaphor. He wrapped his arms around me and very calmly explained that all hope was not lost and that there were ways to secure the house. With some strong pillars and a new drain system, we'd be all right.

Walking around our house in the weeks that followed, I was highly aware of how off-balance the foundation really was. When a kitchen cabinet was difficult to shut, my frustration would rise.

When I'd hear the kids slam the bathroom door, my spine would shiver. Every symptom our house was experiencing seemed to be a glaring reminder of my own needs.

I needed pillars of strength to hold me steady.

I needed to create a system of rerouting my negative thoughts around me instead of absorbing them into me, causing me to sink.

ROOTED IN LOVE, NOT FEAR

In our house, we have a whole wall of framed pictures from adventures we have taken and special memories as a family, and the largest is a photograph of my daughter Gracie at the Tree of Life in Olympic National Park. I had walked by the picture hundreds of times, but in that season of becoming aware of my unstable foundation, I saw that mother tree in a whole new way.

I had first seen the Tree of Life in a magazine and immediately put it on my bucket list to visit when we were traveling through Washington State. It's a Sitka spruce, known for both its towering height and its expansive trunk. The space beneath the tree where there was once soil has been hollowed out by a small stream that drips down from above and flows through its roots to the ocean. A giant cave has formed there, and people just stare in awe, wondering how this tree is still standing. People even place bets on when it will at last tumble down from the rock face, as it is known to sink a couple inches lower every year.

Despite all of the soil being washed out from beneath it, that tree holds steady—*by clinging to the strength of the rock.*

It's the most magical tree I have ever seen.

We arrived about an hour before sunset on what was a fairly gloomy afternoon. The children were exhausted, everyone was a bit cranky from the trip, and I was heavily pregnant with our fifth child.

We thought it might be at most a five-minute walk from our car to the tree. But a hard wind picked up, and suddenly sea water was flying everywhere. We were all walking straight into the wind,

and salt was getting in our eyes. And then it started raining. We finally got there, but we were all cold and the storm wasn't letting up. Donny and I nodded at each other that it was just time to go.

I looked up at those massive roots and traced my fingers along the wood gripping the rocky cliff, wishing for more time. We loaded the kids on our backs and on our fronts, and with the help of that strong wind pushing us, we made it back to our car and then checked in to our cabin without injury.

After the kids fell asleep and it was quiet, Donny asked, "Are we going to try again in the morning?" His kindness made me smile, but I was so exhausted and told him I didn't think so. I finally went to sleep after mindlessly scrolling my phone for hours, then woke up with a jolt in complete darkness at 5:30 a.m. Everyone else was asleep, and I could hear the birds starting to sing outside. I lay there for a moment, feeling the baby kick inside my belly, and then at 5:32 a.m. a notification appeared on my phone: *Your daily message is ready.*

It was just one verse: "Your roots will grow down into God's love and keep you strong."[1]

I thought, *You have got to be kidding me.*

I reached over and woke Donny and the children. I was filled with exhilaration! I can only compare the feeling I had inside my chest to the times I would hop on my bike in childhood and ride fast, feeling the wind blow back my hair, completely free.

We all piled into the car and were able to find an easier way to reach the tree by parking above it instead of coming up from the beach. One at a time, using the thick roots as slides and handholds, we made our way down to the sand.

Gracie cuddled herself up right there on one of the limbs, and Donny stood in the cave behind her with his hand on her back while taking in this majestic beauty of nature. The other kids were curled up in blankets on the beach, watching birds dive down to catch fish from the sea. It was the most peaceful morning and felt like a complete gift to begin our day at the water.

I walked out ankle-deep in the shallow waves, inhaled the beauty, and turned around to face the tree. The sun began to rise,

and it was coming up directly behind the tree. I stood there, lifted my face to the light, and received it.

The giant branches became illuminated little by little, and when I lifted my camera up to my eye and looked through the glass, I saw a rainbow encircle the entire tree. It felt like an unexpected gift to my soul.

I printed the picture and put it on our wall at home because there are many times when I feel like giving up. I often question whether I am firmly planted, rooted, and established in anything but my own worries. But then I look at that tree and hear it saying, *When everything gets washed out from beneath you, the thing that holds you steady is what you are rooted in. Love is the only thing that holds firm.*

BEING MINDFUL OF OUR THOUGHTS

It's been a few years since I awakened to the truth that many of my life decisions were rooted in fear instead of love. Installing pillars of strength and creating a system of rerouting floods—just like we did to secure the foundation of our home—has transformed my mindset toward my life.

The pillars that keep me strong and secure are daily practices of awareness. I work on paying close attention to the thoughts that I allow to ruminate around my mind, and I practice letting my emotions wash through me (instead of holding them inside) so that I do not begin to sink. This gets me out of my mind and into my body and my senses.

Breath work is a huge tool that keeps me stable. Reading books by great voices of wisdom is a pillar of strength for me. Being out in nature—listening to the birds and feeling the grass beneath my feet—can be a pillar. Music, yoga, dancing, stretching, and rhythmically moving emotions through my body are things that give me courage and confidence. Playing with my children is my favorite activity that aligns my balance. Using my imagination, putting myself in the way of sunlight, and trying to make eye

contact with my husband, with my children, and with myself in the mirror (even when I don't feel like it) are all things that help to lessen those embarrassment blocks and bring me into a place of connected peace.

Just like we had to install a drain system around our house to help keep water from damaging our foundation, I have worked diligently on creating a system to help reroute the negative and worrisome thoughts that come into my mind by refusing to let fear direct my thinking. I can direct my subconscious using the power of positive intention. I know that my conscious thoughts direct my subconscious thoughts and that setting a positive intention isn't just a cute idea but an actual *system* of being able to direct what we let into our brains.

So whenever I am exhausted and overwhelmed and get lured into thinking that obsessing is productive, I try to breathe and release my grip from everything that is not mine to control.

I put my hand to my heart and remind myself of the wisdom of the tree: When everything gets washed out from beneath you, the thing that holds you steady is what you are rooted in. *Love is the only thing that holds firm.* ¶

APPLYING THE PRESENCE PRINCIPLE TO BECOME PRESENT TO YOUR FOUNDATION

1. **Slow down and breathe.**

2. **Set an intention and write it everywhere.** When it feels like your life is getting washed out from beneath you and you need to know how to become rooted, set an intention to be mindful of your thoughts. An example: "I am grounded in the present moment."

3. **Engage in a sensory-rich memory.** Look for opportunities to lean into playfulness, allowing yourself to release rather than grasp and control. When fears begin to flood your thoughts, enter your five senses and do everything you can to keep your mind where your body is—in the present moment. Notice the worrisome thoughts but do not focus on them or give them the power of your attention. Instead, step into presence and become aware of what you can hear, see, smell, taste, and touch.

4. **Focus and take a picture.** Create an image that symbolically shows how you are grounding yourself in the present.

YOU HAVE ALL YOU NEED

———

It's always when I put my ear down and listen
that I find what is lost.

Last night it was the warm breath of my son after he fell
 asleep. Heavy on my chest when I leaned in and his exhales
 whispered—

"Come close, Mama."

Last week it was when submerging my tense body in the tub.
 My ears slipped under the water and I heard it—my own
 heart pounding, each beat reminding me—

"Stay awhile, sister."

And year before last it was at a retreat in a monastery. My weary
 mind couldn't find peace, and in a dark, quiet room I curled
 into a heap on the floor, pressed my tear-soaked face to the
 creaky wood, and heard angels singing. I found out later
 it was an actual choir in the chapel below me, but I'd have
 sworn the song was sent to fulfill my solitary prayer at that
 very moment. The holy voices echoed up—

"Rest, child. You have all you need."

I run myself in circles most days trying to figure things out; spin
my thoughts into tangled webs of disbelief and build walls
between compassion and myself.

And so on this day, instead of searching the internet or asking
people for answers, I need to recall all I truly need only
comes through stillness and humble listening.

Breath, heartbeats, and angels all tenderly reminding—

come close,

stay awhile,

rest,

you have all you need.

12

BECOMING PRESENT
with YOUR BODY

The hardest part of allowing myself to be captured in photographs is the surprise of seeing myself *when the picture doesn't match what I think I look like in my head.* In my head, I look like I did fifteen years ago. I feel the aging in my body, but my mind hasn't quite caught up. I feel unsettled, and the reflection of me in pictures feels uncomfortable and unfamiliar.

It is in these times that I have to fight against comparing the current me to the past me. I have to practice imagining that I am expansive enough to embrace the fullness of my current self, knowing it is the version that my children look up to right now.

I have a photo my daughter took of me framed on my bedside. She captured it one day when she saw I was snuggling the baby. I remember her strong little voice demanding, "Mama, you always take pictures of *me*, let me take pictures of *you*!"

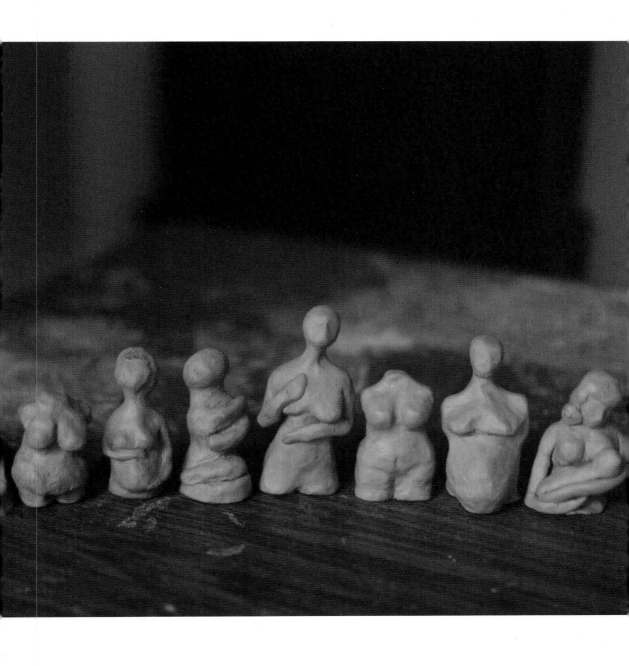

I handed her my phone, and she snapped a few photos and showed me. I smiled, but in my mind all I could think about was how tired and heavy I looked. I wanted to embrace how she saw me, yet all I could see was that my body didn't look the way it once had.

A few seconds later my toddler waddled over, looked at the photo, pressed his finger on the phone screen, and squealed happily, "My Mama!" He looked at that picture and then back to me, his eyes big and sparkling and his rosy cheeks shining. He kissed the picture over and over, and I thought to myself, *Oh wow, this mama is the only one he knows, not a younger, skinnier past version. He loves the feel of this mama—the squishy one that grew him.*

So instead of judging my healing, evolving self, I regularly try to get out of my head and look into the eyes of my children to find my value. No matter how my body looks, they see their mama who loves them, and that is beautiful.

LEARNING ARTISTIC EMBODIMENT

My friend Jane is an artist, and one spring she invited a group of creative women to her 1800s historic house down in Alabama. She says the house is a sanctuary for artists—a place weary "birds" still learning to escape their own "cages" can take refuge for a while to rest while doing the work of creativity and healing. Jane has lovingly named this place The Birdhouse.[1]

Before my trip, I confided to Jane that I had been having trouble with my eyesight. It's really an unfortunate part of living with diabetes and something I didn't expect to be dealing with at this point in life. I let her know that I was scared. I shared with her that I was worried about what losing my eyesight could mean for me as a visual artist. She was so thoughtful and kind, but little did I know how much she had taken what I said to heart.

On our second afternoon together at The Birdhouse, she asked us all to gather around the table. In the center was a ball of clay for each of us, as well as a pile of blindfolds. She told us about

an inspiring blind sculptor in Mexico who, *after* losing his eyesight, began making incredible giant clay sculptures of indigenous people to support his family. He had been an artist all his life, so when he lost his sight to glaucoma at the age of fifty-five, he simply found a way to keep being an artist despite the fact that he could no longer *see*. She said that he learned to see with his *hands*.

Jane delivered what felt like the answer to a prayer I hadn't even been brave enough to pray for myself. That prayer of "But what if . . . ?"

To which she said, "*Even if* . . . you can *still* be an artist."

Your worth and your art are not defined by what you can *do* but by who you *are*.

I held that clay in my hands, feeling more cared for than I had in a long time. Jane asked us to put on our blindfolds and warm the clay. She said to let our hands do the seeing. She said to be as tender as possible and begin forming the shape of a woman, the shape of ourselves out of the clay. It was to be a lesson in creative embodiment, a way to shift *our perception* of our bodies.

As I worked the clay with the most tender pressure, I felt like I was truly learning the art of being gentle with myself. When I got to the belly of my figurine, I felt like I needed to keep adding more clay to make this creation authentic and full-bodied. Like me. What would have once felt shameful to me at a deep level—the fact that I needed to keep adding more clay—actually made me feel gladness. I felt like this larger size of my figure—but also this larger size of me—was good.

The clay helped me to step into feeling worthy of being seen. To believe that my body was worthy of being brought to life through art.

In his book *The Body Keeps the Score*, Bessel A. van der Kolk writes, "As I often tell my students, the two most important phrases in therapy, as in yoga, are 'Notice that' and 'What happens next?' Once you start approaching your body with curiosity rather than with fear, everything shifts."[2] By learning to be

kind, nonjudgmental, and *curious* with the little clay version of myself, I was able to gain a new, more gentle way of relating with my body.

After maybe an hour of working on our clay figures, we all removed our blindfolds and most everyone gasped at what they saw in their hands. A few women giggled while holding their figures. A few cried in amazement, and others shrieked with excitement over the astonishing creations that had been born out of those nondescript lumps of clay.

The next day all of us women gathered outside for photographs. We all remarked how much more confident and at ease we felt in front of the camera after taking part in the experience of modeling versions of ourselves out of clay. Instead of feeling embarrassed at the idea of being photographed, there was a more expansive freedom in the way we allowed ourselves to be seen and documented by one another.

We can learn to embrace our bodies as they are through making art that celebrates our bodies.

I later did more research on the blind sculptor Jane told us about. His name is José García Antonio. In an interview, he talked about pivoting as an artist after losing his eyesight: "I looked at my life and said to myself, I have lost my sight, but I have not lost my life. . . . I discovered that my senses of feeling and hearing were stronger, and I began to work again. Now I feel that I can see, but through my *touch*, because I can make figures using my hands as if they were my *sight*."[3]

José García Antonio's message of resilience with his clay art inspires people everywhere. He shows not only what the human spirit is capable of but that the beauty of humanity and creativity should not be defined by what someone *looks like* or their ability to *see*.

CARRYING THE BURDENS

When I look back at pictures of me from my early years of mothering, I see myself hunched over in a lot of them. My posture dis-

played through photographs reveals the hopelessness I was feeling internally.

There was a season where I had a debilitating migraine almost every day for nine months. I began to doubt that there was hope for me. I didn't want to live, and for the first time I understood why someone would take their own life because of debilitating pain. I spent many, many, many weeks and months on end lying in dark rooms and bathtubs and hospital beds, crying out for some kind of reprieve from this pain. And over time I started losing my ability to hold my camera as my arms and wrists and hands began to go numb.

If I was typing on the computer for even five minutes, just holding my arms upward would cause them to lose feeling. I was sure that I was going to no longer have the ability to be a working photographer. I couldn't hold my children. I could barely hold a spoon to bring it to my mouth to eat. And if you had told me it was my posture that was causing this, I would have laughed at you and thought you were so silly, because I had been to countless doctors and none of them could figure out what was causing my pain or my migraines. They would give me medications, various ways to numb the pain, but nothing that got to the root of my actual problem.

It was only when I began seeing a wonderful masseuse that I finally learned how my body was holding stress. The numbness in my arms was due to poor posture and the way that I carried myself in the world.

Already at my very first massage, I started to recognize that a lot of my pain was because of the way I slumped my shoulders forward, as though I was a turtle trying to hide inside my shell.

As I lay flat on my back on the table, she lifted my body up from beneath, like she was diving face-first under me. She pulled my arms all the way back so that my chest was propelled toward the ceiling and told me, "Now take a deep breath. For the first time, sister, take a breath." And I gasped and exhaled, and I'll tell

you what—it was perhaps the first full breath that I had ever experienced in my *whole life*.

I hadn't known what it felt like to have my shoulders completely back without my own shame, fear, pain, disgust, worthlessness, and worry pulling them forward. From that moment on, I decided that I wanted to breathe fully. I didn't want to go back to shallow breathing.

What I really was committing to, though, was that I didn't want to go back to shallow *living*.

I began listening better to my body and noticing the way my muscles held my trapped emotions. I also began seeing a chiropractor every week and practicing different kinds of yoga, and I really made a serious effort to tenderly care for my body and my spirit.

It took me one entire month of consistently wearing a brace and consciously working on keeping my shoulders back and my head lifted. My arms were so tired, and my body had to adjust. But over time, you know what happened? My migraines went away and so did the numbness in my arms.

I still have setbacks. When I am under immense amounts of emotional stress and pain, I can feel my body starting to curl forward. But I have gotten better at releasing things more quickly. As my therapist reminds me and I must continually remind myself, healing doesn't

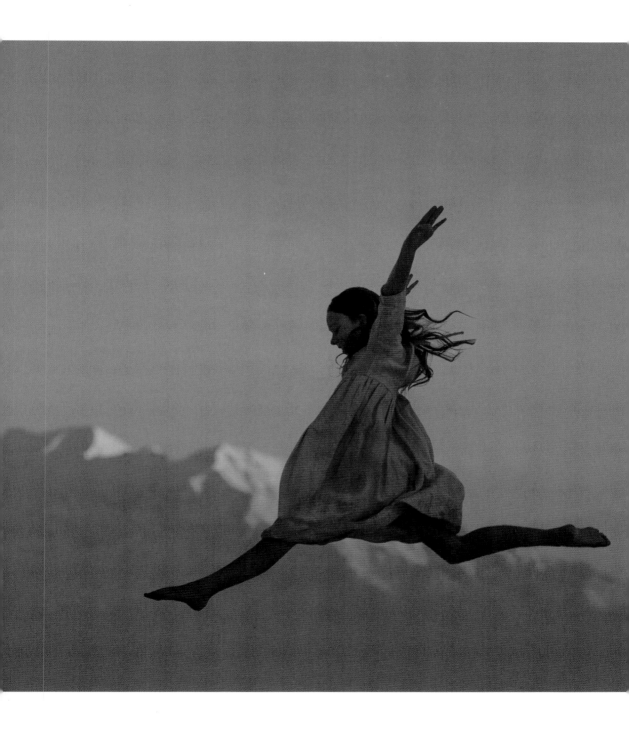

mean that we won't ever be triggered. *We can't avoid the triggers.* But we can learn to recognize how the body is activated by our experiences.

I realized this was the same problem my grandma had struggled with throughout the final decades of her life. I remembered her going in for regular cortisone shots to numb the pain in her neck and shoulders.

I remembered a time when I was about twelve and went out into my grandma's garage to put trash in the bin. When I opened it, I found all of these beautiful watercolor paintings that she had made stuffed inside. I was in complete disbelief and total confusion. *Why would my grandma throw all of these masterpieces away? She's so talented and these are stunning. I don't understand.*

I pulled the paintings out of the trash and took them inside. I laid them all out, pieced them back together, and taped them into their original forms. Hoping to keep them safe, I hid them in a closet where I thought my grandma wouldn't look. But the next week when I came over and went out into the garage, I *again* found the paintings torn up in the trash. She had found them taped back together in the closet and tore them up again!

As a child, I didn't know what that meant. I was confused and didn't know how to talk about it with her. But as I have grown, my best guess is that my grandma didn't want to see any evidence of her artwork that she believed was less than perfect.

My grandma liked to keep her house perfect, with not a thing out of place. Having everything flawless was very important to her—from the meals we had at holidays to the color scheme and theme for every room in her home. Her artistry could be seen everywhere, and it was always so inspiring to me. But now I also see how important it was for her to have *control* when it came to those things.

I wish I could go back and talk to my grandma about her paintings, tell her how incredible each one was and still is to me. I wish I could ask her to give me tips on holding a paintbrush. I wish I could grab her by the hand and tell her that everything she touched

turned golden and that she didn't have to worry so much about everything looking so perfect.

It's the very thing I have to regularly tell myself.

I can't go back and tell her any of that now, but I can honor her legacy as an artist by modeling for her great-grandchildren the value in making beautifully imperfect creations.

CENTERING OURSELVES

I envision my center as the place deep within me where I am able to find peace and calm. Center is childlike but also very wise. When I am centered, I am in alignment with my most true self.

Every day we have a choice whether to allow our spirits and bodies to relax and be held in that centered place *or* to resist, tighten up our bodies, and carry the weight of the world on our shoulders. It is a *choice*—release and relax or resist and hide.

It has been crucial for me to stay in tune with the feelings happening in my physical body rather than just instantly seeking to numb them. For me, if I do not stay attentive to the signs that my blood sugar is imbalanced, I run the risk of doing damage to myself by going into diabetic ketoacidosis where my organs could begin to shut down. Embodied self-compassion has become literally invaluable for me when it comes to daily saving my own life. Yes, it is mentally easier to just keep going and pushing and ignoring my body. But recharging and resting are crucial for being able to function and thrive.

I deserve to be tenderly cared for. You deserve to be tenderly cared for. And when we are able to listen to our bodies and give them what they need, we are able to pour out and nourish all those around us.

BE STILL AND KNOW

I took a picture of a friend's daughter at the beach in northern Florida as the sun was going down and seagulls were flocking

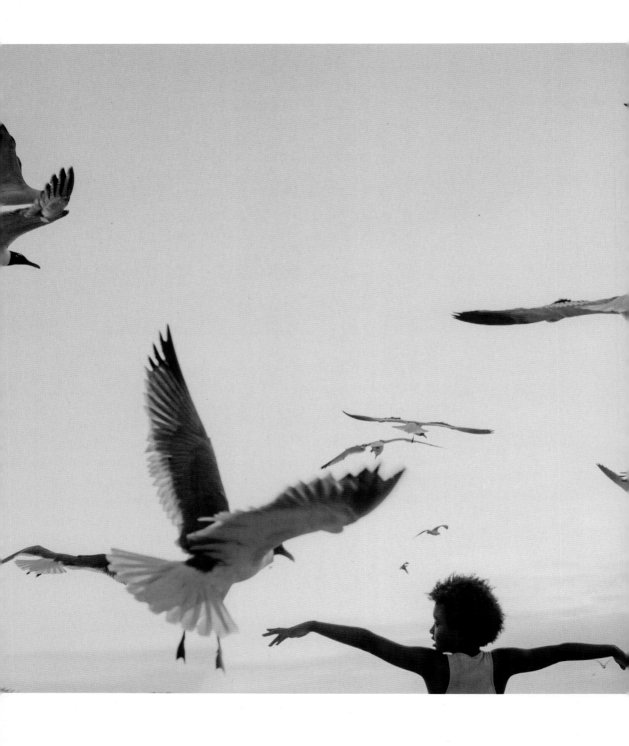

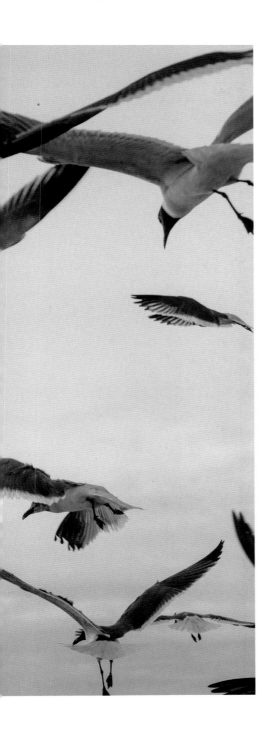

around us. I hadn't planned the photograph, but as my friend and I were chatting and our kids were playing at the ocean's edge, we watched her daughter raise her arms like a bird and pretend to fly with the seagulls, and I couldn't resist preserving the scene.

My nature-enthusiast husband has taught me so much about the flight of birds. Many birds fly by waiting for the warm air currents to rise up beneath their wings. They perch with their wings open, just waiting for the heat to carry them up into the air.

That's what it means to have *stillness* that carries you into forward *motion*.

I have never been someone who liked staying still, but birds have helped me see things differently. I see now that stillness doesn't mean sitting in one place. Rather, by lifting our arms open wide, those currents of movement can come up beneath us and carry us in the way we were always meant to go.

A bird knows that it will be carried, that it will be cared for, that it must simply release and be carried in the wind. This is why birds can soar and not get tired. They're not flapping, flapping, flapping their wings all day long. They're just spreading their wings and allowing the winds to carry them so they can soar.

We are not meant to carry all the weight of the world; we are meant to release and to be *carried*.

Birth can be a fully embodied spiritual process.

I thought my seventh birth would be quick and easy and might I say even spiritual. And, well . . . turned out it was the longest, most difficult, most exhausting and defeating of them all.

The day after the birth I thought back on those thirty-seven hours of intensity, trying to identify the things that had brought me genuine *relief.* And what I realized was that those things also happened to be the same tools I've used when trying to find courage to show up in *photographs.* I encourage you to identify the tools that are helpful for you when things get hard and to compile your own metaphorical toolbox for becoming present.

- *Music* really helps me to set my body to a rhythm. It gives me something outside myself to focus on and set my attention to. I am very intentional about the songs I put on a playlist . . . songs that empower me not to give up and songs that bring me out of my thoughts and worries and into my physical body.

- *Breathing* through the contractions allowed me to have something physical I could focus on that brought about an instant feeling of calm. When I could control nothing else, I could control my breath. I count the seconds of my breaths. I listen to the sound of breath going into my body, and I imagine the cycle of the oxygen swirling inside of me. I feel the relief of the release in the exhale. When I wanted to scream in labor, my nurse reminded me not to let my power escape through my yelling but to channel that into my breath—to use the strength of the contraction to bring the baby even closer into being through the focus on my breathing.

- *Imagination* and visualizing pressure as *waves* can be helpful both physically and mentally. Just knowing that all intense peaks eventually fall enables me to feel pressure

more as a wave I have the honor of surfing rather than as something that I have to keep enduring.

- *Dancing* with my partner and letting him hold me up really helped during labor. He would hold onto my hips and give a bit of counter pressure when he'd feel me tense up from the pain. I also know that in everyday life, instead of scrambling around alone trying to find something to help steady myself within the uncertainty of things, I just need to lean into someone who loves me and listen to the beat of their heart.

- *Rest.* When all of the moving and the shifting and the working hard just becomes too much, allowing myself to lie down, close my eyes, release all the tension in my body, and just rest is the wisest choice. By becoming conscious of how stress impacts my level of pain, I do my best to prioritize peace entering my body, spirit, and mind. When things feel loud and chaotic at home, we remind one another of our family motto: "Home is a place of calm." Knowing that we desire an energetic feeling of calm for our home has made a difference in the way we engage with one another in our space.

Embodiment in my everyday life looks like implementing all of these things and more. When I feel overwhelmed and become triggered and my first instinct is reactive, I try to practice intentional embodiment. I do my best to enter my senses and keep my mind where my body is. ¶

APPLYING THE PRESENCE PRINCIPLE
TO BECOME PRESENT WITH YOUR BODY

1. **Slow down and breathe.**

2. **Set an intention and write it everywhere.** When you find yourself feeling nervous, embarrassed, or worried about letting your body move freely without restriction, set an intention that reminds you embodiment is healing, necessary, and good. An example: "I am expansive."

3. **Engage in a sensory-rich memory.** Look for opportunities to incorporate embodiment into your normal daily tasks. Maybe instead of just standing at the sink while doing dishes, turn on a song and let your tense muscles move around as you work. Or when you see your children playing, instead of just watching, join in and let your imagination fill not only your mind but also your arms, legs, hips, neck, and senses.

4. **Focus and take a picture.** Create an image that shows your embodiment of play, rest, or expansion.

SING YOUR SONG

———

To those who called you—
too much,
not enough,
too loud,
too quiet,
too different . . .
Oh, what they missed!
How could anyone silence a sparrow?

I know you were once afraid to sing,
but have you seen yourself these days?
The way you raise your arms up to the sky?
And how your eyes twinkle when you throw your head
 back in delight?
You paint the world with beauty—
Sing, beautiful bird, sing!

Let the wind carry your song to all the others—
the ones called too much and not enough.
Remind them they too have music within.
Through their fingertips at the canvas,
their dance shoes on the worn wooden floor,
and in every embrace of the child within.

You are a marvel.
You overflow with plenty.
So fear not and feed the world with your melody.

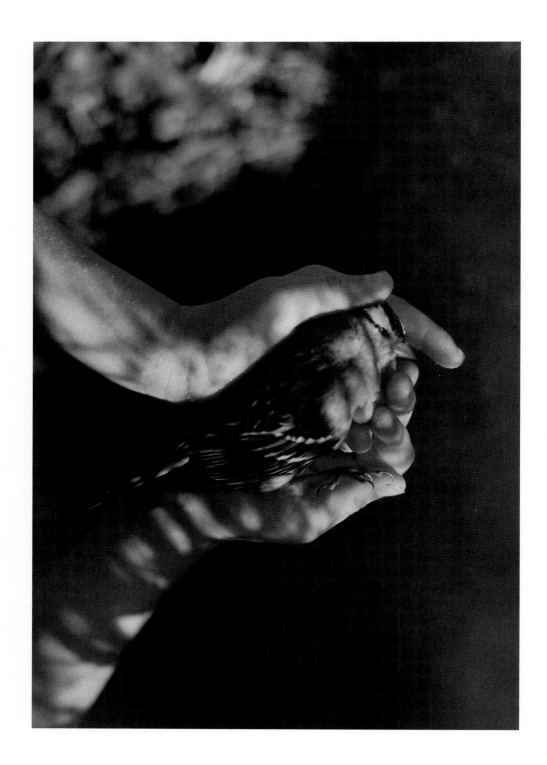

13

BECOMING PRESENT *to* YOUR STRENGTH

I didn't realize that I would simultaneously be grieving the unexpected loss of a dear friend while bearing witness to the miracle of new life.

I had been hired to document a birth for a client who lived in the Midwest. I drove up a few days early, once she had reached forty weeks, to be nearby when she went into labor. I got to be there for the entire birth experience, and I was moved to tears by the strength of her peace while laboring and her completely devoted partner who never left her side. I prayed beside her as their daughter powerfully entered the world, and I preserved all of it into video clips and pictures.

After the birth I left the hospital, returned to my hotel room, and collapsed on the bed, exhausted from being up for so many hours in a row. I had just closed my eyes when I was startled by the phone ringing, and when I answered, I was given the news

that my husband's best friend since childhood had taken his own life the previous night.

I got off the phone in total shock.

The next morning I went back by the hospital to take a few more photographs of that newborn baby girl and her parents. As I looked at this little family through the viewfinder of my camera, I thought over and over about what a gift it was to have been forced into that small experience of celebrating life just before being opened to the depths of sadness.

When I returned back home to Nashville and began to process and edit all of those videos and photographs, I also processed through my grief. I looked at the time stamp on the photographs right as the baby took her first breath, and I couldn't help envisioning our dear friend at that very same moment contemplating his last. That baby had entered the world just before sunrise, and I stood in awe while taking pictures of a weary and expectant mother reaching both hands down to grasp her child. She lifted her daughter's squirming body straight to her heart with ecstatic gladness—*a release and a welcome*. Baby coated in vernix gazing up at her mother who gasped and rejoiced, tears washing clean the blood in her matted newborn curls.

And right then I saw it clear as day, deep in my spirit—this exact image of our *friend* at the moment he left this physical world—divine, mighty, mothering arms reaching down, lifting him up, and bringing him home to God's heart.

No room for shame. Only love.

Looking back at the photographs, the thin place between heaven and earth still feels tangible for me. I can just close my eyes and be back in that hospital room once again, feeling the tears of so many mothers spilling out round the world.

In the weeks that followed, I remember constantly pondering the question, "How are we to somehow hold both the beauty of life and the anguish of death together?" And every time I'd think of that question, I saw the same picture in my mind: I remembered watching the baby take her first breath. I saw my friend's gentle,

mothering hands—she did not look away from her trembling child for a second. She reached down and took her child into her arms and gasped at the beauty of every inch.

Love never ceases to rejoice over us, even in our great sorrow and isolation—*especially there*. Mighty arms wrap around each of us as tears wash clean the bloody barriers we falsely believe keep us from worthiness.

The fourteenth-century English mystic Julian of Norwich wrote, "If there is anywhere on earth a lover of God who is always kept safe, I know nothing of it, for it was not shown to me. But this was shown: that in falling and rising again we are always kept in that same precious love."[1] It is in the moments we are faced with having to hold both grief and joy at the very same time that we really find our *true strength*.

STRUCK DOWN BUT NOT DESTROYED

I once walked into a tiny art gallery tucked into the hills of a small historic mountain town in California, and the art displayed behind the register instantly caught my eye: a painting of a tree that had clearly been through a major storm. It was struck in half and looked like it should have died, yet it seemed to defy gravity by continuing to flourish and grow out of the fallen section. I looked at the painting for a long time, captivated by the sheer determination of the tree that lived.

It could have given up, but it kept reaching for light.

I wanted to buy the painting, but it cost more than I could afford. I did, however, ask the man working in the gallery if the painting had a name. He smiled and told me it was called *Struck Down but Not Destroyed*.

On every cross-country road trip for the next decade, I looked and looked for a struck-down-but-not-destroyed tree in the wild, and I finally found one while photographing a family in Colorado.

A friend had recommended the photo spot where I was to meet my clients and take their pictures. It was a beautiful backdrop—an

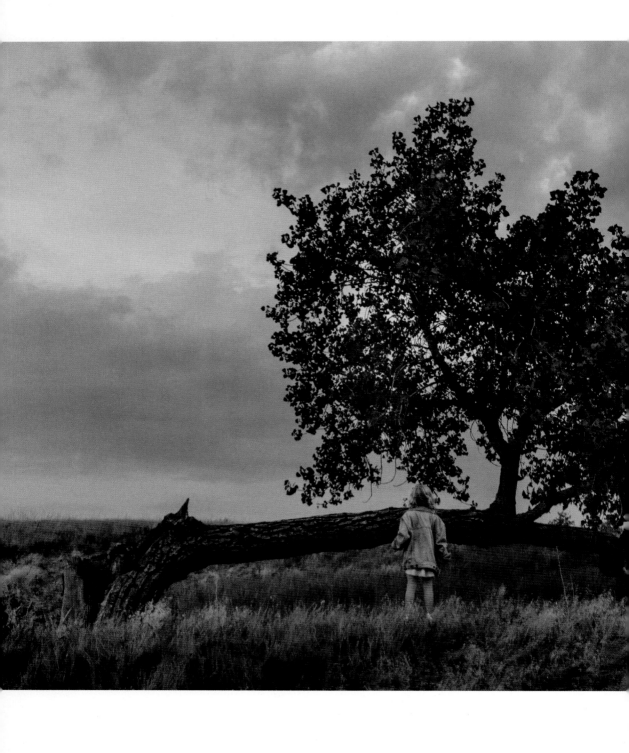

open space preserve near water with plenty of trees. I arrived at the location a little before golden hour—that's what we photographers call the hour just before dark when everything looks coated in a hue of gold.

I sat for a while on a fallen tree, waiting for my clients to arrive. At first I thought the tree was dead. Its base was almost hollowed out, but as my eyes continued to follow the limb reaching out from that stump, I saw that the tree was actually thriving—it was *struck down but not destroyed!*

I sat with that tree until my clients arrived, and then for the next hour or so I photographed them around the lake until the sun set. All throughout the session I kept looking at the tree from the corner of my eye, feeling giddy that I had literally stumbled upon something special I had searched years for.

The sky turned from blue to pink. We were saying goodbye, and as I chatted with my client's daughter, I couldn't help but ask what she thought of that resilient tree. As she stood to ponder it, I saw her eyes grow wide in wonder the same way mine had when I'd first seen that painting back in the gallery all those years ago. With my camera still in hand, I took a few steps back to quickly capture her photograph.

It was my very last picture of the day.

After returning home and while editing the photos from our session, I showed my husband that final photo and asked him, "Can you explain this tree to me? How can it possibly still be growing upward despite what happened to it?" Donny is a tree guy and regularly astounds me with his expansive knowledge on everything in the natural world. He looked at the tree for a few minutes, zooming in on certain parts of the image.

"Well," he began, "clearly it endured a great trauma. Maybe a lightning strike or a big storm. It looks as though the largest part of the tree that would have been growing vertically was ripped completely off."

"But how did it keep on living?" I begged to know. "Why wasn't it destroyed by its great trauma?" What I really meant was, *Maybe if I could make sense of this tree, I could make sense of myself.*

"Well, its roots are strong. Just imagine the size of this tree before the storm. I'm sure it was massive. After the injury, the majority of the tree no longer needed the nutrients supplied by the roots, so all of that goodness went to support the remaining part of the tree. And look how smart it is about conserving resources. It isn't growing any leaves on its lowest branches where it knows it cannot receive enough light to go through photosynthesis. It's putting all its energy into reaching upward."

I looked intently at the image with him. "Okay, I understand that part. It's amazing. But the trauma. Just looking at the base of the tree, it looks fragile. I imagine whatever catastrophe it endured must have weakened it quite a bit, shortening its lifespan."

A knowing grin spread across his face: "No, not at all. *This tree's wounds make it even stronger.*"

He continued, "After an injury, a tree begins tending to its own wounds. It wraps around the trauma, creating barriers of protection so that the wound cannot cause further damage. It does everything possible to turn its place of weakness into a healed place of strength. It embraces the wound and then focuses on new growth. Trees compartmentalize in the most healthy way!"

The tree took great care with its vulnerable places. It refused to be destroyed. It recognized it had been hurt and that it was vulnerable, and then it just began to heal. It went on doing what it was created to do: absorb sunshine and give the gift of oxygen. *Just like us*, I thought. *Made to absorb light and carry much-needed breath into the weary world.*

I wanted to know everything I could about the tree. After almost an hour of attempting to identify its leaves, I sent the photograph to my friend in Colorado—the one who had recommended that location to me—and asked if she knew what kind of tree it was.

She responded, "Well, I'm pretty certain it's a cottonwood tree. They are everywhere here, and people with allergies hate them."

It made me laugh a bit to think of this incredible tree also being known as a nuisance. But her answer also was thrilling to me! Three years earlier we had learned all about cottonwoods on our land in Washington. As the seasons shifted every summer and fall, intense windstorms would knock entire cottonwood limbs to the ground, bringing with them the tiny buds of medicinal resin that grow on the trees and are commonly known as oil of Gilead. The kids would gather hundreds of these sticky buds and then we would submerge them in olive oil in Mason jars. Over time, the mixture became a healing salve for pain.

The tree not only is made stronger for its wounds but also provides healing for the wounded!

Donny and I renewed our marriage vows beneath cottonwoods. I remember looking up at the trees and feeling held in the midst of them.

The cottonwoods just go about growing and doing what they were created to do no matter if anyone comes to collect their gifts or to sit beneath their shade. They don't waste energy stopping to question if they are worthy of being an oxygen-maker or a radiant color-bearer. They just stand up tall to receive light, and without thinking twice, they offer the whole world the gift of breath.

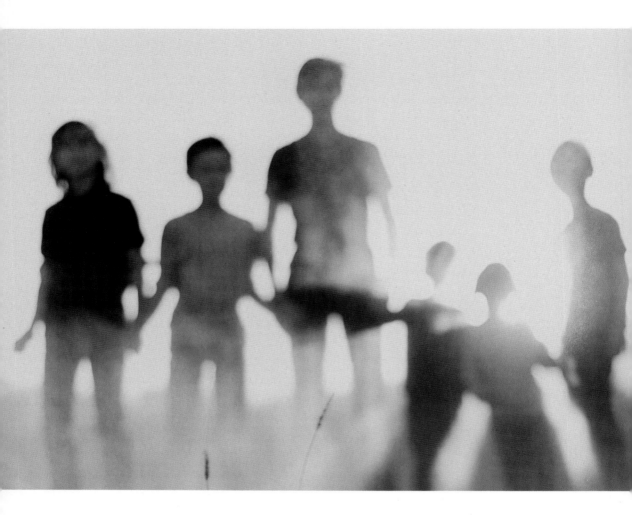

We have each been struck down. Sure, we were destroyed—
abandoned and alone, thought to be beyond the reach of light.
We believe our wounds mark us as victims. Instead, they mark
us for *strength*.

MEMORIALIZING STRENGTH IN PHOTOGRAPHS

Last spring, a past client of mine inquired about having me photo-
graph her family once again. This session would be in celebration
of their new twin baby boys! She let me know that she wanted to

be sure to also document the new tattoo she had just gotten—three arrows on her forearm—as it symbolized her being an advocate and parent of a child born with Down syndrome.

She sent me a video message explaining how their lives had all been transformed by getting to love this sweet little boy, Aaron. There was a radiance in her that was like the shining of the sun. I could truly see a noticeable change in her appearance. I saw her fulfillment, felt her joy, watched her embracing the wholeness of her being. By becoming an advocate for this child she loved deeply, she had stepped into her full power as a woman and mother.

In the message, she held Aaron in one arm as she talked: "I've realized that all the petty things don't matter. Raising him is giving me this new perspective on what's important, what's worth fighting for, what's worth giving my energy to, what's worth my *time*. Not only have I developed compassion for Aaron, but I also know that *I* was specifically chosen to be his mother. I'm exactly who I need to be to do that. And what he doesn't need is a mother who is sitting around worrying about petty things, but who is ready and willing to *fight* for him."[2]

She described so beautifully the raw advocacy that rises up within caregivers when tasked with doing everything possible to help others see the beauty *they* see in the people whom they love.

I asked her why documenting her tattoo in our photo session would be meaningful to her, and she told me, "When I look at the photos later, what it will make me feel is *strong*. I am not ashamed that my son has Down syndrome; I think he's awesome *because* he has Down syndrome. I saw a perspective once that said, 'God created this child with Down syndrome. He has never *not* had it. It's not a flaw about him, but it's how he was *created*.' And I think my tattoo will help me start conversations with that perspective with people to champion his worth." She snuggled little Aaron as her voice grew a bit louder, and I saw her holy rage of advocacy blazing in all its vibrant glory.

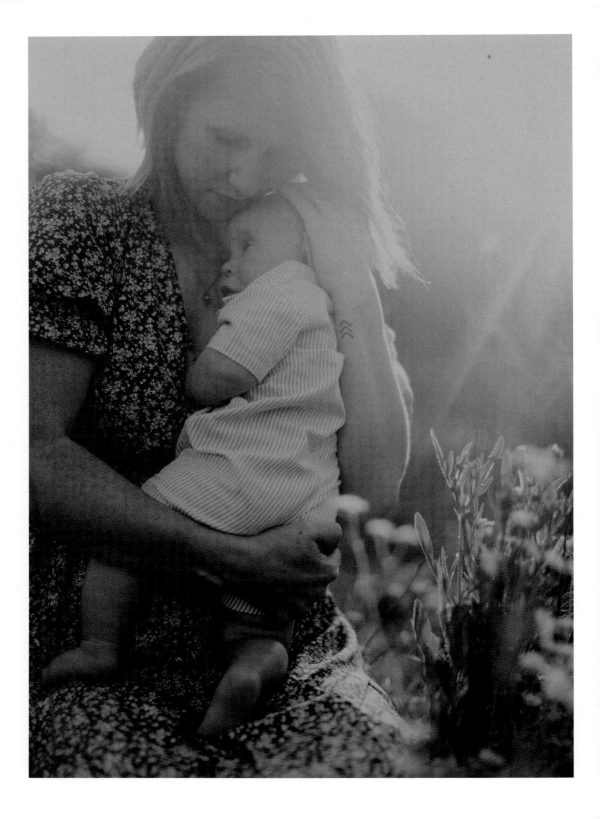

What she said next has really stayed with me: "I've never felt stronger as a *mother* or as a *woman*. I never imagined this being my story. I also never imagined myself getting a tattoo! I'm a pretty vanilla type person and I'm feeling a little edgy lately." At which point she kind of nodded her head back and forth and got into a little rhythm with her shoulders like she was ready to fight anybody that walked by with all that gigantic, beautiful love. She went on, "I'll tell you what . . . he has brought out this side of me that I am *loving*. That I am embracing. I've never felt stronger."

She told me that the tattoo's three arrows represent the three copies of the twenty-first chromosome, and they also represent *parents pushing forward*. Forward motion for children with Down syndrome.

She told me that they later came to realize that the name Aaron actually means "strength"—showing how courage was written all over their story.

I met their family at the same park where we had taken photos a year and a half earlier. We agreed that it felt redemptive, and the whole family was excited to run and play in the meadow. The first time everything had been brown and turning cold, but this time when we arrived, everywhere we looked was covered in *flowers*.

The girls ran around picking bouquets and making flower crowns as I sat across from this mama in the light of the setting sun, Aaron curled against her chest. She smiled at me and began singing to him, then lifted her arm up and around him, making her tattoo visible just beside him. I lifted my camera up to my eye and took what has now become a very special picture.

After sending Jenna some of the photographs from our heart-filling springtime session, she sent me this text in response: "The more time that passes, the more I've recognized how much Aaron didn't need to be changed; *I* needed to be changed. And I received the most gentle and precious gift to soften my heart and heal and expand me in ways I never knew I needed. These pictures—both sessions—show just how tenderly my heart has been transformed."

Jenna's willingness to be vulnerable with her story made space for us to create art together.

We find our strength when we allow ourselves to view life from a wider perspective. And in memorializing that strength through photographs, we create tangible proof of the transformation.

ADVOCACY AND PRESENCE

It has been several years now since Donny's dear friend took his own life. When trying to muster courage of my own in times of grief, I find myself thinking about the strength of his widow, Stefanie. She has devoted herself to the endless work of advocating for chronic traumatic encephalopathy (CTE) awareness in memory of him, sharing the warning signs of traumatic brain injury as well as doing everything she can to fight for suicide prevention.

Stefanie models how to find strength in the midst of incomprehensible sorrow. In the third year after her husband's death, she shared these words online:

> Two years ago we lost a father, husband, son, brother, friend . . . who is missed daily, who is spoken of daily, loved daily. Year One I went through it, just winging it and I made it through. Year Two I set a foundation and worked on forgiveness, forgiving him and myself. Year Three is about joy and presence and we are excited for what the future holds while grateful for what the past brought us to. I cannot reiterate it enough that if you are ever having thoughts that life is too much, please reach out.[3]

She says at first all we can do is just survive and wing it. Over time we are able to soften and forgive. And then, by being grateful for the past, we are able to have hope for the future and maybe even find joy in the present moment. ¶

APPLYING THE PRESENCE PRINCIPLE
TO BECOME PRESENT TO YOUR STRENGTH

1. **Slow down and breathe.**

2. **Set an intention and write it everywhere.** When the grief within feels like it could crush you completely, and still in the midst of it life must go on and joy must be embraced, set an intention to remind yourself that it is in holding both the dark and the light together that we gain our strength. An example: "My openness to holding both darkness and light together makes me strong."

3. **Engage in a sensory-rich memory.** Think back on how the struck-down-but-not-destroyed tree was able to heal. Consider the experiences in your daily life where you might be unnecessarily expending emotional energy that you could instead conserve and put toward cultivating new growth. Let your senses lead you into peace—whatever you are feeling, let it move through you. Listen to yourself the way you would attentively listen to your child, hold yourself with tenderness, nourish your soul with aromatic and savory delights, and look for ways that embracing both the sorrow and the beauty equips you with strength.

4. **Focus and take a picture.** Create an image that honors your inner strength.

IF WE LET IT

———

I stood at the kitchen sink,
migraine coming like a freight train—
God, are you here?
Are you with me?

Spreading my fingers out,
trying to find something to grab hold of
—*like hope*.

I walked through the house looking,
but figured God must be busy—
on the front lines at the hospitals,
giving water to the protesters,
putting out fires in the desert.

Why would God be here with a tired mother
when desperation calls so much louder out *there?*

So I succumbed to the hopelessness—
left the dishes in the sink,
decided not to water the garden.
What's it matter anyway?
God is busy elsewhere.

But then . . .
"Mommy," she hollered—
"Can you bring us a towel?"
The requests never stopping, I thought—
even when hope does.

So I picked myself up,
holding my head,
and a towel,
and I climbed the stairs—
one giant lift of weak knees at a time.

That's when I saw it—
Grace.
My oldest with her arms around her soaped-up little brother
freshly washed from the tub.
"He was dirty, so I washed him," she said kindly.
She smiled and he grinned at her,
the aroma of lavender filling all my emptiness.

I handed her the towel,
first using it to wipe my tears—
the answer is always Grace.
For the moment,
for a lifetime.
It's an unexpected offering of tender kindness without reason,
and always the thing that gets us through—
if we *let* it.

14

BECOMING PRESENT *to* YOUR LEGACY

Recently, while searching for something in my phone, I found a photo on my camera roll that was taken a year before I got diagnosed with type 1 diabetes. Before I was giving myself ten shots a day. Before I worried about having seizures in the night, or losing my eyesight, or dying sooner than I once thought I would. Before we sold and moved away from the house we hoped we would grow old in. Before I was pregnant and terrified. Before a dear friend took his own life. Before grief set in like a thick fog.

Before. Before. Before.

I looked carefree. I looked how I used to hope my children would always remember me—*happy*. But I have grown to hope that they remember the expansive, more nuanced parts of me as well.

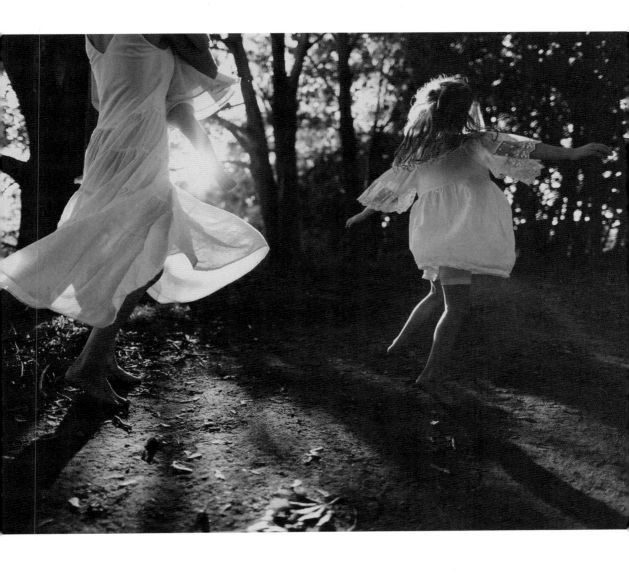

I hope they remember the courageous me who is scared and cries when I give myself shots and also the hugs we share to make it all better.

I hope they remember the humble me who apologizes to their dad through tears when I'm angry at the world and have said things I didn't really mean.

I hope they remember the creative me who writes furiously into notebooks and screams excitedly upon capturing a rainbow through my camera.

I hope they remember me as a woman who didn't give up when things got heavy, and that right there in the middle of all that darkness we still made memories thicker than the fog of grief that once hovered around.

Most of all, I hope they remember the joy of our togetherness in the *midst* of fear, not a shallow happiness or the absence of difficulty altogether.

In her book *Deep Play*, acclaimed author Diane Ackerman writes about the value of fully living:

> One can turn bronco riding into drudgery. One can create mildly. One can live at a low flame. Most people do. We're afraid to look foolish, or feel too extravagantly, or make a mistake, or risk unnecessary pain. One fears intensity. But, given something like death, what does it matter if one looks foolish now and then, or tried too hard, or cares too deeply? A shallow life creates a world as flat as a shadow. In that half-light, the sun never burns, risks recede, safety becomes habit, and individuals have little to teach one another.[1]

The most memorable chapter of your life is not the one where everything is perfect but the one that does not go by *unnoticed*. Despite what anxiety tries to tell us, we *can't* live in the past or in the future—the *present* is our most powerful teacher. I want my life to have depth, and I do not want that to be kept hidden from my children.

Ray Bradbury once wrote:

> Everyone must leave something behind when he dies, my grand-father said. A child or a book or a painting or a house or a wall built or a pair of shoes made. Or a garden planted. Something your hand touches in some way so your soul has somewhere to go when you die, and when people look at that tree or that flower you planted, you're there.
>
> It doesn't matter what you do, he said, so long as you change something from the way it was before you touched it into something that's like you after you take your hands away.
>
> The difference between the man who just cuts lawns and a real gardener is in the touching, he said. The lawn-cutter might just as well not have been there at all; the gardener will be there a lifetime.[2]

I want to live my life like the gardener. I speculate that's what most of us want at the deepest part of ourselves.

Ray Bradbury grew up in poverty during the Great Depression of the 1930s. His stories, which are both fantastic and shocking, were metaphors for everyday life and everything that entailed, and he has said they all came from his Midwest childhood.

My uncle, a lover of great literature, told me that he once spoke to Bradbury at a book signing. The author told him that he would start writing his stories without knowing how they would end. My uncle said those words have stayed with him always and have helped him navigate through the uncertainty of life.

The thing is, none of us ever knows how *anything* is going to end, but perhaps that's supposed to be the fun of it. Not knowing how it is all going to turn out shouldn't stop us from making the most of *right now*.

I think that's what it means to be a gardener . . . to make the normal task of lawn maintenance into an *art*. Our souls live on within the things and people we vulnerably and creatively give ourselves to.

I used to push my grandma in her wheelchair around the gardens by her nursing home, and she made me stop at every blooming flower along our path. She would reach out, cup her frail, delicate hand around the petals, and say in her singsong tone, "Only God could make a flower!" Ever since, I've thought of that and heard her voice in my head any time I gaze upon a flower.

Every. Single. Time.

The legacy of those we love lives on through the small bits of beauty we lovingly give our attention to. We live on in the stories we tell, the recipes we scribble down, the songs we sing, and the photographs we take—each one is proof of our presence preserved. And just like fruit that grows sweeter with time, so do the tangible remnants of our memories.

> Our souls live on within the things and people we vulnerably and creatively give ourselves to.

WE LIVE ON THROUGH OUR COMPASSION

We live on through our tenderness and our attention to the things that matter most. Just like my aunt Sharyn, who traces her finger along everything she sees as beautiful when she comes to visit, we will each be remembered for the *beauty* that we help *others* become aware of. I have learned the art of seeking beauty by watching her. She learned it from watching her mother, my grandmother. And I pray that my children learn by watching *me*.

The legacy of the gardener is that you can feel through the gardener's work how deep his *love* is for the garden. We establish a legacy of presence that will be remembered by tending compassionately to the lives we have been given.

Sometimes talking about legacy can feel a little morbid, but enough of my clients' photographs have been used as the main framed portraits at their funerals that I guess I have accepted it could be any of us at any time. I have really tried to view the idea of legacy from a healthy perspective, taking cues from wise, resilient mentors to light the way forward.

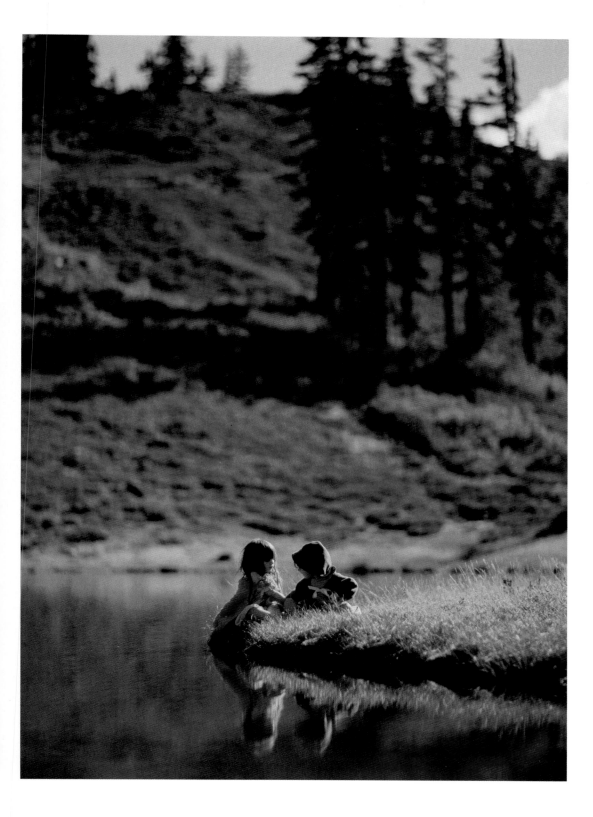

I met Christee only three days before she died in September 2011. She was thirty-five years old, lived in a suburb of Austin, Texas, was married to her childhood sweetheart, and had three children. After beating triple-negative invasive inflammatory stage 3C breast cancer, she was diagnosed with stage 4 spinal carcinomatous meningitis and given a very short amount of time to live.

My friend Chrystal was Christee's neighbor, and she called me and told me her story. She also told me that a group of people who loved Christee wanted to make one of the requests on her self-made bucket list come true. She asked if I could fly out to photograph Christee and her fourteen-year-old daughter trying on wedding dresses. It was something they had always talked about and looked forward to as her daughter was growing up, and it was important for both of them to experience that special moment together before it was too late.

They stressed to me that this was to be an experience of *joy*, not sadness—Christee wouldn't have had it any other way. Kaitlynn, Christee's daughter, described to me the experience she wanted that she said every little girl dreams about . . . the giddy excitement of picking an armful of dresses, trying on each one as her mama laces up the back, and then emerging from the fitting room each time to see the proud look on her mama's face—the look that tells her when she has found *the* dress.

Through my entire trip I prayed for strength not to say the wrong thing or get in the way of this sacred moment between mother and daughter, for clarity to be able to tell their story through photographs in a way that showcased the joy of the moment and the beauty of Christee's love for Kaitlynn. The moment I walked into their home, I was greeted by Christee wrapping her arms all the way around me. She just held me there for a few moments.

I spent all day with Christee and Kaitlynn, driving around town doing errands, stopping to look at flowers growing along the roadside, and going to the local bridal gown shop. I stood in

a tiny dressing room at the back of the shop and listened to the two of them talk.

"Do you like this one, Mom? I mean, would you pick it?" Kaitlynn asked.

"You're so beautiful, honey. I love it!" Christee would reply.

She found things she loved about every gown, and she hollered and rejoiced over each one. There wasn't one she disliked. I'm not sure if Christee's daughter saw her mother's courage the way I did that day—humble, full of grace, and contagious—but I photographed it the best I could so that she would have proof of that tender presence and be able to one day look back and remember.

I could see that Christee was in a lot of pain, but she made it very clear that we were to focus on the purpose of the day and not think about anything that *might* happen in the future. I don't think she stopped smiling for a moment.

As we were in the car driving around, she told me, "The other day we were driving home and we saw a terrible car accident with multiple fatalities, and all I could think was how awful it was that those people who had passed didn't get the blessing of being able to tell their loved ones goodbye. I am so blessed to know already, and so we live every day in the moment together. We laugh, we play, we live life together. The kids sleep with me in my bed and we just hold each other. I am ready to be with Jesus, but until he is ready to bring me home, I will delight in every second with my children and the love of my life."

All throughout the day Christee was unbothered by little annoyances, and whenever she spoke, it was with purpose. She was humorous and optimistic. She was interested in my heart. She asked questions that meant something. She hugged tightly, as if it could be for the last time—and for us, it was.

Christee became very ill and died three days after our day at the dress shop. I was not able to make it to her funeral, but I heard that at Christee's request, everyone wore bright, happy colors, as she wanted it to be a celebration of her life. Joyful songs were sung, and everyone who attended pasted a jewel onto her casket.

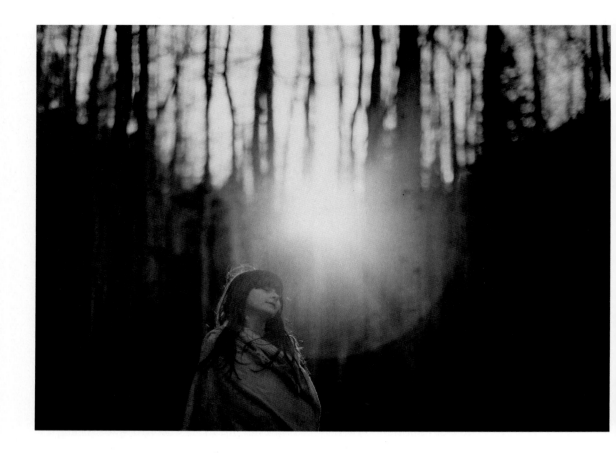

Many stories were told affirming that all throughout her life and the difficult diagnosis, Christee had been just as wonderful as she was when I met her near the very end. Many of her friends called her an angel, and I can say I have never seen a face that more resembles Jesus to me than hers.

Her legacy of presence has stayed with me.

Just before I left her house on that final evening, I found a little plaque that Christee's daughter told me was given to her during her first fight with cancer. On it were these words: "Trust your strength. Pick more wildflowers. Surrender your fear. Find beauty in the small. Unleash your joy. Teach kindness. Celebrate the gift of today. Keep being brave."

Christee lived each of her last days, and all the days before those, by those words. She had divine strength. She had no fear of

death. She found beauty in every tiny bit of living. Joy and kindness dripped from her every word. She celebrated every day she was given, and she kept being brave until her very last moment.

A VILLAGE OF MOTHERS

Twelve years after that holy moment at the bridal shop in Austin, Kaitlynn, Christee's daughter, got married. I remember the moment I saw the notification on Facebook about her wedding; seeing her in that beautiful dress brought the sacredness of our time together flooding into me again. I clicked on the album of wedding photos, and the first thing I saw was that Kaitlynn's radiance was exactly like I remembered her mother's. She had that same smile—the one that just wouldn't quit, the one I had memorized every bit of that day in the car.

I scrolled through the pictures and came to one that showed Kaitlynn surrounded by eight women, all about Christee's age, who had so evidently come alongside her and "mothered" her in the absence of her own mama. She had written a little thank-you in the caption of the photo, tagging each woman and saying how they had loved her in different important seasons of her life.

I wrote Kaitlynn a message letting her know how beautiful she was and how I will always hold close the time we spent together all those years ago. She wrote back to me right away and has given me permission to share her words.

> We all thought about her so much at the wedding. When I did find *the dress*, it made my heart miss her even more. Funny enough, the one I chose was almost identical to the one we tried on together that we both loved so much. Just a little less rhinestones.
>
> I have been gifted so much in this life with so many moms and strong women who love me. My husband's personality is very similar to my mom's—making everyone feel loved and seen at all times. No doubt she hand-picked him for me, and I actually told him that after our first date. The album with the photos from that

day we spent together at the dress shop was displayed proudly at our rehearsal dinner and wedding.

Those memories are some of my most cherished things in this world. Just . . . thank you.

Kaitlynn clearly carries her mother's radiance within her—she has devoted her life to helping others and is currently in school to become a nurse.

I want to leave a legacy like Christee's—loving people with so much compassion and intention that, even after I leave this earth, my radiance is kept alive through their presence.

COMPASSIONATE MOTHERING CHANGES THE WORLD

My dear friend Joel McKerrow, an acclaimed Australian performance poet, wrote a poem for me several years back. It was his creative offering to help me remember that seeking beauty at home in the mindless and mundane of motherhood is not altogether *meaningless*.

I'm prone to giving up, but a good friend never lets you forget your strength. So, in the way Joel has been tender like a mother to me through the giving of his words, I extend that same tenderness now to *you*.

> The sacred coats her life
> and drips from her fingers
> like rain,
> like redemption,
> like love,
> like storms,
> like rivers that break their banks and soak the dry earth.
> She soaks the dry earth.
> She floods her family.
> She drenches them holy.

Pours out upon them until the river runs
and they are playing in the water and she is playing in the
water and screaming in delight and inside her,
the little girl inside her,
dances and squeals and
laughs and plays in the water.[3]

I believe this about me and I believe this about *you*.

The sacred coats *your* life and drips from *your* fingers like rain, like redemption, like love, like storms, like rivers that break their banks and soak the dry earth.

To mother is to create life. Every day you continue to create life with your words, bring new images into being, find light within darkness, nurture all those around you, and learn to be compassionate—maybe even with *yourself*.

Women are mighty rivers.

Mothers are mighty rivers.

You are a mighty river. ¶

APPLYING THE PRESENCE PRINCIPLE
TO BECOME PRESENT TO YOUR LEGACY

1. **Slow down and breathe.**

2. **Set an intention and write it everywhere.** When fear and re-
gret are breathing down your neck, remember that your energy,
your compassion, your joy, and your peace are all sacred. Let
your unfolding legacy reflect the honoring of that sacredness. An
example: "I am a mighty river—I flood my family with love."

3. **Engage in a sensory-rich memory.** Reflect upon ways you
can use your power as a river to influence those you love. Look
for opportunities to play with reckless abandon and moments to
lean in and fully listen. Seek experiences to celebrate the small
things ever before you rather than turning away to numb and
distract.

4. **Focus and take a picture.** Create an image that celebrates
your radiant, creative spirit.

SHELTER

—

Creativity is not an escape from reality
but the shelter in which we take cover.

These safe houses of our own making allow
us space to look tenderly and imaginatively at our realness.

We first build for ourselves,
and then, in time, we invite others in.

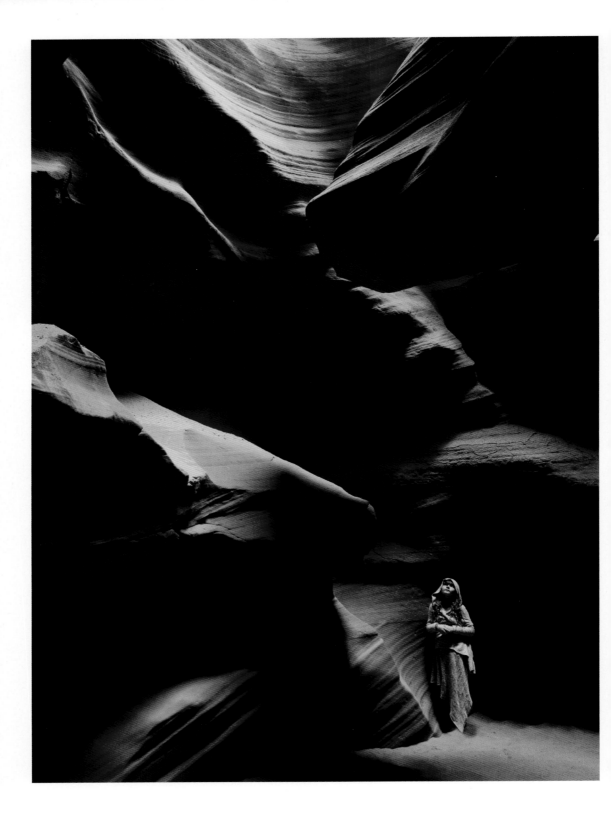

15

BECOMING PRESENT *to* CREATIVITY

I think most mothers want to be practicing some form of creativity, but rarely does that longing move from being an *idea* in the mind to an actual *embodied experience*. This is a struggle for me too, so in my own creative pursuit I seek out the stories of wise women who sustain devoted practices of expressing themselves. Emily Harrington is a woman whose commitment to her practice leaves me in awe. Emily was the first woman to free-climb the Golden Gate route up El Capitan, a three-thousand-foot granite wall in Yosemite National Park, in under twenty-four hours.

She had made multiple attempts at scaling the wall, held in place only by a rope and going most of the way on her toes and fingertips. Each time she came so very close to reaching the top only to suffer near-death falls.

In recounting her experience to a reporter for the *New York Times*, Emily said, "I always received so much advice from men, people telling me how I should do things, how I'm doing it wrong,

but in the end I just decided to do it anyway despite the fact that a lot of people felt that maybe I couldn't or maybe I didn't belong there."[1] She refused to be held back by the opinions of others. When it would have been easier to just believe the naysayers and do something that would have made those around her more comfortable, she instead used that resistance to propel her forward.

Aside from Emily's seeming super strength, what I love most about her is her *inventiveness*. I was listening to a podcast in which she described one particular crevice along her route up El Capitan. It was an important little opening on a ledge only three hundred feet from the top. Emily realized that the reason she had fallen at that spot on a previous attempt was because her foot was too small to stay wedged in the hole, which was the size of a *man's* foot. She learned from her previous "failure" that she needed a creative way to make her foot larger so she could get up into that final section of the route. In her fourth try she finally succeeded because she used her *imagination* to overcome the obstacles that previously held her back.

For safety reasons, Emily had a climbing partner with her at all times throughout the ascent. And that gave her an idea. When they got to that section of the rock face, she put her foot with her own smaller shoe inside her male partner's larger shoe and laced it up nice and tight. It was the perfect fit! She was then able to navigate that difficult crevice without any trouble before giving her partner his shoe back so they could finish the climb together.

In an interview for *Shape* magazine, Emily explained how she has come to think about her fear after doing so many things that others consider terrifying: "I set this big goal for myself that I didn't really think was possible, and I was super scared to even try it and wanted it to be perfect. . . . But then I came to realize that it's never going to be perfect." And she says this is how her relationship with fear completely changed. "Fear just exists inside of us, and I think it's a little counterproductive to feel any sort of shame around it. . . . So, instead of trying to beat my fear, I just started recognizing it and why it exists, then taking steps to work

with it, and in a way, use it as *strength*." She went on to say, "A lot of times, I think we set goals and they seem so massive and so far out of reach, but when you break it down into smaller sizes, it's a little bit easier to comprehend."[2]

I tell myself, "Well, if Emily can scale three thousand feet of sheer granite in less than twenty-four hours using only her fingertips and toes, then I *guess* I can face this day right here in front of me with my children."

Practicing presence requires that we incorporate creativity into the challenges of our days, the way that Emily Harrington used her creativity to free-solo El Capitan. And in time, hopefully, we too will discover what Emily did—that as we deepen our *practice*, we deepen our *confidence*.

> As we deepen our *practice*, we deepen our *confidence*.

Each small step into creative presence adds up to a new way of mothering, creating, and being in the world.

When I am practicing the Presence Principle at home and my kids are around, I often count and say the four steps out loud (slow down and breathe, set a meaningful intention, look for a way to engage in a sensory-rich memory, focus and take a picture) and my kids will often join right in alongside me. I am thrilled for my kids to see me prioritizing my own regular practice of creativity and presence, and my hope is that in time they will adapt it in whatever way feels authentic to *them* and someday put it into practice for *themselves*.

Small intentional steps seem to be the only way we do this parenting thing. We sure as heck aren't going to scale El Cap in a day with all of these children pulling on us and toddlers jumping on our backs. But as author Emily P. Freeman says, we *can* just do "the next right thing."[3]

DON'T HESITATE TO CREATE

I am often asked how to even begin finding the next right thing when it comes to becoming more creative, and I think it just starts

with the intention to *pay closer attention*. Paying attention might look like noticing color in the world or birds outside your window. It could look like making more eye contact with the people around you, or lingering in the sun to feel the warmth on your skin, or taking a deep breath and observing the way shadows are casting patterns all around you. The intention is to be inspired by what is already present rather than feeling the need to *perform* or *produce* anything.

Taking pictures of your life and learning to be creatively curious can be a powerful act that builds resilience. By putting yourself in the way of *light*, you train your mind, heart, and eyes to look for hope even amid the most difficult circumstances.

In late summer, for a mere ten minutes every night, the sun shines into our living room like an orange blazing beam. I've taken many pictures within that gorgeous light, but I can't ever imagine taking *enough*. I am completely captivated by it, and in some ways its arrival feels like a *friend* is visiting—I just want to draw close and listen to what it has to share. I often hear Mary Oliver's wise poetic instruction accompanying the light, whispering, "If you suddenly and unexpectedly feel joy, don't hesitate. Give in to it. . . . Don't be afraid of its plenty."[4]

As I enter fully into the moment before me, I am reminded . . .

Creative expression is not meant to be a crumb.
Self-compassion is not meant to be a crumb.
Joy in motherhood is not meant to be a crumb.
It's time to begin welcoming the plenty.

One afternoon I was taking pictures of some flowers in the kitchen when my son spotted me and ran in my direction with arms outstretched and eyes twinkling. Upon seeing the camera in my hands, he squealed with delight, pushed it up toward my face, and said, "Mama play!" He saw me happy and enthralled, and the only thing he knew to call it was *play*.

The next day I watched my husband show him the veggie sprouts he grew from seed in our garden. They inspected the leaves together and then dug in the soil, giggling. Our boy, still with limited words in his expanding vocabulary, smiled up at his father and said, "Dadda play!" He saw his daddy happily at peace, and the thing he thought to call it was *play*.

When we think we have forgotten how to access the small voice deep within, children remind us that joy is accessible through our creativity. Playful presence is always within reach—take the hand of your child and let them lead you into their world of imagination.

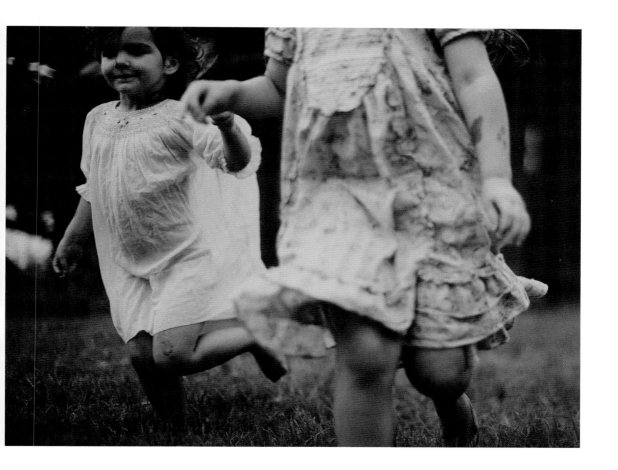

Creativity requires you to use your imagination. And the way your imagination works is by combining things that already exist within your mind from your *past*, with things you are *currently* being exposed to in the *present*. You are able to come up with a connection that no one else could ever come up with—because only *you* have the history that you do, and only *you* are having the precise experience you are having at this very time. That connection spot of imagination is the place we all *create* from.

Creativity allows fear to be named, sorrow to be released, grief to be held, and joy to be expressed. Creativity requires that you fully embody the present moment while also allowing yourself to pull from the wisdom and knowledge that you have gained through past experience.

When Emily Harrington scaled El Capitan, she looked at the things that *scared* her or that made her feel *weak*, and instead of giving in to those voices of fear, she used the feelings as indicators to become more *creative*. It was her *creativity* that propelled her upward. She was constantly looking for ways to view her weaknesses from a different perspective, and in doing so she was able to use as *strengths* what had once been perceived as vulnerabilities.

This is *motherhood*—being confronted nonstop with how ill-equipped you are for the task of raising humans, often worn and weary, yet with no other choice but to just keep going. Motherhood is full of unrelenting challenges that are completely unique to you and your children, which can often feel like an isolating burden. But it is your *imagination* that can take your unique past experience and combine it with what you're being faced with in the present moment to come up with unique creative pivots custom-made exactly for you and your kids. Art is not *only* something that you need paper or paint or a camera to do—it is also a perspective you can take on that allows you to creatively overcome your challenges.

> Creativity allows fear to be named, sorrow to be released, grief to be held, and joy to be expressed.

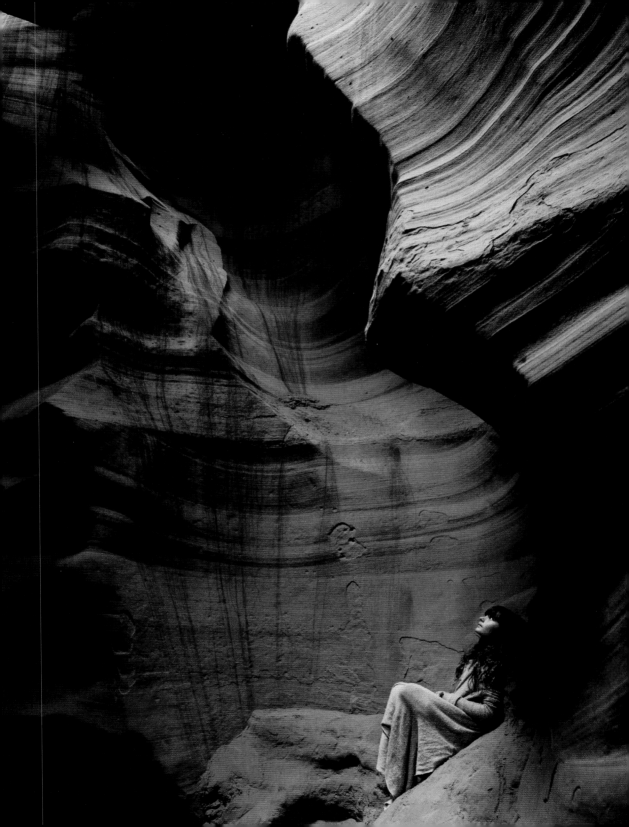

A SPIRIT OF CURIOSITY AND ADVENTURE

Not long ago I heard Emily Harrington speak about her practice of free climbing on HBO's docuseries *Edge of the Earth*. She said, "I am truly happiest when I've gone and done something that feels full, and sort of took me to all the spectrums of emotion, where I've been scared, elated, uncomfortable, or felt like I'm gonna fail, or I had to try really hard. Honestly, it just feels that much more rewarding. I hope that that mentality of exploration and curiosity and adventure inspires other people to find their own form of that."[5]

When she says that her most fulfilling experiences have been those that took her "to all the spectrums of emotion," I couldn't help thinking that it is at *the intersection of motherhood, presence, and creativity* where a lot of us experience those same emotional spectrums.

Creativity requires us to use our imagination, but often the imagination of a mother gets hidden beneath piles of decades-old unrealized dreams and crushed hopes. We put ourselves aside for so long that daring to let ourselves imagine again can feel very scary—like standing at the bottom of a towering, granite peak. But having a mentality of *exploration*, *curiosity*, and *adventure* can once again inspire our embodiment of presence.

THE PRESENT MOMENT IS HOME

Anne Lamott is a voice I often turn to for wise words on creativity and on taking myself lightly when the weight of the world's darkness feels like it might crush me into oblivion. The way she describes her own relationship with presence reminds me that real life doesn't have to look any sort of perfect or proper way. She writes:

> [You can't get to truth] by sitting in a field smiling beatifically, avoiding your anger and damage and grief. Your anger and damage and grief are the way to the truth. We don't have much truth

to express unless we have gone into those rooms and closets and woods and abysses that we were told not to go in to. When we have gone in and looked around for a long while, just breathing and finally taking it in —then we will be able to speak in our own voice and to stay in the present moment. And that moment is home.[6]

Anne says it so well—the home we long for is actually the moment we are already *in*. But we cannot see that until we have gone inside of our own grief and fear and doubt and are willing to sit compassionately *with* the feelings instead of judging them, numbing the pain, or running away.

Only *then*, in the discomfort of that unknown, do we find our creativity again. As we practice that creativity, allowing beauty and light to flow through us, we find the authentic voice we once thought was lost, and the act of becoming present starts to feel a lot more like *home*. ¶

APPLYING THE PRESENCE PRINCIPLE TO BECOME PRESENT TO CREATIVITY

1. **Slow down and breathe.**

2. **Set an intention and write it everywhere.** Imagine who you might be if you freely allowed creativity to flow through you. Let your intention be centered around your entire life being an art. An example: "I am the artist of my life."

3. **Engage in a sensory-rich memory.** Instead of trying to make sense of things that will never make sense, enter your five *senses* and let what you see, hear, taste, smell, and touch transform your tight grip into open hands.

4. **Focus and take a picture.** Create an image that makes visible the often-invisible company of inspiration all around you.

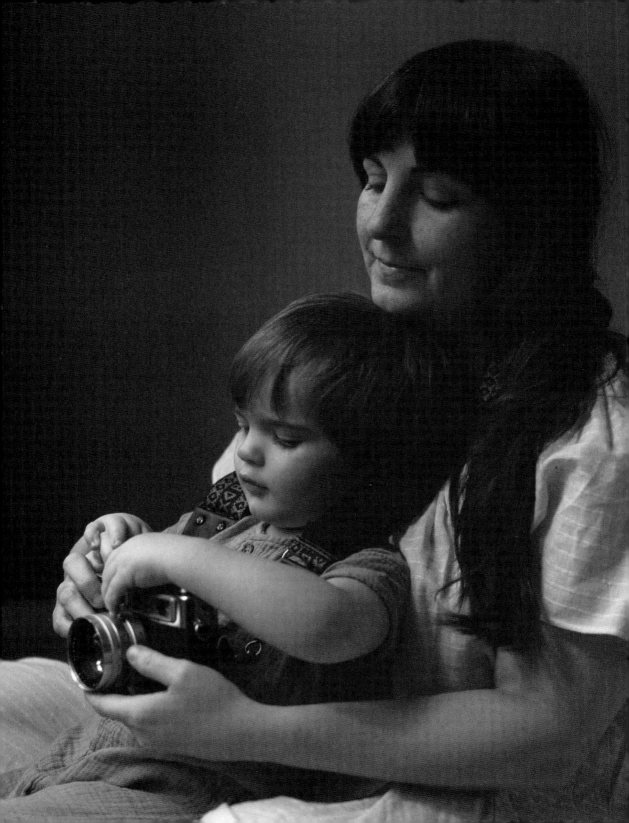

A BLESSING FOR PRACTICING PRESENCE

Let us fix our gaze on Presence,
the place we find our true selves and one another.
When the voice of productivity calls to us,
let us find peace in the stillness.
When overwhelm seeks to cloak the good,
let us stay calm and alert to the beauty.
When we want to give up, let us find gentle words—
to say what we need and to forgive.
Let us find breath in our lungs
and the awareness to receive it fully.
Let us turn our eyes toward wonder
instead of messes.
Let us open our ears to hear laughter
instead of loudness.
Let us set down defensiveness
and pick up creativity.
Let us open our hearts and senses
to the right here and now.
Drawing close instead of away,
seeking the ever-present light within our moments.

ACKNOWLEDGMENTS

To Donny Prouty—this book would not have been possible without your endless encouragement and tender support. Just like our song says, "We get to carry each other, carry each other." You've carried me out of chaos and into exploration, growth, and peace. Thank you for building a family with me and for carrying all of us through so many years of beautiful exhaustion. Thank you for every ounce of intention and heart you poured into our children as I worked on creating this book—they are growing up without judgment, able to learn about themselves and the world alongside a kind, wise, loving father. I can imagine no greater legacy than the one you have planted within them.

To Becky Green—Mom, thank you for giving me the freedom to write from the heart about my experiences. Your life is a song of resilience, trust, and grace, and you've modeled for me how to find my courage, harness my power, and find meaning in all interactions and challenges. I know you say you aren't an artist, but you bring life to everything you touch. Your harvest is abundant and beautiful. Thank you for celebrating this book at every milestone along the way—I write for me, and I also write for you.

To Gracie Prouty—your creative courage is the most inspiring thing I have ever witnessed. I constantly stand in awe of your joy, depth, and commitment to artistic advocacy. Thank you for

the ocean of grace you regularly extend to me—I am a far better artist, human being, and mother because of your radical empathy.

To Sharyn Moore—thank you for speaking the language of creativity with me when nobody else understands. You infused me with inspiration and conviction from the start. Thank you for nurturing my creative soul, supporting my endeavors, and showing me how to dance when the dark settles in.

To Chip Moore—thank you for supporting my dreams and helping launch me into the world with knowledge, wisdom, and tools.

To Taylor Leonhardt—you're the bird that sings in the dead of night, reminding me and all of us within earshot that our broken wings can still fly. Thank you for chasing me down with kindness and melodies when the world feels too harsh.

To Ali Albertson—you've reminded me from day one that *hope is precious*. Thank you for believing in this book as much as I have. You have been a friend, a sister, and the most loyal teammate in this work.

To Tommy Harmon—at times when I would feel too weak to keep writing, I'd think of your strength and your selflessness, and I could keep going. You are the most beautiful person, and to be your sister is an extravagant gift. I wrote this to validate the kids we were and the kids I hope we can become.

To Mick Silva and Jackie Knapp—thank you for your belief in my writing and for your commitment to telling the truth in your own.

To Stefanie Webb—your courage is contagious, and the way you advocate is so brave. Thank you for allowing your words to be shared in this book.

To Kim Jones—thank you for being my creative-wellness doula and my self-validation partner in art. Your joyful spirit is luminous.

To Tiffany Scott—your bravery, kindness, and passionate pursuit of meaning helped me through years of growth that felt endlessly agonizing. Thank you for giving me the gift of getting to know Truman through your love.

To Joel McKerrow—*anam cara*, thank you for helping me to fall in love with poetry again and for offering me a safe, sacred place within friendship to expand as an artist.

To Christina and Stephen Hutson—this book was born in your living room! Thank you for providing a haven of safety, comfort, and inspiration for me to tap into my deepest self and bring forth a majority of the words on these pages. I felt your belief in me on a cellular level.

To Chappel Burnley—thank you for sharing your tender, illuminating poetry and the stunning image of your radiant motherhood. I will never forget the light that day and how it seemed to be shining from within you.

To Stephanie Duncan Smith and the incredible team at Baker Books—thank you for your gentle and insightful guidance and for making this experience a much more artistic process than I expected. To have a whole team working together on a creative project in hopes of expanding women's souls has been so wonderful and fulfilling.

To Joy Eggerich Reed—thank you for being the first one to *get* my vision for this book. Your commitment to this message kept me steady when I would otherwise have been spinning out with confusion. Thank you for wanting to get more meaningful and healing art out into the world and for being a stunning example of authenticity.

To Ann Voskamp—your friendship and words of blessing over my art gave me fire to keep working to get this book made. Thank you for showing up with sacred words in wearisome times.

To JJ Heller—you have been the embodiment of grace to me, both as a dear friend and as an artistic collaborator. Thank you for lending your time, energy, thoughtfulness, and pure love to this book. Your words and presence have truly been my bridge over troubled water throughout many seasons. The words "thank you" will never, ever be enough.

To my clients, who have entrusted me with the honor of documenting your tender stories—thank you for lending me your

hearts, for showing up with brave honesty, and for allowing yourselves to be seen in both shadow and light.

To Kaitlynn Dugan—your courage is breathtaking, your joy is contagious, and I am forever stamped with the glory of authenticity because of my time with you and your incredible mother.

To my village of women artists who have wrapped around me with relentless compassion throughout the making of this book project—thank you: Chrystal Smith, Sarah Neale, Laura Duggleby, Gwen Moore, Gina Dixon, Jenna Wietfeldt, Jane Boutwell, Erin Fox, Maegan Keaton, Tessa Steenbergen, Jenn Furber, and Sarah Cornish.

And to my children—Gracie, Brandon, Clementine, Mabel, Smith, Webb, and Sparrow: your wonder will forever be my greatest inspiration. Thank you for singing and dancing with me in the kitchen and in the car every time I turned in a new draft of this manuscript. Being your mom is the very best thing in my life. I love you so much.

NOTES

Chapter 1 How I Began Practicing Presence

1. Barbara Brown Taylor, *An Altar in the World* (New York: HarperOne, 2010), xvii.

Chapter 2 Reclaiming Childlike Imagination

1. "Eugene Peterson: Answering God," *On Being with Krista Tippett*, NPR, December 22, 2016, https://onbeing.org/programs/eugene-peterson -answering-god/.

2. Robert Henri, *The Art Spirit* (Denver: Innovative Books, 2020), 220.

3. "William Blake Quotes," Quoteslyfe.com, accessed July 25, 2022, https://www.quoteslyfe .com/quote/In-the-universe-there-are-things-that -231900.

Chapter 3 Discovering the True Meaning of Joy

1. Maia Mikhaluk (@mmikhaluk), "Where flowers bloom so does hope," Facebook post, April 25, 2022, https://www.facebook.com/1132635517/posts /10226446147556641/?d=n.

2. Frederick Buechner, *The Hungering Dark* (New York: HarperOne, 1985), 102.

3. Yehuda Amichai, in Mark Nepo, *The Book of Awakening: Having the Life You Want by Being Present to the Life You Have* (Newburyport, MA: Red Wheel, 2020), 91.

4. Brené Brown, *Atlas of the Heart: Mapping Meaningful Connection and the Language of Human Experience* (New York: Random House, 2021), 216–17.

5. Liz Milani (@thepracticeco), "You're Not Selfish to Want Joy," The Practice Co, June 2, 2020, https://www.thepracticeco.com/devotions/youre -not-selfish-to-want-joy?rq=simcha.

Chapter 4 The Presence Principle

1. Rick Hanson, "Take in the Good," accessed June 10, 2022, https://www.rickhanson.net/take-in -the-good/.

2. Amisha Jha, "How to Tame Your Wandering Mind," TED Talk, TEDxCoconutGrove, March 23, 2018, https://www.ted.com/talks/amishi_jha _how_to_tame_your_wandering_mind.

3. Henry David Thoreau, *Walden* (n.p.: Simon & Brown, 2018), 11.

4. As quoted in Kerry Acker, *Dorothea Lange* (Philadelphia: Chelsea House Publishers, 2004), 12.

5. Alain Hunkins, "The Part of Your Brain That Can Make Work a Joy . . . or a Hell," October 15, 2017, https://alainhunkins.com/2017-10-the-part -of-your-brain-that-can-make-work-a-joy-or -a-hell/.

Chapter 6 Letting Go of Perfect Pictures

1. "Why Brené Brown Says Perfectionism Is a 20-Ton Shield," Oprah's Lifeclass, Oprah Winfrey Network, October 6, 2013, https://www.youtube .com/watch?v=o7yYFHyvweE.

2. Bob Ross and Robb Pearlman, *Be a Peaceful Cloud and Other Life Lessons from Bob Ross* (New York: Universe, 2020), 47.

3. Ross and Pearlman, *Be a Peaceful Cloud*, 51.

4. Christina Kotchemidova, "Why We Say 'Cheese': Producing the Smile in Snapshot Photography," *Critical Studies in Media Communication* 22, no. 1 (March 2005): 9–10.

5. Elizabeth Brayer, *George Eastman: A Biography* (Baltimore: Johns Hopkins University Press, 1996), 136.

6. For more on this, see Nancy Martha West, *Kodak and the Lens of Nostalgia* (Charlottesville, VA: University Press of Virginia, 2000).

7. Leonard Cohen, "Anthem," track 5 on *The Future*, Columbia, 1992.

Chapter 7 Becoming Present to Your True Worth

1. Jenny TeGrotenhuis, "Neutrality Is Invalidation," The Gottman Institute, accessed August 5, 2022, https://www.gottman.com/blog/neutrality-is-invalidation/.

2. Brené Brown, "Finding the way back to ourselves and each other," Facebook video, April 1, 2022, https://www.facebook.com/watch/?v=538253600975578.

3. TeGrotenhuis, "Neutrality Is Invalidation."

4. Merriam-Webster.com, s.v. "validate," accessed July 8, 2022, https://www.merriam-webster.com/dictionary/validate.

Chapter 8 Becoming Present to Compassion

1. James Clear, *Atomic Habits* (New York: Avery, 2018), 26.

Chapter 9 Becoming Present to Beauty

1. "Alma Woodsey Thomas," National Museum of Women in the Arts, accessed May 15, 2022, https://nmwa.org/art/artists/alma-woodsey-thomas/.

2. "Late Work," *Alma W. Thomas: Everything Is Beautiful* (art exhibit), Frist Art Museum, February 25–June 5, 2022, https://fristartmuseum.org/alma-thomas-panels/.

3. Quoted in Victoria L. Valentine, "On Occasion of New Exhibition 'Alma Thomas: Everything Is Beautiful,' Curators and Scholars Reflect on Lesser-Known Aspects of Artist's Life and Work," Culture Type, July 28, 2021, https://www.culturetype.com/2021/07/28/on-occasion-of-new-exhibition-alma-thomas-everything-is-beautiful-curators-and-scholars-reflect-on-lesser-known-aspects-of-artists-life-and-work/.

Chapter 10 Becoming Present to Light

1. Richard Rohr, "Walk in Beauty," from a talk given February 2018 at St. John XXIII Catholic Community, Albuquerque, New Mexico, Center for Action and Contemplation, August 10, 2018, https://cac.org/daily-meditations/walk-in-beauty-2018-08-10/.

2. Rohr, "Walk in Beauty."

3. Rohr, "Walk in Beauty."

Chapter 11 Becoming Present to Your Foundation

1. Ephesians 3:17, YouVersion app, https://www.bible.com/bible/116/EPH.3.17-18.NLT.

Chapter 12 Becoming Present with Your Body

1. Jane Boutwell, conversation with author, May 2022. Quoted with permission.

2. Bessel A. van der Kolk, *The Body Keeps the Score* (New York: Penguin, 2018), 275.

3. Daniel Higa Alquicira, "Craftsman, Artist Loses Sight and Learns to Transform Clay by Touch Alone," Orato, April 29, 2022, https://orato.world/2022/04/29/craftsman-artist-loses-sight-and-learns-to-transform-clay-by-touch-alone/.

Chapter 13 Becoming Present to Your Strength

1. Julian of Norwich, *Revelations of Divine Love*, chap. 82.

2. Jenna Wietfeldt, personal message to author, May 2022. Quoted with permission.

3. Stefanie Delk Webb (@stefanie.delk), "2 years ago . . ." April 15, 2021, https://www.instagram.com/p/CNsHoYCL2v-/?igshid=MDJmNzVkMjY=.

Chapter 14 Becoming Present to Your Legacy

1. Diane Ackerman, *Deep Play*, illustrated by Peter Sis (New York: Vintage Books, 2000), 196.

2. Ray Bradbury, *Fahrenheit 451* (New York: Simon & Schuster, 2012), 149.

3. Joel McKerrow, personal communication with the author, September 2017. Used with permission of the poet.

Chapter 15 Becoming Present to Creativity

1. Marie Fazio, "A Record-Setting Ascent of El Capitan," *New York Times*, November 11, 2020, https://www.nytimes.com/2020/11/09/sports/emily -harrington-free-climb-yosemite.html.

2. Megan Falk, "How Rock Climber Emily Harrington Leverages Fear to Reach New Heights," *Shape*, December 15, 2020, https://www.shape.com /lifestyle/mind-and-body/emily-harrington-rock -climbing-fear.

3. Emily P. Freeman, *The Next Right Thing: A Simple, Soulful Practice for Making Life Decisions* (Grand Rapids: Revell, 2019).

4. Mary Oliver, "Don't Hesitate," *Devotions* (New York: Penguin Press, 2017), 61.

5. "Reaching for the Sky," *Edge of the Earth* (miniseries), episode 3 (HBO, 2022) https://www .hbo.com/edge-of-the-earth/season-1/3-episode -iii-reaching-for-the-sky.

6. Anne Lamott, *Bird by Bird: Some Instructions on Writing and Life* (New York: Doubleday, 1995), 201.

JOY PROUTY is a professional photographer, creative educator, and filmmaker who seeks to help people truly see. Her work has been featured on *Entertainment Tonight* and in a variety of publications, including *Magnolia Journal* and *People Magazine*. Joy and her husband, Donny, make heart-stirring films for artists, families, and nonprofit organizations. Through workshops and online courses, Joy teaches empathetic visual storytelling and self-validation through creativity. She lives in Nashville, Tennessee, with Donny and their seven children.